FILM BY DESIGN

FILM BY DESIGN

The Art of the Movie Poster

Edited by Gary D. Rhodes
and Robert Singer

University Press of Mississippi / Jackson

The University Press of Mississippi is the scholarly publishing agency of
the Mississippi Institutions of Higher Learning: Alcorn State University,
Delta State University, Jackson State University, Mississippi State University,
Mississippi University for Women, Mississippi Valley State University,
University of Mississippi, and University of Southern Mississippi.

www.upress.state.ms.us

The University Press of Mississippi is a member
of the Association of University Presses.

Library of Congress Cataloging-in-Publication Data

Names: Rhodes, Gary Don, 1972– editor. | Singer, Robert, 1953 May 30–
editor.
Title: Film by design : the art of the movie poster /
Gary D. Rhodes, Robert Singer.
Description: Jackson : University Press of Mississippi, 2024. | Includes
bibliographical references and index.
Identifiers: LCCN 2024019702 (print) | LCCN 2024019703 (ebook) |
ISBN 9781496853202 (hardback) | ISBN 9781496853219 (trade paperback) |
ISBN 9781496853226 (epub) | ISBN 9781496853233 (epub) |
ISBN 9781496853240 (pdf) | ISBN 9781496853257 (pdf)
Subjects: LCSH: Film posters—History. | Motion picture industry—History.
| Motion pictures in art. | Advertising—Motion pictures. | Commercial art.
Classification: LCC PN1995.9.P5 F442 2024 (print) | LCC PN1995.9.P5
(ebook) | DDC 744.7/8—dc23/eng/20240525
LC record available at https://lccn.loc.gov/2024019702
LC ebook record available at https://lccn.loc.gov/2024019703

British Library Cataloging-in-Publication Data available

CONTENTS

ACKNOWLEDGMENTS

We would like to thank the following archives, institutions, and organizations which helped in the completion of this book: the Bancroft Library at the University of California at Berkeley, the Billy Rose Theater Division of the New York Public Library, the British Film Institute, the Bundesarchiv in Berlin, the Cleveland Public Library of Ohio, the Deutsche Kinemathek, the Free Library of Philadelphia, the Harry Ransom Center at the University of Texas at Austin, Heritage Auctions, the Library of Congress of Washington, DC, the Los Angeles Public Library, the Margaret Herrick Library of the Academy of Motion Picture Arts and Sciences, the Media History Digital Library, and the National Archives of the United States. We would also like to extend our deepest appreciation to the American Comparative Literature Association. The panels we co-chaired at the 2021 conference on movie posters spurred this anthology into being.

Our deepest thanks also go to the following individuals: Ned Comstock, Vlad Dima, Frank Percaccio, Courtney Judith Ruffner Grieneisen, Laura Hatry, Bruce Herschenson, Alicia Kozma, Lynette Kuliyeva, Madhuja Mukherjee, Marlisa Santos, Michael L. Shuman, Anthony Slide, and Phillip Sipiora, as well as Emily Bandy and everyone at the University Press of Mississippi.

As Frank O'Hara wrote, "Mothers of America / Let your kids go to the movies!" We vividly recall beautiful movie posters enticing audiences into long-gone theaters. Those posters supplied moments of colorful cognition, an entry point into something frequently amazing. The editors thank their families and families across the globe entering *any* theater. Behold its vibrant signage: the movie poster.

Gary D. Rhodes, PhD *Robert Singer, PhD*
Oklahoma City, Oklahoma *Brooklyn, New York*
2023 *2023*

FILM BY DESIGN

POSTING THE CINEMA

GARY D. RHODES AND ROBERT SINGER

Whether appreciated or disliked, Steven Spielberg's *Jaws* (1975) remains one of the most important works in film history, inaugurating the age of the Hollywood blockbuster. Whether or not one has viewed the film, we globally share an image that virtually everyone knows, that of a vertical shark heading from the ocean depths directly towards the body of a female swimmer. The picture is unforgettable, but it is not from *Jaws*. It is about *Jaws*, it is a paratext to *Jaws*, and it is an invitation to *Jaws*, but it is not *Jaws*. It is instead a painting created by Roger Kastel, one that appeared on the original American movie poster for the film, as well as on so many subsequent videocassette and DVD boxes, T-shirts, toys, and collectibles.[1] In the film, Hooper (Richard Dreyfuss) explains that Jaws, the shark, is a miracle of evolution. In context of the present discussion, we would argue that *Jaws*, the poster, is a miracle of cinematic evolution. The iconic movie poster advertises a film, but it is also a work unto itself, a work of film history and a work of art, one that deserves consideration, study, and analysis.

Since the earliest days of international film history, film posters have been a significant part of film narrative and the overall experience of film attendance. According to Gary D. Rhodes, "By the year 1915, posters were firmly in place as a key part of marketing moving pictures."[2] From the early cinema period to the present phenomena of digital production, the film poster has been a centerpiece of feature motion picture marketing. Poster designs, no matter what their nation of origin, have become indelibly linked with the films they advertise, often to the degree that their images act as embodiments of their films for collective memory. Long after their initial marketing responsibilities conclude, the posters remain iconic images in film history

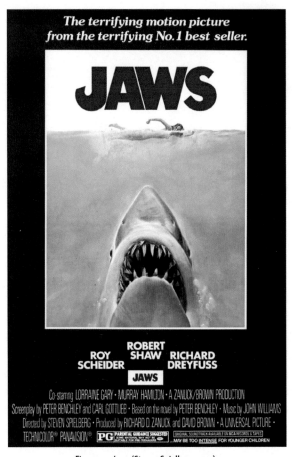

Figure 1.1. *Jaws* (Steven Spielberg, 1975).

and culture at large. One may recall the poster regardless of actually seeing the film as an evocative recollection. Born out of the circus poster tradition, the moving picture poster was a marketing strategy, a literal "presence" in the fin de siècle and was flourishing by the years 1910–1915. This strategic presence remains evident in the contemporary era: the movie poster signifies and induces expectation and desire.

David J. Alworth's essay, "Paratextual Art," discusses the aesthetic and industrial function of the book jacket as "paratext" in terms are equally applicable to the film poster; both are historically significant narrative parts of a greater whole experience. Alworth writes:

When does the paratext, the book jacket in particular, cross the threshold from marketing device to full-fledged interpretation? And

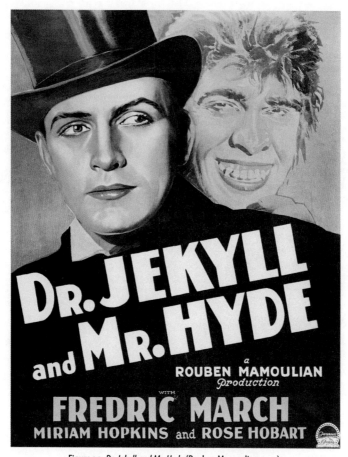

Figure 1.2. *Dr. Jekyll and Mr. Hyde* (Rouben Mamoulian, 1931).

to what extent is visualizing a novel a way of reading it; or, what happens to the notion of reading when designing a jacket is understood to comprise *giving a reading* in a meaningful sense?[3]

Alworth's notion that the paratext is "giving [an interpretive] reading" of its narrative precedent is an essential recognition of the paratext, whether book jacket, or in the case of this volume, the movie poster. More specifically, as well-known as Robert Louis Stevenson's naturalist novella, *Strange Case of Dr. Jekyll and Mr. Hyde* (1886) might have been to the literate public, it is likely that the majority of the film-going audience attending a screening of Rouben Mamoulian's *Dr. Jekyll and Mr. Hyde* (1931) in Depression-era America, as well as thousands or millions of others across the globe, would be unfamiliar with its themes of atavism, psychological dualities, medical-clinical

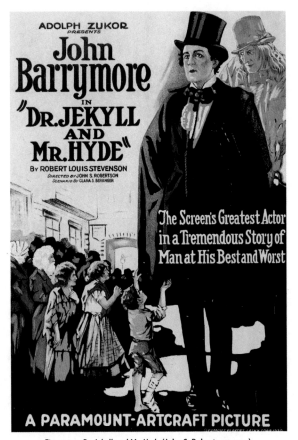

Figure 1.3. *Dr. Jekyll and Mr. Hyde* (John S. Robertson, 1920).

hypotheses, and its class-based setting. Yet, the celebrated movie poster of Mamoulian's adaptation creates an auratic presence of anticipatory spectacle, visual delights, as it features the "face that launched 1,000 nightmares."

This famous poster art is not the first of its kind as it concerns the Jekyll/Hyde narrative and film culture. Such contrasting personal and class-based spectacles were previously visualized in the film poster for John S. Robertson's film adaptation, *Dr. Jekyll and Mr. Hyde* (1920), with its towering figure of the caped, patrician doctor (John Barrymore) posing before the huddled mass of poor supplicants. The yellow background highlights the graphic information and contrasts with the dark clothing and stolid gaze of the doctor, who unknowingly stands in front of his other self, a sinister, apparition-like presence. These two commercially released film posters announce essential narrative tropes of duality and lurking danger via the advertising platform. Posters advertise; a movie poster is an industrial standard, a marketing strategy.

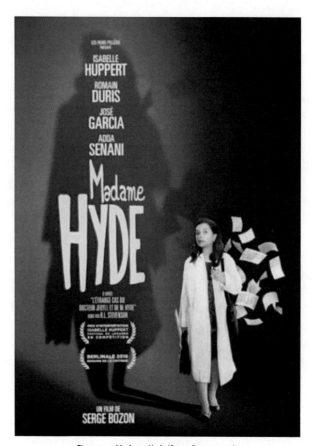

Figure 1.4. *Madame Hyde* (Serge Bozon, 2017).

In both *Dr. Jekyll and Mr. Hyde* posters, the viewer gazes upon the split image of one man as two selves. In the Mamoulian adaptation, the doctor appears in top hat and is attractive, while his "other," a gruesome, grinning apish figure, indicates there is a sinister, bifurcated presence within. Who are these men? The poster leads the audience as paratextual referent into the Jekyll/Hyde source narrative as well as creating a pathway to future Jekyll/Hyde film narratives and their derivations on a theme.

In 2017, French director Serge Bozon reclaimed the Jekyll/Hyde theme in his contemporized adaptation, *Madame Hyde*, in which Hyde is an unhappy, intelligent woman laboring as a teacher who undergoes a radical, unnatural and transformative change that deleteriously affects her life and the lives of her students. Who is this woman? *Madame Hyde* introduces a feminist slant to the world of work and its discontents.[4] The original French poster for Bozon's adaptation reveals a white-jacketed Madame Hyde, the clothing

appearing similar to a laboratory coat. She stands between two interrelated images: to her right, white note papers float in the air—a marker of her vocation—against a shadowy blue background. To Madame Hyde's left, a greatly enlarged image of her shadow, another "self," lurks as a presence, containing graphic credits. The placement of Madame Hyde's literal and reflective selves—identity markers and her shadowy "other"—strategically suggests inherent, contrasting dualities and recalls the graphic images and placement of Mamoulian's earlier film poster. Across the global audience, this industrial practice remains evident in today's marketing and presentation of films.

Like the aforementioned Jekyll/Hyde examples, a film poster means something: inviting, soliciting a response, a memory invoking colors, sounds, and images. The Jekyll/Hyde poster, as with all poster art, invites the observer within the literal and imagined narrative, as images and lettering, color and design, link to a broader aesthetic schema. Posters establish a coherent whole "experience" and are a critical part of the film industry and its history. *Film by Design: The Art of the Movie Poster* documents in its twelve diverse chapters the creation of meanings that both exceed the boundaries of the films and affect the content within the films by focusing on historical and contemporary, aesthetically significant movie posters. For some, Proust invokes the presence of evocative pastries to recall the past; this volume replaces that sensual experience with paper displayed on walls and billboards. According to Peter Childs, "The poster can . . . re-accentuate interpretations of the many thousands of single images that comprise the film reels."[5] As this volume demonstrates, the film poster is a critical intertextual agency linked to film narrative, a recollection of images past frequently leading to a present.

In his article "Remembrance of Films Past: Film Posters on Film," Stephen Parmelee notes that: "Although the creation of a poster for a film is nearly exclusively monetary in its purpose, with the passage of time, film posters can serve another purpose: they trigger the viewer's memory of past films and, with them, past eras and events in our personal and collective history and culture."[6] Parmelee then suggests the posters' purposeful presence, an existence beyond mercantile considerations: "These artifacts of what was arguably the most powerful cultural influence of the 20th century, the movies, allow us to envision and place in a historical, aesthetic, and cultural framework the films for which they were created."[7] The editors and contributors to this volume concur with Parmelee's assessment. Although movie posters have an acknowledged commercial, industrial design, they are also significant art objects that warrant critical and aesthetic clarification.

In the conclusion to his study, Parmelee notes: "Film posters from both classic and more contemporary films, then, have become icons recognizable

to many in the American [and international] viewing public—even the television viewing public."[8] From the silent era to the virtual image on a computer screen, displayed in theaters, public sites, and museum walls, the film poster—viewed as an illustrative, interpretive practice or as an industrial, commercial product—possesses a distinct historical and aesthetic function. Not only does the poster, as Gérard Genette might suggest, *presentify* and comment on the film narrative, functioning in an intertextual capacity, we contend that the film poster invites its audience inside and beyond its immediate framing and establishes an independent artistic, cultural identity. According to Genette and Marie Maclean, the paratextual, in this case, the movie poster, creates a space of reception and consumption, a "threshold," and "these features essentially describe its spatial, temporal, substantial, pragmatic and functional characteristics."[9] This volume confirms the theoretical logic and applies this methodology in every chapter. Each of the chapters will demonstrate that these film posters are not considered solely as historical artifacts or advertising tools; each poster is discussed critically as part of a greater whole, an aesthetic component of the respective film narrative.

This volume examines the international and Hollywood movie poster as a dynamic, paratextual formation in theory and practice as a vital, ongoing component of film art. *Film by Design: The Art of the Movie Poster* explores the diegetic and extradiegetic meanings created in and around the promotional poster.

MODELS OF DISCOURSE

Gary D. Rhodes's chapter, "Lurid Disgrace or Artful Advertising?": The American Movie Poster, 1916–1934," discusses how the origins of the American moving picture poster teemed with controversy, to the extent that perceived salacious and illicit imagery receded as part of an effort to make moviegoing and publicity for it more respectable. However, studios hoping to increase profits at the dawn of the Great Depression couldn't resist the urge to return to sexualized and violent imagery. This chapter covers the history of the movie poster controversy from the dawn of the feature film to the adoption of codes meant to curtail its visual excesses.

Alicia Kozma's chapter, "Pushing the Limits of the Para: The Industrial Complications of Second-Wave Exploitation Film Posters as Paratext," considers two different examples of second-wave exploitation posters and their controversial relationship to text, paratext, and their destabilizing potential for textual hierarchies. Initial examples feature a series of posters for New

World Pictures' "nurse cycle" films, including films directed by Stephanie Rothman, George Armitage, Jonathan Kaplan, Clint Kimbrough, and Allen Holleb. The second example focuses on the film and poster for *The Hot Box* (1972) directed by Joe Viola. The purpose of this examination is to grapple with how alternative film production contexts require scholars to rethink hierarchical relationships amongst filmic texts, thereby acknowledging that mainstream filmmaking as the blueprint for mapping processes of textual conjunction explicitly homogenizes and flattens cinema histories. Kozma considers the limits of the paratextual by appraising alternative textual chronologies and relationship referents between movie posters and their associated films as paratextual companions.

INTERNATIONAL POSTER CULTURE

Madhuja Mukherjee's chapter, "Print, Publicity, and Place: Intersecting Histories of Cinemas in India (1930s–1960s)," develops from research on popular Indian cinema and its diverse, intersecting visual cultures, and focuses on film publicity material from the 1930s to the 1960s. In the case of Indian cinemas of the period, the publicity system comprised print as well as various sonic mediums, which included the simultaneous release of gramophone records of film songs, as well as the circulation of songs via radio programs and related cultural venues. In this chapter, Mukherjee discusses the publicity material available principally in print, alongside those imprinted on glass plates (negatives) and used for the display and projection inside the theatres in order to examine print cultures and the art of early film posters, song booklets, lobby cards, advertisements, and picture plates (published in the magazines), as well as a wide variety of material which constitute the entire repertoire of film publicity to present the compelling points of intersection between film and other media industries, specifically the mechanism of image making and print cultures in Calcutta (presently Kolkata), Bengal, East of India.

In "The Cuban Film Poster: Revolution by Design," Laura Hatry analyzes how the context of the Cuban Revolution influenced and determined the design of film posters, whose raison d'être tends to be, first and foremost, to convince the potential spectator to make the decision to watch the film in question. However, the typical marketing techniques aimed at swaying consumer behavior in Cuba are less present than in other contexts. The creation of the Instituto Cubano del Arte e Industria Cinematográficos (ICAIC, Cuban Institute of Cinematographic Art and Industry) played an important role in the close relationship that film posters bore with the revolutionary process, not only for Cuban

films, but also the Cuban posters for films made in other countries. One of the design teachers at the Institute, René Azcuy, created some of the most striking film posters, known for their visual synthesis and preference for black and white with some red. Most of the posters generally lean towards minimalism and clearly differentiate themselves from Hollywood-style designs. These posters often incorporate the identity of the films, but at the same time, and most importantly, the political identity, propaganda, and intentions of the Cuban Revolution and prevalent maxims of the Cuban school of graphic design.

Vlad Dima's chapter, "Meaningful Posters and Postcolonial Melancholia: *Black Girl*, *Touki Bouki*, and *Cuties*," explores the diegetic and extradiegetic meanings created in and around three "African" and transnational film posters by analyzing the various shapes (postcolonial) melancholia takes across these mediums. Two posters come from the first decade of sub-Saharan filmmaking, Ousmane Sembene's *La Noire de . . .* (*Black Girl*, 1966) and Djibril Diop Mambety's *Touki Bouki* (*The Journey of the Hyena*, 1973), while the third represents a temporal jump forward, into the contemporary, with Maïmouna Doucouré's *Mignonnes* (*Cuties*, 2020). First, in Sembene's case, the promotional Senegalese poster acts as a semiotic negotiator between the original short story, film, personal identity, and postcolonialism. Second, between June and October 2018, Beyoncé and Jay-Z—two major international celebrities, musically or otherwise—performed their latest World Tour, titled "On the Run II." Their marketing poster and the promotional video offered an almost identical copy of the poster for Mambety's *Touki Bouki*. Third, Doucouré's *Mignonnes* created a huge controversy on social media, when Netflix decided to change the original French poster, going from an innocent photo of the preteen heroines running around happily to a hyper-sexualized image from one of their dance competitions. This chapter traces the creation of meanings that both exceed the boundaries of the films and retroactively affect the meanings within the films.

AMERICAN POSTER CULTURE

Michael Shuman's chapter, "*Silent Running*: Art and Eco-Memory," focuses on the 1972 film directed by Douglas Trumbull as it represents both the impending maturity of the modern science fiction movie genre and a response to the impassioned environmental concerns of the 1960s-era youth movement that continue into the present day. Trumbull envisioned a post-apocalyptic Earth where forests have been eradicated and just three specimens of natural terrain, tended by a small team of astronauts, are preserved in pods floating in deep space. One crew member, Freeman Lowell (Bruce

Dern), is genuinely dedicated to preserving these natural resources and consequentially is ostracized by his companions, all anxious for the termination of the preservation program and the return to their paved-over home world. The film's poster, designed by artist George Akimoto, establishes an aesthetic context for Trumbull's vision by depicting the intersection of man, nature, and technology in vibrant shades of blue, green, and yellow against the darkness of outer space. Lowell's figure glances just outside the poster's boarder, as though worried of impending tragedy, as he teaches his robot helper to tend and nurture a small plant. A fleet of spacecraft and a cold representation of Saturn encroach upon the scene, constricting Lowell's attempts to preserve nature just as technology and profit have marginalized the environment on earth since the Industrial Revolution. Trumbull produced the film, before the development of modern special effects and on a small budget, by building miniature spacecraft using parts harvested from hundreds of plastic model kits, yet *Silent Running* remains visually convincing, even stunning at times, while communicating a sense of environmental and social consciousness that continues the tradition established by Fritz Lang's *Metropolis* (1927) and William Cameron Menzies's *Things to Come* (1936). The poster attracts the viewer by representing essential themes and conflicts within the film itself, while offering a nearly nostalgic appreciation—an eco-memory—for an environment already lost to the movie's characters. Akimoto's work, commissioned to attract film audiences in the early seventies, remains today both an artifact of commerce and an aesthetic statement of an era excited with technological progress yet concerned with environmental annihilation.

Frank Percaccio's chapter, "Beauty and Her Beasts: *Creature from the Black Lagoon* and Beyond," illustrates central concepts from Rhodes's research as it focuses on how film poster art sexualizes relationships between female actors and their nonhuman romantic counterparts. Artwork and posters from Jack Arnold's *Creature from the Black Lagoon* (1954), and the more recent production set in the sequestered laboratory setting of the 1960s, Guillermo del Toro's *The Shape of Water* (2017), a plausible reworking of illicit themes and visual images absent from Arnold's film, suggest that the interhuman capacity for interpersonal relations is not confined to the imagination alone, as select posters amply indicate in full color.

Courtney Ruffner Grieneisen's chapter, "*Shutter Island*: A Doppelgänger's Dream," examines Martin Scorsese's *Shutter Island* (2010). In this film, Scorsese lures us to an island where a patient has gone missing. This film, dubbed by Arnaud Schwartz as a puzzling psychological detective story, toggles between the reality of mental health disassociations experienced

by Teddy Daniels (Leonardo DiCaprio) and the complexity of Hitchcock-ian tenets. In the film poster, issues associated with the representation of experience and reality can be detected as the isolation of the island, situated underneath the dark portraiture of the main character, sets up a visual dichotomy involving identity throughout the film. This vertically balanced juxtaposition, enhanced by the symbol of fire, functions as the key to unlocking the puzzle within the film as it illustrates the depth of secrecy and loneliness the DiCaprio character feels as he leads and is led through a troubling criminal investigation. A point of view in the movie poster is the obvious balance and contrast between dark and darker as the poster is surrounded in black, but the island is highlighted in dark blue. The color palate of the poster is shrouded in the dark only to be slightly lit by the fire of a match, as if to suggest that all is not lost on the island imbued with darkness, as if commenting on the mental health care received in criminal facilities.

Lynette Kuliyeva's chapter, "Abandoned Cars and Bending Skyscrapers: Architectural Disjuncture in M. Night Shyamalan's *The Happening*," presents contrasting scenarios depicted in three posters advertising Shyamalan's 2008 film. Perhaps the two most recognizable posters present clear apocalyptic previews, revealing accurate renderings of events that transpired in the film. The third poster, however, diverges from an accurate portrayal of events and instead focuses on cowering figures of husband, wife, and the girl committed to their care amidst skyscrapers bending in an abstract and ominous man-ner. Unlike the other two posters, this third poster builds false expectations regarding its content by deliberately contorting the architectural landscape into something construed as paranormal. The third poster alters the audi-ence's comprehension of the plot by intentionally redirecting audiences away from the revelation of the visualized threat—a natural occurrence—into an entirely different impression of the threat as something supernatural.

Film noir posters, regardless of the studio that produced them, vividly reflect the pessimism, anxiety, and emotional turmoil that were central to the cycle itself as evaluated in Marlisa Santos's chapter, "Round Like a Circle in a Spiral: The Poster Art of Film Noir." And just as noir films were groundbreaking in their depiction of psychological distress, so too did noir posters depict innova-tive representations of the internal gaze, expressing traumatic disconnections, memory ruptures, and psychotic violence. Extreme close-up facial illustrations, transparent, ghostly imagery, and weapon fetishization, combined with claus-trophobic composition, encapsulate the fractured psyches of noir protagonists. From RKO's subtle watercolor washes to Poverty Row's brash iconography, such posters provide the fun-house doorways into the noir nightmare.

Robert Singer's complementary chapter, focusing on the noir aesthetic, examines "Marketing the Beastly: Lang's *Human Desire* (1954)," an adaptation of Zola's naturalist novel, *La Bête humaine* (1890). Fritz Lang's film situates the space and time of the imaginary world of postwar cultural and psychological anxiety in a sexualized dreamscape. Several international film posters of Lang's film noir narrative of triangulated social decline visualize near-bestial (fe)male behavior and varieties of illicit passion. These are realistic bad dreams located in the conscious world of work and family. For the film's international posters, interpretive marketing strategies artfully "presentify" the downward spiraling of Lang's working-class characters, as depicted in colorful, sexualized poses, and prepare the audience for conflict and resolution, while seemingly violent and carnal in design. Lang's visually encoded messaging is rendered as naturalist tropes of erotic entrapment in these posters, as framed by windows, doorways, and bedrooms. This chapter discusses Lang's nightmarish series of adulterous escapades as the film re-experiences and renews aspects of Zola's narrative.

Taglines on the poster for *Human Desire* explains that its lead character was born "to be kissed" and "to make trouble"—put another way, to inspire dreams and to induce nightmares, which is what film posters has accomplished for over 120 years. Roger Kastel's artwork for the film *Jaws*, like hundreds of other global examples designed over the decades, achieves both aims in a single poster. The aesthetics and the emotions they inspire have spawned a collector market in which some posters have sold for hundreds, thousands, even hundreds of thousands of dollars. For those on a budget, poster reproductions of posters are readily available. Roger Kastel, Tom Jung, Drew Struzan, and other poster artists are towering figures, not only in film history and in popular culture, but also as masterful artists in their own right.

Thankfully, coffee-table books of movie posters abound, collecting stunning images for readers to peruse. Among the most fascinating and beautiful are Anthony Slide's *Now Playing: Hand-Painted Poster Art from the 1910s through the 1950s* (Angel City Press, 2007) and Ian Haydn Smith's *Selling the Movie: The Art of the Film Poster* (University of Texas Press, 2018), though there are many others, including a number published by poster auctioneer Bruce Hershenson.[10] These are valuable repositories of images that deserve to be examined and appreciated, scrutinized and admired.

By contrast, this volume is an intervention of a different type, addressing a noticeable gap in film studies. As research and written by a selection of international film scholars, *Film by Design: The Art of the Movie Poster* is the very first academic book on the subject. We hope it proves to be the

first of many books, initiating an ongoing colloquy about the movie poster in all of its manifold facets.

NOTES

1. Gary D. Rhodes, "When *Jaws* Premiered; or, The Hottest and Coolest Weekend on Record," Medium.com, October 16, 2020, https://medium.com/@gdrhodes/when-jaws-premiered-or-the-hottest-and-coolest-weekend-on-record-9e9a94b60b19.

2. Gary D. Rhodes, "The Origin and Development of the American Moving Picture Poster," *Film History: An International Journal* 19, no. 3 (2007): 242.

3. David J. Alworth, "Paratextual Art," *ELH* 85, no. 4 (Winter 2018): 1130.

4. There have been several other female-feminist versions of the Jekyll/Hyde theme.

5. Peter Childs, "Movie Poster: Alien Nature," *Texts: Contemporary Cultural Texts and Critical Approaches* (Edinburgh: Edinburgh University Press, 2006), 33.

6. Stephen Parmelee, "Remembrance of Films Past: Film Posters on Film," *Historical Journal of Film, Radio and Television* 29, no. 2 (June 2009): 181.

7. Parmelee, "Remembrance," 181.

8. Parmelee, 193.

9. Gérard Genette and Marie Maclean, "Introduction to the Paratext," *New Literary History* 22, no. 2 (Spring 1991): 261–63.

10. Anthony Slide, *Now Playing: Hand-Painted Poster Art from the 1910s through the 1950s* (Santa Monica, CA: Angel City Press, 2007); Ian Haydn Smith, *Selling the Movie: The Art of the Film Poster* (Austin: University of Texas Press, 2018).

MODELS OF DISCOURSE

LURID DISGRACE OR ARTFUL ADVERTISING?

The American Movie Poster, 1916–1934

GARY D. RHODES

The poster needn't be highbrow just because it's stuck up . . .[1]
—MOVIE THEATER EXHIBITOR, 1927

Recalling the moving picture poster of the early cinema period, Daniel Petigor, the founder of the Poster Artists' Association of America, wrote the following in 1919:

> The first moving picture posters were obviously inspired by the old-fashioned circus posters, and they were handled in much the same manner—they were striking and lurid, and had a color scheme consisting of about twenty-eight different shades of red. Nevertheless, in their day and time they served their purpose—certainly they got results, for the motion picture had an immediate audience. For that, the poster was largely responsible, as it was the direct link between the exhibitor and the public. . . .
>
> As the audiences grew in size, the poster developed in quality, and a definite demand, an insistent demand, was made for better, and ever better paper. . . . A perfect poster was wanted.[2]

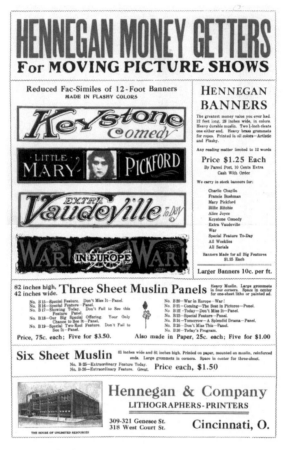

Figure 2.1. Flyer for Hennegan moving picture posters from circa 1915–16.

But what constituted the "perfect poster"? Petigor believed it was "rendered in a strong, vigorous manner, in an arresting manner," free from "crude or gross artistry."

Here was an important concern, given that the moving picture poster had faced major controversies due to violent and sexualized imagery, particularly in the years from 1911 to 1914.[3] Many in the industry wanted to banish such posters; others did not, believing that they attracted ticket-buyers. Though it subsided, the poster problem did not end during the early cinema period. Controversies continued, heightening during the thirties.

In 1916, an editorial in the *Moving Picture World* declared, "That the lurid poster is evil goes without saying and needs no demonstration."[4] As of 1920, *Moving Picture Age* reported that the "lurid poster" was "dying

a slow but sure death."[5] But it didn't die. As *Motography* claimed in 1917, "the right kind of a poster is the one that attracts the greatest number of people, and let me say that the exhibitor judges the value of his paper by one standard—its effect upon the box office."[6] Ten years later, *Exhibitors Herald* wrote that "the poster with the punch pulls in a lot of patrons."[7] "Punch" that attracted the "greatest number of people" often meant sensational colors, as well as also violent and/or sexual imagery and language. "The more lurid the poster, the better," one San Francisco exhibitor confidently said in 1922.[8]

Even if a moral-minded person avoided scandalous films, and even if parents refused to allow their children to see them, they were still confronted by movie posters for them, and not just on theater fronts and lobbies. Many exhibitors posted movie "paper," as it was called, anywhere they could. As the book *Building Theater Patronage: Management and Merchandising* (1927) instructed:

> Be constantly on the lookout for good poster locations. Watch new buildings and excavations for "sniping" possibilities. Work along transportation lines leading to the theater. Choose locations that will be visible from the more traveled side of the street. Posters facing schools, large factories, markets, and transfer points are particularly effective. Athletic contests, parades and outdoor meetings offer possibilities for poster display that should not be overlooked.[9]

Movie posters were very present in many communities, even ubiquitous. And they were often "alluring," including in ways that rankled moralists.[10]

In 1916, a syndicated newspaper article described the damage they could do, specifically to children:

> Objectionable theatrical performances or motion pictures are fortunately confined to restricted habitats, but the poster flaunts its crude or insidious suggestions where none can escape them. . . . There has been great improvement in recent years in the character of the theater poster, but the "movie" poster, which confines its ministrations to limited localities, remains a flagrant menace to childhood. There is an opportunity for enlightened motherhood to help through community service.[11]

Some heeded the call. In 1916, the Council of Clubs in Kansas City lobbied for the formation of a censorship board that would "regulate the posters and

advertising matter of the moving pictures."[12] In 1917, a woman's organiza-
tion in Brooklyn met with the district attorney to discuss "unclean" movie
posters.[13] Two years later, *Photoplay* published an article about community
organizations that demanded "Cleaner Posters!"[14]

Occasional complaints continued in the 1920s. The chairperson of the
"Better Films Committee" in Chattanooga, Tennessee, condemned movie
posters in 1927. At one meeting, she "gave reports of [the] display of nude
pictures advertising recent shows in front of leading drug stores in Chat-
tanooga, of motion picture theaters for [African American] people, which
are also opened to and patronized by white people."[15] Then, in 1930, a letter
published in the *Minneapolis Star* designated movie posters as a "positive dis-
grace, breeders of sensuality and shame, a curse to the growing generation."[16]

The offended parties included some religious leaders. At a meeting in
Brooklyn in 1916, a group of Catholics voiced their concerns.[17] In Janesville,
Wisconsin, in 1921, a Baptist minister railed against posters for "bathing-
beach pictures."[18] In Portland, Oregon, that same year, the pastor of the First
Norwegian-Danish Methodist Episcopal Church preached about the need
to regulate "the type of pictures to be shown on posters."[19] Ten years later,
Rabbi Samuel Baron of Austin, Texas, decried movie posters for being "too
often suggestive."[20]

While exhibitors relied heavily on posters, they were also quick to say that
they did not design them. In 1917, a theater manager in Delaware revealed
that the representative of an "established film organization" kept trying to
give him either a "lurid poster, or else one showing nudity of the female
form." The exhibitor believed he might see increased business for one night
but would pay for it in a subsequent "storm of protest."[21] In 1920, the owner of
four Ohio theaters complained, "Why in the world posters are made depict-
ing scenes of cutting and shooting escapades, strangling and other sordid
sights, is a mystery to me. They are detrimental to the business and should
be tabooed."[22]

At times, local officials restricted advertisements. A censorship board
in Nashville required a poster for *The Birth of a Race* (1918) to be removed
because it depicted Eve in the Garden of Eden.[23] The mayor of Batavia, Ohio,
forbade the screening of F. W. Murnau's *Faust* (1926) in 1927 because its
poster depicted a woman that he believed to be "insufficiently clad." He even
removed the "bottom thumb tacks and fastened up the poster in a way to
hide the offensive portion of it."[24]

In 1920, Chicago passed an ordinance to censor movie posters, because
some of them were "crimes against art and decency alike."[25] The prior year,
the Chicago police had demanded the removal of posters at the La Salle

Theater promoting *The End of the Road* (1919), a film about venereal disease.[26] By 1921, the city's chief censor claimed the ordinance had been successful, particularly in eliminating "nudes from street display."[27] She also spoke about the gulf that could exist between poster content and film content:

> [W]e passed a harmless, picture, featuring a well-known star, without a cut. A little later people began writing in to the censor board asking why it allowed such a dreadful picture to be shown. We received several hundred letters.
>
> At the picture house big colored posters were hung outside with legends like this: "The White Slave Mart," and "Do you know your daughter may at any moment step off the curb into a life of nameless degradation?"
>
> I asked the manager who wrote his copy. His chest puffed out a bit as he said "I do."
>
> Then I gave him a little light on poster advertising. "You know that's a perfectly innocent picture," I told him. "Whatever you did mean by putting up this line of stuff? Why, even the policemen at the corner wanted to know what kind of a picture the censor bureau was passing, and when a policeman complains—"
>
> So he got some new ideas, and though he remonstrated I was making him "lose a lot of shekels," he took his spectacular advertising in and replaced it with something nearly approaching the truth.[28]

The issue of movie posters making promises not kept by the film content was not uncommon. In 1927, a Texas exhibitor grumbled about a poster that pictured a "bathing girl," not because the image was salacious, but because the film it advertised "didn't have a bathing suit in it!"[29]

Being covered in newspapers throughout the United States, Chicago's censorship might well have encouraged other cities to become vigilant. In late 1920, police arrested a theater manager in Baltimore for "exhibiting posters of immoral and improper pictures."[30] In 1921, Seattle passed a bill regulating movie posters.[31] The city's Amusements Inspector soon required a local theater manager to "cover up" nude figures depicted on posters for *The Fall of Babylon* (1919).[32] And by 1926, the vice squad of Milwaukee purged movie posters that violated local statues.[33]

In 1930, police in Jersey City, New Jersey, "whitewashed" movie posters that showed a "reclining girl in [a] party dress." The Commissioner of Public Safety "acted on his own volition as he considered the twenty-four sheets 'too lurid' for children." After initially placing white paper over the woman's

knees, the commissioner required the "entire picture to be obliterated."[34] Here again the issue was not just offensive artwork, but also its sheer visibility. Twenty-four sheets were sized for billboards.

The moralists were not without evidence. Newspapers occasionally reported cases of movie posters allegedly causing harm and instigating crime. In Baltimore in 1920, two small boys blamed "lurid posters" for influencing them to sneak in the emergency door of a movie theater.[35] In 1928, newspapers reported that a seven-year-old boy was kidnapped because he refused to "go home in the company of a playmate." He insisted on remaining where he was in order to keep "gazing at movie posters."[36] Then, in 1930, a University of Wisconsin student found himself in jail after trying to steal a movie poster that he wanted to hang in his room.[37]

Even without sexualized imagery, movie posters could cause trouble. In 1916, one that bore the slogan "To Hell with Mexico" nearly caused a riot in Dallas, Texas.[38] Five years later, the Boy Scoutmasters of Philadelphia filed a grievance with the local police, arguing that a movie poster for a jungle serial "might possibly cause development of a wrong idea of bravery in a boy." It depicted a "man in a garb usually attributed to the jungle, with a vivid jungle background. The man is armed with a bow and arrow. The caption is, 'Jack grew as fearless as the jungle beasts themselves.'"[39] In this instance, the police did not agree there was cause for concern.

For that matter, many film fans didn't perceive problems with movie posters. Quite the opposite. For example, a "movie party" in Arizona in 1917 used numerous movie posters as decor.[40] A New Mexico chapter of the Sigma Chi covered the walls of their house with posters for a 1923 "movie dance."[41] And a "gala affair" at an Indiana country club in 1929 featured a vast array of movie posters to accentuate its cinema theme.[42]

And so, despite the controversies, movie posters held the potential to make many people happy. In January 1919, following the deadly influenza pandemic, a California newspaper told readers:

> When a fellow has been cooped up at home for three months, with nowhere to go and forced to wear a muzzle when you go even there, isn't it a grand and glorious feeling when you see the good old movie picture posters and can go inside and see Theda vamp, Dug [sic] drop off a skyscraper, or Hart plant a few villains.[43]

Five years later, a produce company in Kansas pasted dozens of movie posters on one of its interior walls, much to the delight of many customers, including children.[44] Rather than promoting a film to view, these posters could make

customers remember films they had seen in the past, as well as be enjoyed for themselves, without the need to see the film at all.

Some persons even began to see movie posters as a new type of art, or at least advertising art. In 1920, the Ritchey Litho Corporation touted its movie posters as "powerful and artistic."[45] That same year, artist Leone Bracker described painting posters for First National: "It is not my plan to do anything highbrow, but to get right down to earth, to create something that will affect 'the man in the street,' but withal that will have the dignity of work well done, and done with pride."[46]

Professional and amateur artists in America increasingly took the movie poster seriously. In 1921, a newspaper and theater contest in Springfield, Illinois gave prizes for the best locally created movie posters.[47] Theaters in Portland, Oregon, ran their own contest in 1930. The winner of a $50 prize was a commercial artist.[48] And then there was Harry Warner of Warner Bros., who held a nationwide poster contest in 1923.[49]

In 1924, *Exhibitors Trade Review* proudly reported that the movie poster had reached a new plateau:

> [Early movie poster] atrocities yielded to the present high average of art and composition prevalent in picture posters. And the improvement is more marked in each succeeding issue. The names of famous artists are now affixed to lithograph designs, and taking the general run of paper, motion picture material compares favorably with that of any other advertiser.[50]

As a journalist told readers in 1929, "A few years ago the best works of modern art to be seen in Chicago were the posters outside of certain of our loop motion-picture theaters."[51]

Nevertheless, movie posters still held the potential to cause trouble. As a writer quipped in 1928, "Looking at the movie posters, one concludes that mobs always tear off just enough, and no more, of the heroine's clothes."[52] In 1930, another journalist claimed that "students interested in female anatomy need no longer consult dreary medical books, but merely march to the nearest movie poster and become thoroughly enlightened."[53]

As a result of ongoing concerns, Hollywood studios finally undertook an organized effort at reform in 1930. A syndicated newspaper article told readers:

> The producers have even agreed to clean house in the advertising department—so that even the most modest observer can gaze upon the colored posters without a mask to hide the blushes. It has long

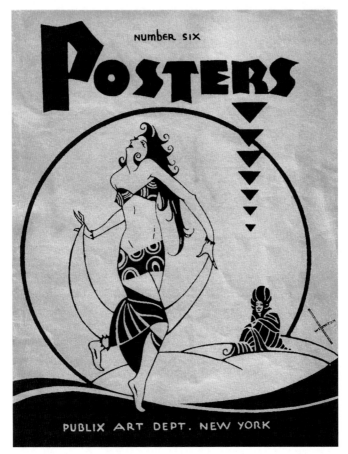

Figure 2.2. Provocative artwork on the cover of Publix Theatres' publication *Posters* (1930).

been the consensus of opinion that the advertising matter needed dry cleaning far more than the moving picture itself.[54]

Will H. Hays, the president of the Motion Picture Producers and Distributors of America (MPPDA), championed the need to eliminate "lurid, sexy advertising" from the motion picture business. It came in the form of an industry-adopted set of rules.

The Code of Advertising Ethics became an addendum to the Motion Picture Production Code of 1930, its text explaining that the rise of the talking picture provided the rationale to rethink publicity materials.[55] Not everyone believed that was the real reason. In his book *The Motion Picture Industry* (1933), Howard T. Lewis wrote that "its actual purpose was to prevent any further increase in public antagonism toward the industry,

particularly opposition which has taken form in demands for legalized censorship."[56]

Whatever the impetus, the Code forbade "misrepresentation, ['meretricious'] nudity, profanity, vulgarity, capitalization of court actions censoring pictures, and ridiculing of any religious faith in advertising and publicity copy."[57] Neither were "salacious postures" permissible. Nineteen film companies and theater chains adopted the Code, which applied to posters as well as "all other forms of motion picture exploitation."[58]

In order to judge violations, the International Motion Picture Advertising Agency would first inform the "offending company," which could then present its case to a "committee of three duly authorized members." While the Motion Picture Producers and Distributors of America was "not directly connected with enforcement of the code," it could "exert a limited amount of pressure on offending members."[59] Here was a potentially convoluted process.

Many exhibitors voiced their approval of the new Code. Others viewed it suspiciously. The manager of "one of the largest Broadway motion picture theaters" said:

> If the new advertising code is adhered to, and I am sure it will not be, our business, which is now bad enough, will be come very much worse. We are paying entirely too much attention to the squawking of the professional reformers for whose benefit this code was obviously intended. . . . If we cannot arouse the curiosity and imagination of our public by the use of a little creative showmanship, we may as well restrict our advertisements to just the name of the theater and picture.[60]

This exhibitor was correct. The Code was no more "adhered to" than the Motion Picture Production Code of 1930, which many filmmakers and studios ignored in varying degrees. One need only look at a 1930 issue of *Posters*, the publication of the Publix Theatres, to see a major chain embracing provocative art on its cover (see figure 2.2).

By November of 1930, journalists were already reporting that the "Advertising Code," as it was sometimes called, was an abject failure.[61] "Mr. Hays, we believe, should take another look at screen advertising. It is working much harm," the *Billboard* reported.[62] The following month, the same publication added:

> The growth of cheap, lurid, and sensational advertising in connection with motion pictures has become a real menace. Will Hays and his

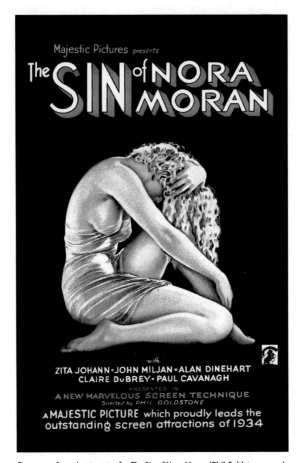

Figure 2.3. One-sheet poster for *The Sin of Nora Moran* (Phil Goldstone, 1933).

organization had better do something to check it immediately. . . . Irreparable damage is being done [to] the good name of the entire industry, and unless action is taken soon the infection may prove fatal.

The principal difficulty seems to be that the advertising is written in New York. What the picture companies fail to consider is that Broadway's likes and dislikes are peculiar to that thorofare [*sic*].[63]

By the end of December 1930, *Motion Picture Daily* informed readers that "Smutty Ads Boomerang," because twelve state legislatures were considering new censorship laws. "Sexy advertising is entirely responsible," the trade claimed, for "the worst censorship situation in recent film history and, perhaps, in the history of the business."[64]

In January of 1931, newspapers in Washington, DC, began censoring "sexy ads" for film releases.[65] That same month, an editorial in the *Film Daily* implored studios to eliminate "hot" advertising, contending that it was "building a wall of needless resentment" with some moviegoers.[66] Not only was the Advertising Code ignored, it might have inadvertently heightened the use of lurid paper, which only intensified the negative response. On January 30, 1931, the *Film Daily* wrote:

> Efforts to dignify theatre advertising have hurt attendance, according to Carl Laemmle [Sr., the founder of Universal]. A timely warning is sounded in the Laemmle statement. There's much talk of fumigating advertising copy. Very likely sensible talk, too. But copy, although it should be kept out of the offensive class, shouldn't be dry-cleaned. That is, rendered so colorless that it makes dry, uninteresting reading.[67]

Universal also encouraged exhibitors to post advertising on every "fence and barrel" near their theatres.

Debates over movie posters continued. In 1933, artist Hugh M. Poe spoke eloquently about why he chose to paint them.[68] The Gallery of the School of Applied Arts at the Pratt Institute even held an exhibit of "movie poster art" that year.[69] By contrast, 1932, the *Christian Science Monitor* declared, "Let us by all means raise the standard of the films, but let us raise the standard of the posters as well."[70] Methodist clergymen in Philadelphia in 1933 argued movie posters were "positively indecent."[71] And while discussing "filth" in film advertising, *Harrison's Reports* pointedly asked, "What has become of the Hays code of advertising ethics?"[72]

The question is relevant when examining the poster tagline for Lowell Sherman's *She Done Him Wrong* (1933), which promised, "Mae West gives a HOT TIME to the Nation," and William A. Seiter's *Hot Saturday* (1932), which confided, "They called her 'BAD'—and she tried to live up to it!" It is further relevant when examining the partial nudity on posters for Victor Halperin's *White Zombie* (1932), Lloyd Bacon's *Footlight Parade* (1933), Roy Del Ruth's *The Mind Reader* (1933), and others.

Nowhere during this period was the link between allegedly indecent content and the artistry of the movie poster more apparent than in Alberto Vargas's painting for Phil Goldstone's film *The Sin of Nora Moran* (1933). The depiction of the scantily clad actress Zita Johann is as provocative as it is stunning, as famous as it is infamous. Vargas had earlier painted artwork

for the Ziegfeld Follies. He would later create the "Vargas Girls" for *Esquire* magazine in the forties, before contributing work to *Playboy* magazine during the 1960s and 1970s. Many of his paintings are now archived at the Spencer Museum of Art at the University of Kansas.[73]

Sins beyond those of Nora Moran seemed apparent to some in the industry, those who thought the Advertising Code needed major revisions. In 1933, Martin Quigley, editor of *Motion Picture Herald*, called the Code a "hollow and insincere gesture to satisfy certain quarters of outraged public opinion."[74] He specifically worried about the following clause: "Nudity with meretricious purpose, and salacious postures, shall not be used." Quigley countered, "There can be no proper use of nudity in the advertising of a picture. Rules which apply to the Museum of Art have nothing to do with us."[75]

The year 1934 became pivotal in the history of Classical Hollywood due to the import of the Hays Code and the Production Code Administration (PCA), headed by Joseph I. Breen, which, as of June 13, 1934, required films to obtain a certificate of approval from its office to be exhibited in mainstream movie theaters.[76] Here was stringent oversight of Hollywood film content as well as film advertising.

Some exhibitors were pleased with these developments, as in the case of a Nebraska theater manager who wrote in *Motion Picture Herald*:

> [T]he reforms of eliminating sex and indecent pictures of nude women, bedroom scenes, bath scenes, etc. have never materialized and the indecent advertising of some real good pictures has done a lot of damage to small town exhibitors. . . . When a small town exhibitor does his utmost to keep his show clean and convince the critical public that he has regard for moral integrity, it is humiliating to be compelled to put up lewd advertising or none at all, when perhaps the show itself is OK.[77]

Many other exhibitors either disapproved of new regulations or were skeptical they would have real impact.

Joseph I. Breen insisted that reforming movie posters was not only necessary, but also achievable. In April of 1934, he declared, "No single phase of motion picture merchandising is so provocative to public ill will as the wrong kind of advertising. . . . You can't flaunt indecency and hope to get away with it."[78] In some measure, he was correct, as the MPPDA developed its own Advertising Advisory Council, headed by J. J. McCarthy.[79] By late 1934, *Motion Picture Herald* credited McCarthy for a new era of "clean advertising."[80]

Despite the successful implementation of standards for movie posters, questions remained in the minds of many exhibitors and moviegoers about exactly what was lurid or disgraceful, what was acceptable and artistic. Not everyone agreed, of course. In 1933, a syndicated article explained, "What was deemed indecent a few years ago is now [as] commonplace [as] the bathing beach and the movie poster."[81] Some balked; others did not. While there was no clear, single answer to Daniel Petigor's important question about what constituted the "perfect poster," the most effective posters were those that helped sell tickets without inviting unwanted controversy.

Perhaps the endurance of potentially offensive content in movie posters— the ability to be "stuck up" without being "highbrow"—is best understood by the following poem, excerpted from a 1927 issue of the *Film Spectator*:

As nightly I go down the street
I scan each lurid poster sheet
To find some play whose theme will merge
With my own temperamental urge;
That is to say, when strong desire
Needs fuel to feed its smold'ring fire.
I yearn to see emotions shown
In some accordance with my own.[82]

NOTES

1. M. W. Larmour, "Paper Must Pack a Punch," *Moving Picture World*, January 29, 1927, 329.

2. Daniel Petigor, "The Development of the Poster," *Motion Picture News*, October 4, 1919, 2858.

3. Gary D. Rhodes, "The Origin and Development of the American Moving Picture Poster, *Film History* 19, no. 3 (2007): 228–46.

4. W. Stephen Bush, "New Light on Posters," *Moving Picture World*, April 29, 1916, 777.

5. "Slides," *Moving Picture Age* (May 1920), 25.

6. "Posters that Bring the Money," *Motography*, November 3, 1917, 950.

7. "Not All Photos Good," *Exhibitors Herald*, April 9, 1927, 54.

8. Sumner Smith, "Regional News and Gossip," *Moving Picture World*, December 2, 1922, 410.

9. John F. Barry and Epes W. Sargent, *Building Theatre Patronage: Management and Merchandising* (New York: Chalmers Publishing Company, 1927), 135.

10. "The 'Movies' and Their Youthful Patrons," *Springfield (Massachusetts) Republican*, January 30, 1916, 17.

11. Sidonie M. Gruenberg, "Training Today's Boys and Girls," *Ordway (Colorado) New Era*, September 29, 1916, 6.

12. "Would Regulate Movie Posters," *Topeka (Kansas) Daily Capital*, December 24, 1916, 2.

13. "Lewis for Clean 'Movies,'" *Brooklyn Daily Eagle*, February 9, 1917, 18.

14. "'Cleaner Posters!'—New League Slogan," *Photoplay* (March 1919), 78, 108.

15. "Attack Launched on Movie Posters," *Chattanooga (Tennessee) Times*, February 3, 1927, 6.

16. "Everybody's Ideas," *Minneapolis Star*, February 12, 1930, 6.

17. "Catholics Protest at Birth Control," *Standard-Union (Brooklyn, New York)*, December 18, 1916, 5.

18. "Lurid Movie Posters Scored by Fondy Pastors," *Janesville (Wisconsin) Gazette*, March 14, 1921, 3.

19. "Movie Poster Attacked," *Oregonian (Portland)*, December 6, 1921, 9.

20. "Edwards Named President of Beaumont Rotary Club," *Beaumont (Texas) Enterprise*, April 30, 1931, 11.

21. H. S. Newman, "The Small Town Exhibitor," *Moving Picture World*, March 10, 1917, 1531.

22. "Abe Libson Judges Pictures by Posters; Taboo Strangling Scenes, Says Schwalm," *Moving Picture World*, December 11, 1920, 705.

23. "Movie Censor Objects to Poster of 'Eve,'" *Tennessean (Nashville)*, April 15, 1920, 16.

24. "Batavia Mayor Doesn't Like Movie Poster; Bars Production of *Faust*," *Portsmouth Daily Times* (Portsmouth, Ohio), February 15, 1927, 2.

25. "Censoring Movie Posters," *Prescott (Arizona) Journal-Miner*, May 26, 1920, 4.

26. "Police Order End of Road Posters Torn Down in Chicago Theatre Lobby," *Exhibitors Herald and Motography*, June 1919, 33.

27. "Censorship of Movie Posters Is a Success," *Sioux City (Iowa) Journal*, August 30, 1921, 3.

28. "Censorship," 3.

29. Larmour, 329.

30. "Movie Posters Cause Arrest of Exhibitor," *Baltimore Sun*, December 3, 1920, 22. The film in question was *The Right to Love* (1920).

31. "Poster Bill Becomes Law Despite Its Veto," *Exhibitors Herald*, March 12, 1921, 29.

32. Epes Winthrop Sargent, "Selling the Picture to the Public," *Moving Picture World*, February 4, 1922, 531.

33. "Reform Worker Says Movie Posters Are Violations of Law," *Wausau (Wisconsin) Daily Herald*, October 18, 1926, 4.

34. "Police Whitewash Movie Poster Girl," *Record (Hackensack)*, February 27, 1930, 1.

35. "Movie Posters Lured Them," *Baltimore Sun*, October 6, 1920, 7.

36. "Boy Believed Kidnap Victim," *Standard Union*, November 20, 1928, 3.

37. "Movie Poster Lures 'U' Student to Jail," *Eau (Wisconsin) Claire Leader*, January 19, 1930, 6.

38. "Dallas Has Near Riot," *Waxahachie (Texas) Daily Light*, July 10, 1916, 1.

39. "Boy Scouts Shocked," *Philadelphia Public Ledger*, March 4, 1921, 3.

40. "Movie Party," *Copper Era and Morenci Leader (Clifton, Arizona)*, March 16, 1917, 1.

41. "Movie Dance at Sigma Chi House," *Albuquerque Journal*, January 3, 1923, 5.

42. "Society," *Star Press (Muncie)*, May 17, 1929, 17.

43. "Pen Points," *Hanford (California) Sentinel*, January 30, 1919, 2. The persons mentioned in this quotation are film stars Theda Bara, Douglas Fairbanks, and William S. Hart.

44. "Uses Movie Posters for Wall Paper," *Emporia (Kansas) Gazette*, June 3, 1924, 9.

45. Advertisement, *Motion Picture News*, May 1, 1920, 2814.

46. "Leone Bracker Is Assigned Work of Painting First National Art Posters," *Exhibitors Herald*, November 13, 1920, 71.

47. "Winners in Journal Movie Poster Contest for Free Lyric Tickets Announced," *Springfield (Illinois) Journal*, February 13, 1921, 18.

48. "Commercial Artist Wins Movie Poster Contest," *Oregonian (Portland)*, August 10, 1930, 13.

49. "For Film Fans," *Baltimore Sun*, March 12, 1923, 12.

50. Lon Young, "Problems of the Photoplay Posters," *Exhibitors Trade Review*, May 17, 1924, 38.

51. Meyer Levin, "A Young Man's Fancy," *Chicago Daily News*, February 4, 1929, 11.

52. Untitled, *Wiregrass Farmer (Headland, Alabama)*, April 5, 1928, 2.

53. E. L. Meyer, "Making Light of the Times," *Capital Times (Madison, Wisconsin*, February 13, 1930, 20.

54. "Purifying the Movie Posters," *Cimarron (Boise City) News*, May 16, 1930, 2.

55. The full text of the "Code of Ethics for Motion Picture Advertisers" appears in *The 1931 Film Daily Year Book of Motion Pictures*, ed. Jack Alicoate (New York: Film Daily, 1931), 663.

56. Howard T. Lewis, *The Motion Picture Industry* (New York: D. Van Nostrand Company, 1933), 259.

57. "Urge All Exhibitors, Affiliated or Not, to Comply with Ad Code," *Exhibitors Herald-World*, June 28, 1930, 9.

58. "Urge," 9.

59. Lewis, 260.

60. "What They Say About Code for Advertising," *Exhibitors Herald-World*, Jun 28, 1930, 10.

61. Martin J. Quigley, "Editorial," *Exhibitors Herald-World*, October 25, 1930, 22.

62. "Lurid Screen Advertising," *Billboard*, November 22, 1930, 53.

63. "A Stop Must Be Put to Lurid Motion Picture Advertising," *The Billboard*, December 27, 1930, 44.

64. "Smutty Ads Boomerang," *Motion Picture Daily*, December 29, 1930, 1.

65. "Sexy Ads Being Censored by All Newspapers at Capital," *Motion Picture Daily*, January 5, 1931, 1, 3.

66. Jack Alicoate, "Hot Advertising Has Got to Go," *Film Daily*, January 13, 1931, 1.

67. "The Mirror—A Column of Comment," *Film Daily*, January 30, 1931, 1.

68. Embree Headman, "Poe's Paintings Are Attractive for Physicians," *Knoxville (Tennessee) Journal*, December 6, 1933, 6.

69. "Movie Poster Art on View," *Brooklyn Times Union*, February 5, 1933, 4.

70. Quoted in "Clean Posters," *Motion Picture Herald*, May 28, 1932, 8.

71. "Call Movie Posters Indecent," *Plain Speaker (Hazleton, Pennsylvania)*, December 5, 1933, 8.

72. "Newspaper Publishers Indignant at the 'Filth' in Many Advertisement Copies," *Harrison's Reports*, June 17, 1933, 96. Offending advertisements catalogued in this article were for William A. Wellman's *Frisco Jenny* (1932), Ande Roosevelt's *Goona Goona* (1932), Richard Halliburton's *India Speaks* (1933), Edward F. Cline's *So This Is Africa* (1933), Stephen Roberts' *The Story of Temple Drake* (1933), and Arthur Gregor's *What Price Decency?* (1933).

73. Shirley Christian, "But Is It Art? Well, Yes; A Trove of Pinups at the University of Kansas Is Admired by All Sorts, Including Feminists," *New York Times*, November 25, 1998.

74. "Give Advertising Code Meaning, Says Quigley," *Motion Picture Herald*, October 28, 1933, 10.

75. "Give," 10.

76. For more information, see Thomas Doherty, *Hollywood's Censor: Joseph I. Breen and the Production Code Administration* (New York: Columbia University Press, 2009).

77. G. E. Byars, "Commends Work of Advertising Council," *Motion Picture Herald*, February 10, 1934, 40.

78. Victor M. Shapiro, "Code Will Be Adjusted, Rosenblatt Tells MPTOA," *Motion Picture Herald*, April 14, 1934, 11.

79. For more information, see "The Advertising Advisory Council," in *The 1931 Film Daily Year Book of Motion Pictures*, ed. Jack Alicoate (New York: The Film Daily, 1931), 675.

80. "Clean Advertising," *Motion Picture Herald*, November 24, 1934, 8.

81. "The Literary Lantern," *Greensboro (North Carolina) Daily News*, August 20, 1933, 7.

82. "How Can We Know?", *The Film Spectator*, February 19, 1927, 2.

PUSHING THE LIMITS OF THE PARA

The Industrial Complications of Second-Wave Exploitation
Film Posters as Paratext

ALICIA KOZMA

Gérard Genette's formative work on paratexts and other textual vicissitudes has had far-ranging application outside of the literary structure his efforts concentrated on, including a transubstantiated value to contemporary media frameworks. Standing firmly on Genette, Jonathan Gray pointedly translates the paratextual formulation to contemporary media products in 2010's *Show Sold Separately*. Gray's work considers the imbrication of source text, para-materiality, and economic imperatives as key structures that build and bound the cultural life of media commodities. In considering movie posters, Gray understands their signifying function as what he terms "the beginning of meaning,"[1] an originating process that "opens its respective film's story world before the film has reached the scene"[2] while simultaneously hailing potential audiences: a synergy of experience and economics. In this configuration, movie posters introduce the film as text into the cultural landscape while instigating early audience coalescence.

These functions are predicated on a hierarchical textual relationship between posters and their films: while movie posters appear first in the cultural landscape, they are secondary texts to the film they represent. However, this ranked interrelation is dependent on a mainstream Hollywood industrial context, where movies posters as marketing material are generated in service of a completed—or mostly completed—film. Outside of this specific industrial condition, the hierarchy of text and paratext is more ambiguous. This

is particularly true when considering the function of second-wave exploitation films and their movie posters. Indeed, an exploration of select second-wave exploitation films and their posters requires theorizing paratextuality through industrial historiography and textuality as opposed to narrowing focus to the text, reconsidering the often-attenuated connection between textual primacy and film histories. When one does so, it becomes clear that non-mainstream film ecosystems like second-wave exploitation destabilize the boundaries of the paratextual relationship between a film and its associated posters as paratextual companions. As a result, second-wave exploitation posters off a fertile pathway to test the limits of the *para* in paratextual.

Second-wave exploitation filmmaking privileged paratexts, particularly movie posters, which were created in disparate ways. For example, film titles and posters could be the text's originating content, created before the film itself and leveraged by producers to finance production. The subsequent film would, more often or not, have very little to do with the paratextual promise of its poster. For those films whose posters were created after production ended, film titles and/or key imagery were altered to heighten the promise of salacious and scandalous content, regardless if said content appeared in the film. Additionally, posters were often created not to necessarily reflect the film it was promoting, but rather to explicitly call the audience back to an earlier, usually successful film as a way of building the upcoming release's reputation from previous success. In these instances, the posters and their mismatched movies create two tenuously connected narrative imaginaries. Exploring these last two instances of poster creation, I am interested in articulating the necessity of theorizing paratextuality along specific industrial frameworks and examining how the poster/film textual relationship is destabilized when one moves outside of a mainstream Hollywood industrial framework.

Using Gray's ideas in *Show Sold Separately* as a theoretical starting point and focusing on industrial and textual analysis, I consider two different examples of second-wave exploitation posters and their relationship to text, paratext, and their destabilizing potential for textual hierarchies. The first is a series of posters for what would become known as New World Pictures "nurse cycle" films: *The Student Nurses* (directed by Stephanie Rothman; screenplay by Don Spencer; 1970); *Private Duty Nurses* (directed by George Armitage; screenplay by George Armitage; 1971); *Night Call Nurses* (directed by Jonathan Kaplan; screenplay by George Armitage and Danny Opatshu; 1972); *The Young Nurses* (directed by Clint Kimbrough; screenplay by Howard R. Cohen; 1973); and *Candy Stripe Nurses* (directed by Allen Holleb; screenplay by Allen Holleb; 1974). The second example is the film and poster for

the 1972 film *The Hot Box* (directed by Joe Viola, screenplay by Viola and Jonathan Demme), also from Roger Corman's New World Pictures.

The purpose of this examination is to grapple with how alternative film production contexts require scholars to rethink hierarchical relationships amongst filmic texts, thereby acknowledging that mainstream filmmaking as the blueprint for mapping processes of textual conjunction explicitly homogenizes and flattens cinema histories. To do so, I will briefly review Gray's core tenets of paratextuality and their specific relation to posters, provide an overview of the industrial context of second-wave exploitation, and then move directly to a discussion of my texts as I consider the limits of the paratextual by appraising alternative textual chronologies and relationship referents between movie posters and their associated films as paratextual companions.

PRIMACY'S INDUSTRIAL COMPLICATIONS

Gray's conceptualization of paratext is embedded in what he terms "off-screen studies,"[3] or a consideration of the myriad tangible and intangible paraphernalia surrounding films: from trailers, to digital material, to toys, to hype, and spoilers. While Genette defines paratext at its most basic as the "accompanying productions"[4] of a text, the idea of what, exactly, constitutes the text itself is expansive. Gray critically notes that the film itself "is but one part of the text, the text always being a contingent entity in the process of forming and transforming or vulnerable to further information or transformation."[5] This concept is well typified by filmic versioning. For example, the various versions of Ridley Scott's film *Blade Runner* include the US theatrical release (1982), the international theatrical release (1982), the US broadcast version (1986), and the director's cut (1992).[6] These versions of the film are essentially the same: same characters, story, plot, aesthetic, actors, director, etc. Yet, they each contain distinct differences, whether it be the inclusion of a voice over in the US theatrical release or additional footage in the director's cut. Consequently, each iteration of the film is the same without being a textual replicant, as successive releases transmute the film while retaining its textual legibility.

While the film as text has a wider cultural berth to engage in this type of malleability, paratexts often serve a utilitarian function, acting as "filters through which we must pass on your way to the film or program, our first and formative encounters with the text."[7] It is in these initial encounters with paratextual filters that shades of textual meaning begin to take shape. Note that I am careful here to emphasize the *beginning* of meaning rather than

its wholesale imprint. Indeed, when considering the function of paratext as agenda-setting tool (to borrow a concept from communication theory), meaning is suggested rather than shared. As Bernard Cohen once noted, "the press may not be successful much of the time in telling people what to think but it is stunningly successful in telling its readers what to think about."[8] Similarly, "paratexts tell us what to expect, and in doing so they shape the reading strategies that we will take with us 'into' the text, and they provide the all-important early frames through which we will examine, react to, and evaluate textual consumption."[9]

This is certainly true of movie posters, which function as what Gray terms entryway paratexts: "paratexts that grab the viewer before he or she reaches the text and try to control the viewer's entrance to the text."[10] As an entryway paratext, movie posters are embedded in a complicated hierarchy of textual status and meaning making. From an audience perspective, movie posters appear on the cultural landscape first; they are often released months— sometimes a year or more in the case of hotly anticipated films—before the film itself. Unlike the cover of novels, genre of literary paratext, movie posters are almost always disassociated from their accompanying text. It is very common to see movie posters on highway billboards, subway cars, magazines, and a host of other public non-theatrical venues. Even in exhibition spaces, posters and films are uncoupled. For example, when I visit my local movie theater for a screening, the posters that line the lobby walls are for upcoming releases, not the films currently playing in the theater's auditoriums. Exposed to public well before the film is, and physically and spatially unconnected from the primary text, movie posters hold chronological primacy in establishing the film as a cultural entity and in suggesting the meanings we initially associate with it, as they "create texts, they manage them, and they fill them with many of the meanings that we associate with them."[11]

There is, of course, a mundane yet critical industrial logic to movie posters' role as entryway paratext: they are first and foremost advertisements. Developed from a long tradition of show printing for non-theatrical entertainment spaces, movie posters have been a core strategy of film advertisements since the 1910s.[12] Despite this critical function, movie posters are often derided for their advertising function, with many scholars dismissing what one film historian called their "humble and grubby reason for existence,"[13] choosing instead to focus on movie posters as solely aesthetic or cultural products. Yet movie posters encapsulate the partnership of economics and art that has always defined film as industrialized art. To ignore their economic imperative is to undermine their holistic function as industrial and cultural trademark and their critical commission as paratext. For as Gray

reminds us, "promotion suggests not only the commercial act of selling, but also of advancing and developing a text."[14] To integrate, rather than simply acknowledge, movie posters' economic function as indistinguishable from their paratextual role is paramount. As paratext, they hail audiences, establish early codes of textual meaning, guide and bound expectations, and mark the film's locus in the cultural landscape before it opens in market, and in doing so create "identities and personas and [determine] the type of 'life' the film will enjoy."[15] The intertwined capacity of movie posters to interpellate audiences, set early textual expectations, and generate box office returns creates a type operative paratext Grey terms hype, which implores us to "judge books by their glossy covers."[16]

Hype as superficial judgement was critical to second-wave exploitation film; superficiality and a hyper emphasis on paratextual promise was a founding pillar of exploitation filmmaking—an industrial paradigm with a longstanding tradition in the film landscape and a shifting, often derided reputation. Exploitation's chief offense is that, as an industry and cinematic philosophy, it privileges the economic over the artistic. To be sure, exploitation film has never hidden its economic imperative, but as Mark Whitman reminds us in his article "Exploitation is Not a Dirty Word": "in the sense that they are designed, at least to recoup their money and hopefully to turn a profit, almost all films are exploitation movies."[17] If the foundational but often overlooked capitalist foundation of commercial filmmaking implicates most film as economically exploitative, what do we means when we use the label "exploitation film?"

The exploitation industry has a variable relationship to Hollywood; often antagonistic, sometimes complimentary, but always in dialogue with mainstream filmmaking. Early exploitation, or what Eric Schaefer calls classic exploitation filmmaking, dominated independent film production between 1919 and 1959.[18] With a twinned focus on shock and spectacle and education[19] and exposé, classical exploitation films were generally concerned with "sex and sex hygiene, prostitution and vice, drug use, nudity, and any other subject considered at the time to be in bad taste."[20] Produced, distributed, and exhibited independently, classical exploitation had little interaction with Hollywood, and functioned primarily as what Schaefer terms a "shadow industry"[21] to mainstream filmmaking. By the end of the 1950s, classic exploitation was overrun by a shift in acceptable mainstream film content, as "the lines that had once divided exploitation film's subject matter from releases of the majors were far less distinct."[22] Exploitation did not disappear as a result of this alteration, but it did evolve; as classical exploitation recedes in relevance, second-wave exploitation filmmaking ascends.

Figures 3.1 and 3.2. One-sheet posters for *Ghost in the Invisible Bikini* (Don Weis, 1966) and *How to Stuff a Wild Bikini* (William Asher, 1966). From the Harry Ransom Center at the University of Texas Digital Movie Posters Collection.

Second-wave exploitation filmmaking runs roughly from 1960 to 1980 and is characterized by its melding of classical exploitation and mainstream film influences, its appeal to new audience demographics, and the transitional industrial space it occupies.[23] As Linda Williams notes, "Since the 1960s . . . the history of exploitation has been on the one hand concerned with the pursuit of more extreme spectacle and on the other a story of mainstream absorption of exploitation's stock-in-trade."[24] A shadow industry no longer, second-wave exploitation was a medial space in which the formal, aesthetic, narrative, and business practices of its classic progenitor and its mainstream counterpart intermingled. This fusion of influences helped to make the boundaries between exploitation and mainstream filmmaking more porous, as professionals, content, and strategy migrated freely between the second-wave industry and Hollywood. For example, Hollywood icon Joan Crawford starred in William Castle's low-budget horror film *Straight-Jacket* (1964) and second-wave exploitation mainstay actor Jack Nicholson began making studio features in the mid-late 1960s on his way to international stardom. Solidly exploitative narrative content like murderous outlaw couples on the run or killer sharks who decimate bikini-clad beach parties found its way into high-profile Hollywood films like *Bonnie and Clyde* (Arthur Penn,

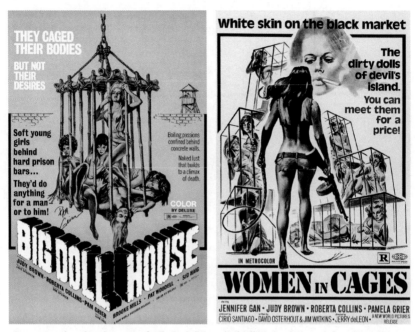

Figures 3.3 and 3.4. One-sheet poster for *The Big Doll House* (Jack Hill, 1971) and *Women in Cages* (Gerry de Leon, 1971). From the Harry Ransom Center at the University of Texas Digital Movie Posters Collection.

1967) and *Jaws* (Steven Spielberg, 1975), while second-wave exploitation impresario Roger Corman borrowed the tried-and-true Hollywood strategy of adapting classic literature in his series of Edgar Allan Poe films, including *The Pit and the Pendulum* (1961) and *The Raven* (1963). Unlike classic exploitation, second-wave exploitation filmmaking was formally influenced by classic Hollywood style and had a general three-act narrative structure, but in a direct link to its history, the films used continuity filmmaking fairly loosely and primarily as a formal tool to link together narrative and aesthetic spectacle. Indeed, "many exploitation films, which, no matter what era they spring from, tend to vacillate between frenzied instances of display (what I have referred to as 'spectacle') and long stretches of torpor."[25] Time-tested exploitation exhibition strategies like four-walling[26] would be adopted by mainstream Hollywood and evolve into wide release, and second-wave exploitation would utilize Hollywood's hyperawareness of audience demographics to great success. Indeed, centering audience demographics was the crux of second-wave exploitation's boom, which was prominently displayed in their appeal to the newly minted teenager market.

Youth audience demographics played a crucial role in second-wave exploitation content; a majority of films combined sex, drugs, rock-and-roll,

and aspects of the cultural zeitgeist—for example, free love and the hippie movement, identity politics, a general "revolutionary" sentiment, and even innocuous new youth trends like skateboarding. These content trends were tellingly reveled in second-wave exploitation's portmanteau-based typology, which classified films based on the foregrounded exploitative content for example, hippiesploitation (see Ted V. Mikels 1971 *The Corpse Grinders*) hicksploitation (see Herschel Gordon Lewis's 1964 *2000 Maniacs*), sexploitation (see Doris Wishman's 1965 *Bad Girls Go to Hell*), or Blaxploitation (perhaps the best-known type of films to come from second-wave exploitation; see films like Jack Hill's 1974 *Foxy Brown*).

Audience considerations were also influence by second-wave exploitation's spaces of exhibition, often drive-in and grindhouse theaters. Drive-in theaters grew slowly in popularity from their inception in the early 1930s, but the rapid development of suburbs in the 1950s and 1960s was a boon for drive-ins, as the increase in large swaths of available land, expanded distance from urban cultural centers, and an economically stable teenager middle-class centralized drive-in theaters are foundational spaces of suburban leisure. Drive-ins were youth culture spaces that required a constant stream of youth-centered content, and second-wave exploitation took up much of that space. Antipodean to drive-ins were grindhouse theaters. Formerly first- and second-run theaters in urban centers that has suffered massively decreased tickets sales due to mass suburban exodus and weathering the corresponding neglect and despair resulting from long-term lost revenue, "grindhouse" was both a generic term applied to a spectrum of exploitation-based theaters as well as a specific industrial reference. Industrially, the theaters were named for their embracement of grind policy, which is "the screening of films continuously throughout the day and evening for cut-rate admission process—a 'grind scale' that often increased over the course of the day and peaked below the standard ticket prices of non-grind houses."[27] The popularity of drive-in theaters, the competition for their screen space, and the sheer content churn pace of grindhouses compelled second-wave exploitation's dependence on film marketing. The movie poster, in particular, was a key marketing product.

Lisa Kernan notes that paratextual film marketing like trailers and posters are built around three staple rhetorical appeals: genre, story, and stardom.[28] These core strategies are not easily mapped onto exploitation films. As Schaefer historicizes, classic exploitation films lacked "conventional narratives, stars, or genres with which to sell their films, exploitation producers relied on marketing address that transposed to paper the key attributed of their films: spectacle in the form of education and

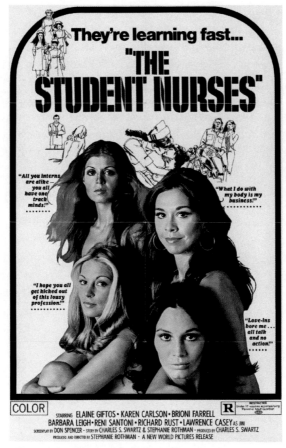

Figure 3.5. One-sheet poster for *The Student Nurses* (Stephanie Rothman, 1970). From the personal collection of the author.

titillation."[29] Second-wave exploitation fared only slightly better. While there were still no stars to market, the recognizable genre touchstones were an easier sell. For example, bright colors, bikini-clad women, surf, and sand were recurring aesthetic motifs for the beach party films of the 1960s. Many of these films also included the word "bikini" in the film's title; see, for example, *How to Stuff a Wild Bikini* (William Asher, 1965) and *Ghost in the Invisible Bikini* (Don Weis, 1966). The women in prison genre of second-wave exploitation focused on scantily glad women, corralled behind bars or holding weapons, ready to fight for their freedom. Two apt examples are *The Big Doll House* (Jack Hill, 1971) and *Women in Cages* (Gerry de Leon, 1971).

URTEXT AND ITERATIONS

While there are identifiable generic similarities in the posters for both beach party and women in prison movies, a second style of second-wave exploitation film posters evolves the aesthetic genre patterning past recognition and into repetition. Here I turn to Roger Corman's "nurse cycle" of films. In 1970, Corman commissioned writer-director Stephanie Rothman and her writer-producer husband, Charles S. Swartz, to make the first film for his new production and distribution company New World Pictures; the film, *The Student Nurses*, was released the same year.

While Rothman and Swartz were sure to incorporate the minimum amount of nudity, sex, and violence Corman required from his films, *The Student Nurses* surpassed many assumptions and/or expectations of second-wave exploitation filmmaking as a "stylistic and forcefully ideological film that . . . explicitly addressed issues of police brutality in the Latino community, access to abortion, gender politics in the free love movement, and the complications that women faced in the workforce."[30] The film was a tremendous success with audiences, and resultingly, Corman produced four more "nurse cycle" films between 1971 and 1974: *Private Duty Nurses, Night Call Nurses, The Young Nurses*, and *Candy Stripe Nurses*.

The poster for *The Student Nurses* features the four main characters centered in the middle of the field and surrounded by a frame created by a thick black line with rounded top corners and a straight horizontal line connecting the bottom left and right edges of the frame. The women are unclothed with their breasts strategically covered by their bodies or by others. They stare directly at the poster viewer, and next to each is a block of quoted dialogue from the film. At the top of the frame are line drawings of four scenes from the film, which surround the film's tagline, printed in a rounded font and title, printed in block letters. Outside of the title of the film and two of the line drawings, the poster has little indication as to what the film is about. Rather, like the classic exploitation posters that came before it, the poster is most concerned with teasing the titillation the film is promising. Three of the four block quotes of dialogue directly reference or infer sex and the presumably nude bodies of women, and half of the line drawings imply in-film scenes of sex and nudity. The culmination of these elements are six distinctive features: a black border that presents the subjects simultaneously contained within and bursting free from a picture frame; photorealistic subjects centered and facing the viewer with an outward gaze; nudity; line drawings of presumptive sex and nude scenes from the film; block quotes of presumptive filmic dialogue referencing explicit situations; and a sexually

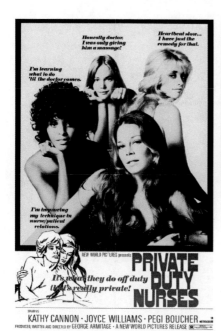
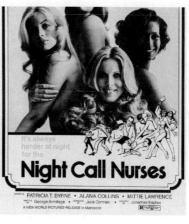

Figures 3.6 and 3.7. Movie posters for *Private Duty Nurses* (George Armitage, 1971) and *Night Call Nurses* (Jonathan Kaplan, 1972). From Critical Condition and the Harry Ransom Center at the University of Texas Digital Movie Posters Collection, respectively.

suggestive tagline. As noted previously, the success of *The Student Nurses* spawned four duplicative films based around the idea of young, attractive nurses navigating life and love.

While none of these films had the same thematic heft, technical skill, or commercial success as *The Student Nurses*, they all share an overriding commonality: their poster design. In evaluating the function of repetition in second-wave exploitation movie poster design, Rick Altman's explanation of the semantic and syntactic function of genre is instructive. While originally applied to films themselves to theorize the complicated yet unspoken typologies of genre, Altman's work is conducive to understanding second-wave exploitation movie posters as texts in and of themselves, particularly in their audience interpellation. Combing a genre's semantic elements, or its "building blocks"[31] with its syntax, or the "structures into which they [building blocks] are arranged"[32] provides a generic analytic frame with both explanatory power and broad applicability.[33]

In the case of the poster for *The Student Nurses*, its aesthetic properties serve as the text's semantic elements, defining the poster and the film as the origin point for the "nurse film." However, it is the visualization of the film's

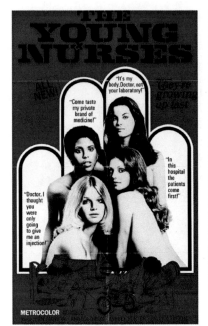 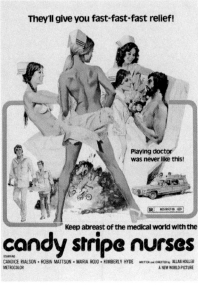

Figures 3.8 and 3.9. Movie posters for *The Young Nurses* (Clint Kimbrough, 1973) and *Candy Stripe Nurses* (Allen Holleb, 1974). From the Harry Ransom Center at the University of Texas Digital Movie Posters Collection.

narrative elements that defines the syntactic elements that will eventually typify the nurse film for audiences: young professional women often pushing against outdated cultural norms—explored as conflict with the institution of the hospital—and signaling their autonomy through nudity, sex, and/or sexual situations. These narrative themes are signaled via the film's block quotes, which read: "All you interns are alike—you all have one track minds," "I hope you all get kicked out of their lousy profession," "What I do with my body is my business," and "Love-in bore me . . . all talk and not action!" The semantic/ syntactic relationship of the nurse cycle films is predicated on subsequent replications of the poster and the broad outline of the film's narrative it presents. Indeed, *The Student Nurses* only achieve its genre status retroactively once successive nurse films were released, and its poster as nurse cycle urtext is post factum as well. The film poster as text, then, serves to "establish new meanings for familiar terms only by subjecting well-known semantic units to a syntactic redetermination, so generic meaning comes into being only through the repeated deployment of substantially the same syntactic strategies."[34]

Three out of the four duplicative films share the primary semantic elements of *The Student Nurses*: a black frame, enclosing four women as if inside a picture; all four women in the image gazing outward toward the viewer;

all women in a nude state; the primary image of the women expressed pho-
tographically; each poster containing four block quotes from the film; and
each with a sexually suggestive tagline. The "semantic expectation"[35] of the
poster, then, establishes the "sematic signal"[36] sent to potential audiences:
you've enjoyed this film once before, and you can enjoy it again. The outlier
is *Candy Stripe Nurses*, which boasts an orange frame that is decorative rather
that picturesque, drawn (rather than photographic) images, no outward
gaze, and no block quotes. While the indirect references to its urtext can
be read as a likely last-ditch effort to reinvigorate interest in the conceit,
the semantic signal is still strong enough to allows audience to interpellate
the film as part of the cycle. Repetition in movie posters is not unique to
second-wave exploitation. However, aesthetic similarities in posters like
these pattern mood and tone—and to a lesser extent genre—rather than the
direct repetition of diegesis like with the nurse films. The children's film *Puss
in Boots* (Chris Miller, 2011) and the vampire action thriller *Blade* (Stephen
Norrington, 1998) have similar posters: both feature a central figure clad in
black against a dark background with their back to the viewer, face turned
to the left and visible in profile, while each clasps a sword behind their back
with their right hand. Both swords glint from an unplaceable light source,
and the title of each film sits directly under each figure, blended into their
backs. However, it is highly unlikely that a potential audience member will
expect the same text from the two films, despite their poster similarities.
In contrast, New World's paratextual patterning in the nurse cycle posters
directly references overlapping filmic texts. The subsequent nurse film post-
ers, then, *depend* on their paratextual relationship not to their own films, but
to *The Student Nurses* poster as antecedent urtext, necessarily expanding the
boundaries of the text/paratext relationship.

SPECULATING ENJOYMENT

Like *The Student Nurses* and its descendants, *The Hot Box* was produced by
Corman's New World Pictures. Corman, and by extension New World, had
a reputation for ensuring a film's profitability by keeping its production costs
as low as possible. In the 1970s, much of that low overhead was facilitated by
location shooting overseas, most notably in the Philippines. The Philippines
became a favorite location for independent productions from the 1960s
to the 1980s, owing in large part to the cheap availability of labor and to
the welcoming climate then-Prime Minister Ferdinand Marcos cultivated
for foreign production companies. Marcos was so invested in drawing film

production into the country that he readily offered national supplies, includ-ing the army, for use during productions.[37] By the mid-1970s, New World was spending so much time in the country that Corman built an office on the archipelago.[38] Compounding Marcos's economic incentives was the fact that the Philippines was already home to a vibrant—albeit small—film industry, which allowed New World to draw from a pool of trained labors for work in front of and behind the camera.

There were two unintended benefits of Philippines location shooting: first, the diversity it brought to the films shot there; and second, the ways the country's complicated political past and present interlaced filmic content in unexpected and interesting ways. Casting Filipinos greatly broadened the racial composition of actors in the New World film shot there, expanding this representation on screen past a conventional white/black binary. Indeed, due to the country's colonial past and the multiple ethic and racial influences, Filipino actors represented a mix of Tagalog, Chinese, Arab, Spanish, British, Japanese, and Korean ancestry. In this way, casting unknowingly became a tool for exploring "a constant discourse on the relationship between the US government and various Third World countries and liberation struggles."[39] To be sure, critical explorations of the United States' colonial role in the Phil-ippines was already underway in the country's native industry. In his book *Dream Factories of a Former Colony: American Fantasies, Philippine Cinema* (2010), José B. Capino notes that a major recurring theme within Filipino film was the country's complicated colonial relationship with the Unites States.[40] The presence of New World further complicates this relationship, as the all-encompassing American film industry returned to the nation to exploit its people and its resources, a reenactment of the US government's colonial past.

There were, however, some New World films that may have taken inspira-tion from these geopolitical complications—or at least taken advantage of them—including *The Hot Box*. The film takes places in the fictional Republic of San Rosario and follows four American visiting nurses who are working at the country's government medical center for three months. On a rare day off, the women are kidnapped and delivered to the People's Army of San Rosario, a group of militant revolutionaries fighting against an intertwined and oppressive government and military. The women have been brought to the People's Army camp to teach basic first and emergency aid. Once the People's Army is educated, the nurses will be set free. After a few days at the camp, the women escape and are eventually rescued by the military. Rather than ensure safety and return, military officers rape and torture the women for information about the People's Army. Realizing the revolutionaries were,

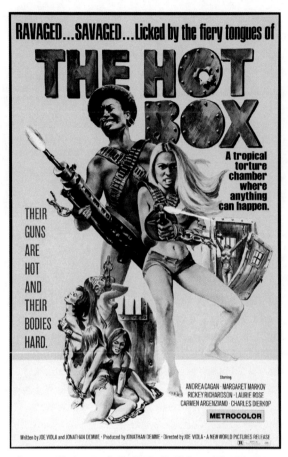

Figure 3.10. Movie poster for *The Hot Box* (Joe Viola, 1971). From the Harry Ransom Center at the University of Texas Digital Movie Posters Collection.

indeed, fighting for justice and peace, the women escape the military, return to the People's Army, train them in healing, and eventually help overrun the military's most violent and oppressive battalion. At the end of the film, one nurse elects to stay and join the revolution while the three others return.

However, if once were to look at the poster for *The Hot Box*, neither the film's plot, story, or themes would be apparent. Instead, the poster focused on what Gray terms "speculative consumption, creating an idea of what pleasure any one text will provide, what information it will offer, what 'effect' it will have on us, and so forth."[41] Speculative consumption is the lynchpin of exploitation marketing, as both classical and second-wave exploitation marketing paratexts promoted "not necessarily what the films actually showed on screen, but what the audience 'might' see if they paid for a ticket."[42] While

some may argue that a ticket purchase to any film indicates only the "*chance of entertainment*,"[43] second-wave exploitation films like *The Hot Box* use film posters as, essentially, a bait-and-switch, enticing audiences into theaters and resolutely failing to deliver on their scintillating promises. To borrow the idea of editing as edging from Harper Shalloe's work on sexploitation director Doris Wishman—wherein editing strategies are used to produce "a suspension of the scene of desire through the forestalling of release"[44]—second-wave exploitation movie posters, like the one-sheet for *The Hot Box*, act as paratextual edging: marshalling the juxtaposition of aesthetics and expectation to generate excitement for a climax of salacious content that never appears. Indeed, the titular hot box, which the posters promises is a "tropical torture chamber where anything can happen"[45] and in which women's bodies are "licked by [its] fiery tongues"[46] does not exist in the film.

The closest the diegesis get to a "hot box" is a storage closet framed with chain-link fence material and housed in a garage-like area of the military's compound; the four nurses are forced into it and are sprayed with a fire extinguisher until they agree to remove their clothes. In truth, the film was originally called $R_x Revolution$ (pronounced as *Prescription Revolution*), but Corman thought the name was cumbersome, uninteresting, and the idea of revolution did not lend itself to the type of debauched marketing materials that were New World's stock in trade; the name was changed, the one-minute scene in the storage closet was filmed, and *et voilà*, *The Hot Box* was born.[47]

The poster, then, links to a narrative imaginary of a text that does not exist, stretching the concept of para so far that the poster and the film as two distinct texts in and of themselves. *The Hot Box* poster is an apt example of how the industrial norms of second-wave exploitation filmmaking stretch the boundaries of the movie poster as the para in paratext. These examples demonstrate how the industrial norms of second-wave exploitation filmmaking manipulate the boundaries of the *para* in paratext when considering alternative filmmaking processes. Hopefully, the small explorations undertaken herein offer a first step in uncoupling mainstream Hollywood as the presumed normative model for vicissitudes of text and paratext, thus expanding our understanding of these processes to encompass the diverse industrial film ecosystems that comprise film histories.

NOTES

1. Jonathan Gray, *Show Sold Separately: Promos, Spoilers, and Other Media Texts* (New York and London: New York University Press, 2010), 52.
2. Gray, *Show*, 55.

3. Gray, 4.

4. Gérard Genette, *Paratexts: Thresholds of Interpretation*, trans. Jane E. Lewin (Cambridge: Cambridge University Press, 1997), 1.

5. Gray, *Show*, 7.

6. In total, there are seven different versions of the film that are all as easily recognizable as the film itself.

7. Gray, *Show*, 3.

8. Bernard Cohen, *The Press and Foreign Policy* (Princeton, NJ: Princeton University Press, 1963), 13.

9. Gray, *Show*, 26.

10. Gray, 23.

11. Gray, 6.

12. Gary D. Rhodes, "The Origin and Development of the American Moving Picture Poster," *Film History* 19, no. 3 (2007).

13. Stephen Parmelee, "Remembrances of Films Past: Film Posters on Film," *Historical Journal of Film, Radio, and Television* 29, no. 2 (June 2009): 181.

14. Gray, *Show*, 5.

15. Simon Hobbs, *Cultivating Extreme Art Cinema: Text, Paratext, and Home Video Culture* (Edinburgh: Edinburgh University Press, 2018), 22.

16. Gray, *Show*, 3.

17. Mark Whitman, "Exploitation Is Not a Dirty Word," *Cinema '79* (1978): 36.

18. Eric Schaefer, *Bold! Daring! Shocking! True: A History of Exploitation Films, 1919–1959* (Durham, NC: Duke University Press, 1999).

19. "Education" was very loosely defined. Effectively, classical exploitation films would claim an education function to avoid legal ramifications for their content. For example, a film that showed the live birth of a baby and the physical effects of sexually transmitted infections was marketed as sex education—with no attention to the veracity of the educational claims made or information presented in the film—to avoid criminal pornography charges for exhibiting images of genitalia.

20. Schaefer, *Bold!*, 5.

21. Schaefer, 12.

22. Schaefer, 325.

23. For a full accounting of second-wave exploitation, see Alicia Kozma, *Radical Acts: The Labor of Filmmaking and the Cinema of Stephanie Rothman* (Jackson: University Press of Mississippi, 2022).

24. Linda Ruth Williams, "Exploitation Cinema," in *The Cinema Book*, 3rd Edition, ed. Pam Cook (London: British Film Institute, 2007): 299.

25. Eric Schaefer, "Exploitation Films: Teaching Sin in the Suburbs," *Cinema Journal* 47, no. 1 (Fall 2007): 95.

26. Four-walling was an exhibition tactic with deep roots in classic exploitation wherein a film producer would rent out an entire movie theater (i.e., all four walls) for a contracted number of days. They would then show their film, and only their film, continuously during the contracted time period, keeping 100 percent of the box-office grosses. Four-walling allowed for high-volume screening and quick box-office returns, ensuring

even a poorly received film could earn back its costs before being impacted by negative audience word of mouth. Contemporarily, Hollywood uses the core of this concept—high volume and fast returns—in their wide release strategy where films are released on thousands of screens across a variety of markets on their opening weekend.

27. David Church, *Grindhouse Nostalgia: Memory, Home Video, and Exploitation Film Fandom* (Edinburgh: Edinburgh University Press, 2015), 77.

28. Lisa Kernan, *Coming Attractions: Reading American Movie Trailers* (Austin: University of Texas Press, 2004).

29. Schaefer, *Bold!*, 105.

30. Alicia Kozma, "Women Filmmakers: Stephanie Rothman," in *The International Encyclopedia of Gender, Media, and Communication*, eds. Karen Ross, Ingrid Bachmann, Valentina Cardo, Sujata Moorti, and Cosimo Marco Scarcelli (London: Wiley Blackwell, 2020), 1–2.

31. Rick Altman, "A Semantic/Syntactic Approach to Film Genre," in *Film and Theory: An Anthology*, eds. Robert Stam and Toby Miller (Malden, MA: Blackwell Publishing 2000), 183.

32. Altman, "A Semantic."

33. Altman, 183–84.

34. Altman, 188.

35. Altman, 189.

36. Altman, 189.

37. Mark Hartley, *Machete Maidens Unleashed!* DVD, dir. Mark Hartley (Australia: Dark Sky Films, 2010).

38. Gary Morris, "Roger Corman on New World Pictures: An Interview from 1974," *Bright Lights Film Journal, no.* 27 (January 2000), https://brightlightsfilm.com/roger-corman-new-world-pictures-interview-1974/.

39. Suzanna Dannuta Walters, "Caged Heat: The (R)evolution of Women-in-Prison Films," in *Reel Knockouts: Violent Women in the Movies*, eds. Martha McCaughey and Neal King (Austin: University of Texas Press, 2001), 122.

40. José B Capino, *Dream Factories of a Former Colony: American Fantasies, Philippine Cinema* (Minneapolis: University of Minnesota Press, 2010).

41. Gray, *Show,* 24.

42. Robert G. Weiner, "The Prince of Exploitation: Dwain Esper," in *From the Arthouse to the Grindhouse: Highbrow and Lowbrow Transgression in Cinema's First Century*, eds. John Cline and Robert G. Weiner (Maryland: Scarecrow Press, 2010), 42.

43. Gray, *Show*, 24 (italics in original).

44. Harper Shalloe, "Trans/sexual Negativity and the Ethics of (S)exploitation in Let Me Die a Woman," in *ReFocus: The Films of Doris Wishman*, eds. Alicia Kozma and Finley Freibert (Edinburgh: University of Edinburgh Press, 2021), 57.

45. *The Hot Box* one-sheet movie poster, Harry Ransom Center at the University of Texas Digital Movie Posters Collection.

46. *The Hot Box.*

47. Hartley, *Machete.*

INTERNATIONAL POSTER CULTURE

PRINT, PUBLICITY, AND PLACE

Intersecting Histories of Cinemas in India (1930s–1960s)

MADHUJA MUKHERJEE

This chapter builds from research on popular Indian cinema and its diverse and intersecting visual cultures, focusing on film publicity material from the 1930s to the 1960s. In the case of Indian cinemas of the period, the publicity system consisted of print as well as sonic media, including gramophone records and radio.[1] In this chapter, I put the spotlight on the publicity material available principally in print, alongside those imprinted on glass plates (negatives) and used for the display and projection inside the theaters. I reflect on print cultures and the art of early film posters, song booklets, lobby cards, advertisements, and picture plates (published in the magazines), and a wide variety of material which constitute the entire repertoire of film publicity. I examine the compelling points of intersection between film and other media industries, to formulate an industrial map, and study the mechanism of image making and print cultures in Calcutta (presently Kolkata), Bengal, East of India. While there is little focused study on print and publicity material of Indian films,[2] I use a multifocal lens, described here as "print, publicity, and place," in an attempt to look into the multiple types of print and publicity cultures and the sites of crosscurrents—those which galvanize industrial networks, and are deeply entrenched in the local history of print and other cultures as well as in the accounts of evolving Calcutta/Kolkata neighborhoods. The purpose here is to speculate on alternative approaches and methods of doing film history, and flag the assemblages of multifarious media forms which constitute a media-scape and fabricate histories of cinema.

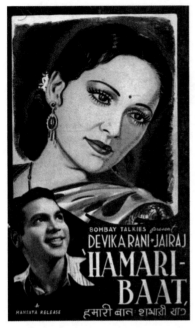

Figures 4.1 and 4.2. The front and back cover of the song booklet of the Hindi film *Hamari Baat* (d. M L Dharamsey, 1943), which was printed and circulated in Bengal (East of India), principally for the Bengali speaking viewers. From the author's collection.

PRINT, PUBLICITY, PUBLICS

Indian songbook/lets (see figures 4.1 and 4.2), often printed in cheap newsprint paper, mostly comprised a poster image (on the cover), alongside film stills, plot synopsis, lyrics or the text of the songs (which were reproduced in disparate Indian languages), and a detailed credit list, inclusive of the names of distributors and exhibitors. The back cover of such booklets frequently incorporated advertisements of forthcoming films. Therefore, such booklets entailed multiple genres of publicity, for instance, the art of posters, the style of portraiture, textual matter, and melodic elements. Such objects of consumption were easily available at the local shops in the cities and were widely sold in India from the 1930s through the 1960s, since the audiences collected them as souvenirs and retained them as fragments of films.[3] As a matter of fact, these materials are referred to as "song" booklets precisely because they predominantly incorporated the lyrics of all songs of the film and thus enabled the viewers to hum along when they played on the gramophone and on the radio.[4] Consequently, "song booklets" are available from private collectors, in public archives, and through e-commerce, where they circulate as high-priced memorabilia.

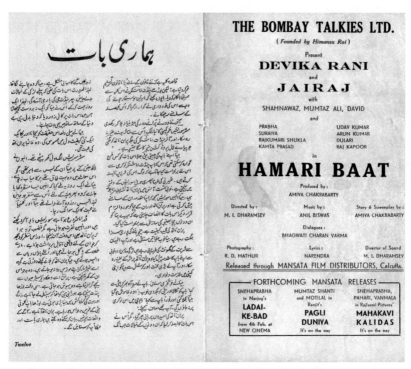

Figure 4.3. Plot synopsis in Urdu script, and credit list in English. *Hamari Baat* booklet pages 12 and 13. From the author's collection.

I argue that, working as an interface between a robust public culture of the Bazaar[5] and personal experiences of going to the cinema,[6] such song booklets, as well as publicity material at large, signal a new direction of film historiography, and allow us to explore the expanded field of media ecologies as a site of interlaced domains.[7] In Bengal, for instance, the art and printing of song booklets overlapped with the complex sociopolitical accounts of photo and art studios,[8] and the history of local press, printing, the popularity of cheaply produced literary texts (described as "Battala" publications),[9] as well as accounts of paper industry in India, which was initiated by the British Empire during mid-nineteenth century.[10] Therefore, thorough research on the song booklets (and film publicity in general) debunks a circumscribed study of cinema via author-texts-movements, refocuses our attention toward narratives of film production and consumption, and histories of places and publics, and illustrates how such material is located at the cusp of multiple media forms and cultural industries. Briefly, such methods generate, what I describe as, provocative and productive histories.

As produced by the illustrious Bombay Talkies, the song booklet of the Hindi film *Hamari Baat* (M. L. Dharamsey, 1943) prompts us to trace the multilayered field concerning film, other media, and cultural industries. For instance, while the audio clips of two of the film songs circulate via the internet,[11] the film per se, and even its publicity material, has hitherto been untraceable. Moreover, the booklet, which I myself rediscovered, has survived in part, and features Hindi lyrics (or words) of the songs (or "geet") in Bengali fonts, alongside a plot synopsis (in a typical suggestive manner) in Urdu script, together with a credit list, which is in English. The booklet prompts us to reconsider the multilingual urban viewership in the colonial cities—comprising Hindi, Bengali, Urdu, Persian, and English educated publics—and also underscores the linkages between disparate media texts, images, idioms. Note, the credits page of the booklet also mentions that the film was released through "Mansata Film Distributors, Calcutta."

I refocus this study to emphasize the importance of Mansata Film Distributors (and other distributors) and rethink the ways in which the film industry, particularly the distributors and exhibitors, reimagined and reconstructed a multilingual audience as opposed to the perception of a predominantly Bengali *Bhadralok* (educated gentry) viewership.[12] Furthermore, the case of distributors and exhibitors (operating across the Eastern part of British India) alerts us to the multifocal scene of print-publicity enterprises. Also of note, the back cover of the booklet presents an advertisement of a skin whitening cream;[13] moreover, the booklet provides details of the editor, engraver, printer, and the publisher (and includes their office addresses). While I shall return to the subject of film advertisement and the location of cinema within the gamut of emergent consumerism and urban cultures later in the chapter, at this point, it should be noted that Mansata Film Distributors were not alone in the field, specifically at the juncture when the film industry (in Calcutta/Kolkata) was gradually transiting from production of silent films to the "talkies," and consequently, the industrial-cultural milieu was becoming a site for multiple sociopolitical dealings.[14] A methodical scanning of film publicity material of the early sound period demonstrates the shifting boundaries of the so-called "Bengali" film industry; additionally, an advertisement of Mansata Film Distributors (see figure 4.4) effectively generates the roadmap of our research by situating itself at the crossroads of manifold industrial formations.

The intersection of Chitpur Road (now Rabindra Sarani) and Harrison Road (Mahatma Gandhi Road at present) and the entire span drawn out in the advertisement (next page)—Sealdah (Station) in the east, Howrah

Figure 4.4. Published in *Film land* (October 1931), this advertisement of Mansata Film Distributors entices exhibitors and presents the list of films in their hold, and also mentions the producers they are working with. Along with the address of the company, the advertisement chalks out a figurative road map of the location of film companies. Courtesy the Media Lab project, Department of Film Studies, Jadavpur University.

(Station) in the west, Bag Bazar in the north and Dharmatala (Esplanade) at the center—is precisely the area in which the English educated Bengali gentry built their mansions, and peri-urban and rural youth arrived to stay at the boarding houses; also schools, colleges, a university, hospitals, gyms, theaters, cinemas, and a range of cottage industries, shops, and printing presses were set up in the vicinity. By the nineteenth century, printing presses were popular across Calcutta/Kolkata, although the earliest printing presses were owned by the Europeans (and were located in central Calcutta/Kolkata). The Bengali type and printed books were initially published from Sreerampore (approximately twenty-seven miles from Calcutta/Kolkata), while one of the

Figure 4.5. Back cover of the songbook of *Kisi se na kahna* (Keshavrao Date, 1942), stating the names of editor, publisher, and printer of the booklet. From the author's collection.

first printing presses in Calcutta/Kolkata, owned by an Indian, was located in West of the city. Nonetheless, the so-called "Battala" area—basically the road map charted by Mansata Film Distributors—witnessed a remarkable growth of Indian-owned printing presses resulting in as many as forty-six presses by the mid-nineteenth century. Moreover, this culturally marked "Battala" belt eventually extended unto Bhowanipore-Kalighat (towards the southern quarters of the city), which was also dotted with colleges, offices, shops, eateries, cinemas, theaters, and houses of the nuvo-gentry. The cheaply produced chapbooks involving mythological tales, plays, poetry, short stories, manuals, and the almanac, often included advertisements of indigenously manufactured products and erotic images. The "Battala" press

FILM LAND ART SUPPLEMENT 11TH JULY 1931

ANANDA PRESS BLOCK A.R.C.

MARLENE DIETRICH is one of Germany's most beautiful and
talented srceen stars. After her part opposite Emil Jannings in
"The Blue Angel" she became prominent in the eyes of the film
fans. Her acting in 'Morocco' a Paramount picture made her famous
across the Seven Seas. Her latest picture is 'Dishonoured.'

Figure 4.6. Full page picture plate of Marlene Dietrich in the July 1931 issue of *Film Land*.
Courtesy the Media Lab project, Department of Film Studies, Jadavpur University.

had close ties with the Bengali popular theater, and Diamond Library to date houses and prints such material. Note, while the songbook of *Hamari Baat* was printed at Tagore Castle Road (north), the booklet of *Kise se na Kahna* (see figure 4.5) was printed at Ezra Street at the center; likewise, the picture plates (see figure 4.6), printed in *Film Land*, were created by Ananda Press, Bhawanipore (south).

In my photo-essay "Inside a Dark Hall," which focused on the theaters across Calcutta/Kolkata, I have underlined the import of place and locality and have illustrated how film theaters were primarily built in three neighborhoods of the city—basically, on Beadon Street (now Bidhan Sarani) in the north, between Sealdah Station and Dharmatala–Chowringhee expanse in central, and in Bhawanipore area, south of the city.[15] Also, in an

unpublished paper titled "Doing Material History of Cinema: Transmuta-tions of Materials, Methods, Models,"[16] I reimagined the material history of cinema and by assessing "place" *as a resource*, and consequently, I am not only contemplating the history of film theaters but also outlining a route map, via certain locations of the film offices, workshops, and storehouses; my purpose is to reimagine the map of the film industry. Therefore, it is in with such framework that I analyze para-filmic material, ephemera, modes of publicity, and subjects of intermediality, in an attempt to question approaches of examining "landmark" films, and the "great" authors, as well as chronological and filmographic models, and address the multifaceted and nonlinear history of cinema. The process provokes me to think through non-teleological passages of cinematic material, and to rethink subjects of media ecologies and make meaning of the overlaps and ellipses as well as continuities and breaks.

It is within such contested methods that I evoke the narrative of one of few surviving Bengali silent films, *Jamai Babu* (Kalipada Dass, 1931), and reread the movement of the character through the city as a possible mapping of the industrial networks. Consider the first half of the film, in which the character Gobardhan (Kalipada Dass), described as an imprudent "Jamai-Babu" (literally meaning brother-in-law), arrives from the proverbial village to the sprawling urban space of the late colonial city. The film opens with Gobardhan's arrival at the iconic Sealdah Station, and thereafter, he is escorted to a nearby boarding house at Scott Lane (currently Raj Kumar Chakrabarty Sarani). Nonetheless, in due course, Gobardhan ventures into the big city alone and is astounded by cars, people, buildings, and hoardings. Terrified by the crowd and commotion around him, Gobardhan begins to run through the city, and in the process, he traverses Bow Bazaar area, Wellington (presently Nirmal Chandra Street), and eventually reaches the governor's house at central Calcutta/Kolkata and then the iconic Great Eastern Hotel. I am, however, not analyzing the plot of the film; rather, I wish to accentuate the invisible route map crafted through Gobardhan's walking, which effectively crisscrosses the map of film industry. So, on one hand, Gobardhan navigates certain milestones of Bengal modernity, and on the other, such routing enables us to negotiate the accounts of cinema-halls in the city, the locations of films offices and workshops (for new sound machines, such as Csystophone sound machine created by a local scientist)[17]— which were situated between Amherst Street (Raja Ram Mohan Roy Sarani) and Dalhousie (square)—as well as to identify popular gramophone company offices (like those of Megaphone and Hindustan Records).[18] Besides, several printing presses, which printed the magazines, song booklets, and posters, were also located in these parts of the city (see figure 4.7).

Figure 4.7. Usha Press, which printed *Varieties Weekly*, was located at city center, published in *Variety's Weekly*, 1931.

PATTERNS, PICTURES, PROCESSES

The story of Calcutta Art Studio, situated at Bow Bazaar (now B B Ganguli Street) since the late nineteenth century, is perhaps one of the most well documented accounts of art and printing presses in Bengal. From lithography techniques to the application latest Bengali letterpress, the company has survived multiple phases of colonial inflictions as well as the complex and complicated processes of decolonization. As the story goes, Ananda Prasad Bagchi, a proficient portrait painter and a teacher at the Calcutta Art School eventually ventured into independent commercial enterprise, and initiated the Calcutta Art Studio, which specialized in portrait painting and photography but became popular in producing picture-prints (and

chromolithographs) for the mass market. Calcutta Art Studio developed its techniques and augmented its technological resources, and also widened its market in book illustration and designing of English and Bengali ornamental alphabets, which remained influential—and operated as templates—even during the late colonial and postcolonial periods.

During the late nineteenth century, the homegrown circuits of commercial printmaking rapidly grew and developed the art of book illustrations, cover design, product advertising. Among the most prolific artists by the turn of the twentieth century was the graphic designer and illustrator Preo Gopal Das, whose skill in multi-chrome wood-engraving enabled indigenous print-making and picture cultures to produce a parallel aesthetic style in relation to European influences. The technological and aesthetic transformations that transpired via such art studios become crucial, and as suggested by Tapati Guha-Thakurta:

> [w]hat had also been flourishing in Calcutta since the turn of the century, was a vibrant indigenous circuit of print-making, graphic design and commercial picture-making, both within and outside the art school, that was spilling beyond the Bengali book and periodical press into product advertising and new forms of publicities.[19]

Moreover, Asit Paul demonstrates how, by the late nineteenth century, the almanac became one of most accepted platform for advertising. As a matter of fact, advertisements of more or less all types of local goods and services were printed and published in the almanacs. Paul writes, "Such advertisements lured the reader in two ways: with seductive language and dazzling pictures."[20] These picture prints were created by metal etching (lithography); and while the local printers and presses also applied ornamental borders, such designs were imported from abroad (mostly Germany). In time, almanacs became the most important medium for local and popular advertising. Paul particularly writes about Krishnachandra Karmakar of Sreerampore, who had developed the art of engraving, as well as Bengali and Hindi typography, and shows how in due course, Karmakar's types and engravings influenced popular printing practices to a large extent. As chronicled, Karmakar drew the layouts and then created woodcuts for printing purposes, and as mentioned by Paul:

> [T]he pictures used in the advertisements would be published repeatedly—especially if the advertisement gained popularity. Keeping the original woodcut intact, a metal block used to be prepared from this through the means of electroplating, and millions of copies could be

Figure 4.8. *Apna Ghar* (Debaki Bose, 1942), an adaptation of Nobel Laureate
Rabindranath Tagore's story; the song booklet of the film was sold for
"1/2 annas." From the author's collection.

printed from this block without damaging it. The whole operation would
be performed in the small and not-so-small studios mushrooming in
Chitpore.[21]

While making of the woodcuts for the Almanacs was a distinct genre,
enterprise, and a practice, the invention of local typography left its imprints
on various modes of advertising, including printed advertisements of films,
film posters, song booklets and lobby cards.[22] Such typographic art circu-
lated widely, and is used by the local (musical) theater companies located
in the Chitpore area. Furthermore, Paul cites the example of B. Basu and
Co., and the full-page advisement of "Bijaya Batika" (a medicinal supple-
ment literally called "Triumphant Tablet"), in which "a beautiful European

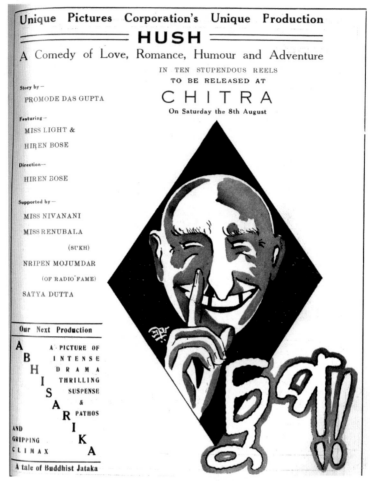

Figure 4.9. *Chup* (d. Hiren Bose, 1931) was released at Chitra, a premium theater in North Calcutta. Courtesy the Media Lab project, Department of Film Studies, Jadavpur University.

woman in a gown and a hat decorated with flowers, [is] holding a [rectangular] poster in her hands."[23] With reference to such advertisements, and many more, I argue that, such designs—like the rectangle in the "Bijaya Batika" advertisement, as well as squares, star, and diamond shapes (see figures 4.8 and 4.9)—principally simple line drawings which were applied for almanac advertisements became productive design templates, and subsequently, these were used on the cover of song booklets, and also in other film publicity material. Such patterns put the accent on the titles of the films and on the popular stars, and are connected to a long history of popular printing and design-making in Calcutta/Kolkata.

I borrow from Tapati Guha-Thakurta to underscore how

[t]he public for the new kinds of pictures now included sections of the educated middle class along with the semi-literate readership of the religious tracts and trash literature of Battala, and the large non-literate clientele for pictures of gods and goddesses—almost the same amorphous mass audience that would later be drawn in by the radio or the Hindi movie."[24]

Furthermore, as opined by Guha-Thakurta in another instance,

[w]e can also note the formation of a distinct middle-class market for journals, illustrations and advertisements, where the earlier clientele of the mythological color prints gradually faded away before the new consumers of advertised products: products range from jewelry and cosmetics to novel items like gramophone records and films.[25]

This new print culture and its publics, as noted by Guha-Thakurta, was embedded into the (then-new) late colonial urban culture in which the publics were consuming it all—from jewelry to cosmetics to novels, as well as gramophone records, films, theater, and related material. It is within such debates that I put the focus on the design "templates," which flowed widely, as printmaking became more and more commercialized, and the slim song booklets and other printed (film) advertisements circulated amongst the middle-class clientele. Moreover, this consumer was *not* a specific linguistic community rather, as in the case of almanac advertisements which were published in different languages such as "Hindi, Urdu, Assamese and Oriya, to lure potential customers who spoke these languages," and, as apparent from our discussions on film audiences, occupied a culturally 'amorphous' space and were a heterogeneous crowd—or groups of (migrant) people who were walking the colonial city, that was pulsating with transforming media cultures.[26]

PLACE AND PROJECTED FANTASIES

In 2004, I had located hundreds of glass-plate negatives via a private collector. The research, supported by Sarai CSDS (Delhi) Independent Fellowship (2004) and Jadavpur University Research Grant (2008), brought forth small (roughly 4 inches by 2 inches), breakable, and gleaming glass plates or slides, which appeared like miniatures, as well as modernist

Figure 4.10. Lobby card of *Sipah Salar* (Mohammed Hussain, 1956). Note the ornamental border involving men and guns. Retrieved from glass plates negatives. From the author's collection.

abstract paintings. The initial process was to retrieve the bulk of the material (about 1,000 glass plates) by digitally scanning, restoring, and making positive images of the same. Finally, a comprehensive catalogue (comprising director, year of release, title of the film, language, production, and other details) was created. A historical meaning began to emerge from what initially seemed like some incomprehensible black-and-white negatives. The recovered material was largely made up of lobby cards (from the 1940s through the 1960s) or a series of cards designed for exhibition at the impressive theater lobbies.[27] Typically, the print size of lobby cards are A3 or smaller, and includes stills of the relevant film, alongside various designs, and patterns, which were often applied as ornamental borders. Additionally, I have discussed elsewhere that these were *not* posters for presentation on the streets, despite certain similarities of the layout and address; rather, these were created for exhibition within the cinemas.[28] Consequently, the import of these images is connected to accounts of places (or neighborhoods, as discussed earlier), and of spaces (for instance, the impressive theatrical spaces). In brief, I propose that, there is a spatial function of such material.

Figure 4.11. Lobby card *Resham* (Lekhraj Bhakri, 1952), starring the exceptional singer-dancer of the period—Suraiya. Retrieved from glass plates negatives. From the author's collection.

A thorough study of lobby cards, and publicity material designated for projection (during the intervals), as cited above (see figures 4.10 and 4.11), as well as the decorative borders, underline the art of such material, and further accentuate its complex relation with the art of poster-making (as well as it association with the narrative address of the song booklets). In fact, the lobby cards used stills from films, and effectively regenerate and re-emphasize the genre, as well as locations and the settings of the films, and also re-channelize the wide acceptance and the fantasies about the (female) stars.[29] Furthermore, Tapati Guha-Thakurta informs us how

there was a special focus on the abstraction and detailing of patterns from a variety of architectural structures and objects—wooden

Figure 4.12. Lobby card of *Sipah Salar* (Mohammed Hussain, 1956). Retrieved from glass plates negatives. From the author's collection.

door-jambs, corbelled pillars, brass and copper utensils, jeweled armory, or woven textiles and carpets. The folio pages [of *Journal of Indian Art*] reveal a constant passage from the materiality of structures and artefacts to their drawn images, also from the whole specimen objects to their extracted scheme of decoration.[30]

Such historical tracing of the patterns of industrial art, creation of "specimen" and its extraction, fragmentation. and reapplication in varied types of commercial art (including lobby cards, as well as song booklets and other publicity material) illustrate how film publicity material and its production was intricately linked with a range of visual and industrial forms.

Likewise, Sabeena Gadihoke reminds us how lobby cards are distinct from, and need to be differentiated from, film stills, especially those which are simply shot to record the continuity of the film and the process of film production. Gadihoke states that:

In contrast to the raw documentary quality of the production still, publicity photographs were rehearsed tableaus from the film. They

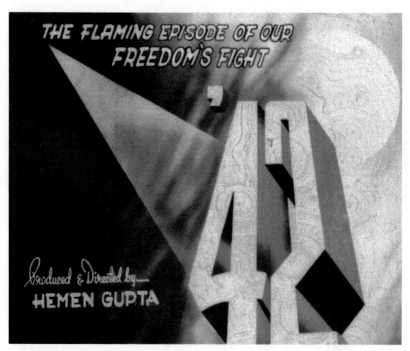

Figure 4.13. Title design of the Bengali film *Biyallish* (Hemen Gupta, 1951), based on the Indian independence movement. Retrieved from glass plates negatives. From the author's collection.

showcased key dramatic moments and other promised pleasures, evoking curiosity about the narrative, the genre or the star. Lobby cards [like the plot descriptions of the song booklets] were deliberately ambiguous about the plot, so that they could appeal to the curiosity of diverse audiences.[31]

For instance, I have discussed at length how the lobby cards of *Andaz* (Mehboob Khan, 1949) reinvented certain narrative hinge points and highlighted the melodramatic imagination (unfolding in tandem with the drama of Indian modernity) and replayed the ambiguity of the times through the portrayal of the female protagonist.[32] My project also located negatives and blueprints of posters used for theatrical projections, images (or stills) of popular stars and actors, as well as discrete and stand-alone title cards of films, together with a variety of advertisements of assorted consumer products (predominantly health drinks and medicines, as in the case of almanacs), as well as publicity material of variety shows and programs (see figures 4.12–4.15). In this chapter, however, I wish to draw attention principally to the *frame*, which hold the cinematic couples and the generic conventions together.

Figure 4.14. A theatrical advertisement of a wrestling match with the famous "B-movie" star Dara Singh. Retrieved from glass plates negatives. From the author's collection.

One of the most conspicuous examples of uses of decorative frames and the framing of the couples is the series from the film *Gorilla* (Akkoo, 1953). Each of the cards in the set fifteen lobby cards (as found by me) displays a gigantic gorilla carrying an ornamental frame. Such embellished frames, enclosing the film frames, encompass images of the couple in romantic postures, fabulous dance scenes, as well as the gorilla depicted in the film, which is seen in jungles, at the recognizable Bombay (or Mumbai) Victoria Terminus station, engaged in terrifying fights, and so on. Since such imageries of the lobby cards rework the melodramatic plot, the re-presentation of the plot unfolds in an iconic (and exaggerated) manner. Besides, as visual styles apparently vary from one generic tendency to the other (from action, comedy to romance, for example), film publicity material like lobby cards, by and large, emphasize its design or the art—and address the crowd gathering at the theater lobby. Nevertheless, what transpires through close-readings

Figure 4.15. A theatrical advertisement of the Hollywood film *Zamba* (William Berke, 1949). Retrieved from glass plates negatives. From the author's collection.

of publicity images—comprising posters, song booklets, lobby cards, stills for theatrical projection etc.—is the fact that the mode of address, and the imagined audience, of the advertisements of A-movies *may not* differ significantly from those of the B-movies. Rather, they take up specific visual shapes and textual forms, with particular reference to the local industries and its location within the larger field and the publics. Thus, such findings challenge and problematize dominant approaches of making meaning of popular films, as we consider the accounts of distribution-exhibition networks and revisit film histories via city neighborhoods.

Sabeena Gadihoke discussed the way the B-circuit or "trash" films circulated "in small towns, the countryside and working-class neighborhoods of big cities," and brought forth a "visceral attraction" as one considers the "images from *Adam Khor* (1955) directed by Akkoo."[33] Gadihoke also alerts us to the contemporary artistic techniques of making the lobby cards, which are

Figure 4.16. Lobby card of *Gorilla* (Akkoo, 1953). Retrieved from glass plates negatives. From the author's collection.

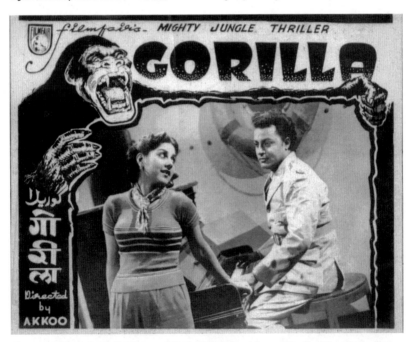

Figure 4.17. Lobby card of *Gorilla* (Akkoo, 1953). Retrieved from glass plates negatives. From the author's collection.

basically composite images, incorporating cutouts of different film stills, and which are thereafter stitched together to create a collage like visual layout. And, to echo Gadihoke, such material further "represents a different history of hybrid photography in popular print culture," just as, the collection of lobby cards cited here—of practically "lost" films—indicates a parallel and vibrant history of cinema which persists as "personal" and "informal" collections and memory, and continue to circulate.[34]

CONCLUSION

In conclusion, it is important amplify that a thorough scanning of Bengali journals like *Dipali* and *Chitrapanji*, brings to light the density of the media fields. For example, a close reading of a specific issue of *Dipali* (October, 15, 1936, no. 42) shows in what way cinema was located within the ecology of a range local industrial products like shoes, child care products, cooking ware, soaps, syrups, homeopathy medicines, contraceptive pills, day and night cream, perfumed oil, skin ointments, Darjeeling tea, beer, "Swiss" Viagra, breast enhancement creams, life-saving drugs, ammunitions, and life insurance, as well as paper, camera, film rolls, lens, radio sets, gramophone records, and so on.[35]

Besides, note the advertisement of the "Tigier Brand Paper" (see figure 4.18), which is laced by a nationalist fervor and presents a call to support Indian industries (in the face of British control over large scale industries). Moreover, it states that "Dipali [was] printed on TIGER BRAND White S. C. Printing 18" x 22"—14 lbs—500 sheets," which means that *Dipali* was printed in relatively high-quality archival paper (comparable to "ledger" or "rag" paper). Furthermore, *Dipali*'s modest advertisement in *Filmland*, alongside advertisements of other consumer products, notes cinema's location within the gamut of locally produced commodities. In addition, while by the 1930s some of the big industries included cotton, jute, cement, sugar, and paper, alongside the massive industrial setups such as iron and steel, some of the film journals of period professed and claimed that film industry's scale was larger than the cement industry if its investments and labor were to be calculated in association with the paper industry.[36]

The film industry in India clearly had links especially with the paper industry; and the production of print-publicity material thus, was as much a question of the materiality and production of paper as it proliferated with the growing business of printing presses, art studios, and new technologies and techniques of printing. It is against such a backdrop that one examines film publicity material of the period—comprising, as discussed earlier, song

Figure 4.18. Advertisement of 'Tiger Brand Paper' *Dipali* (October 15, 1936, no. 42).
Courtesy the Media Lab project, Department of Film Studies, Jadavpur University.

booklets, lobby cards, posters, print advertisements in magazines—and considers the material and spatial history of cinema. For instance, the location of *Dipali*'s office, which was precisely in the Bottala area, on one hand informs us about the map of the film industry, and on the other, it reaffirms my moot point and illustrates in what way film publicity emerged and expanded in conjunction with other media industries. Such a study unpacks a complex and quilted narrative of the film industry and that of print and publicity cultures, and enables us to explore a new route toward history of print, publicity, and place. In the process, we should also note how several addresses (or production houses) have disappeared; their absence and erasure, nonetheless, as elaborated in this chapter, provoke us to imagine newer theoretical and historical road maps.

NOTES

1. See Madhuja Mukherjee, "The Architecture of Songs and Music," The Architecture of Songs and Music: Soundmarks of Bollywood, a Popular Form and Its Emergent Texts," *Screen Sound Journal*, no. 3 (2012): 9–34.

2. For more information on Indian cinema and visual cultures, see Tasveer Ghar, "A Digital Archive of South Asian Popular Culture," http://www.tasveergharindia.net/AdvanceSearch.html?lst_Subject=30&conentType=essay&searchterms=.

3. See also Ada Petiwala, "The Film Poster and Song Booklet for *Zerqa* (1969)," *Film History: An International Journal* 32, no. 3 (Fall 2020): 215–20.

4. See Vebhuti Duggal, "Seeing Print, Hearing Song: Tracking the Film Song through the Hindi Popular Print Sphere, c. 1955–75," in *Music, Modernity, and Publicness in India*, ed. Tejaswini Niranjana (New Delhi: Oxford University Press, 2020), 135–57.

5. See Madhuja Mukherjee, "The Public in the Cities: Detouring through Cinemas of Bombay, Calcutta and Lahore (1920s–1930s)," in *South Asian Filmscapes: Transregional Encounters*, eds. Elora Halim Chowdhury and Esha Niyogi De (Seattle: University of Washington Press, 2020), 119–39.

6. See Madhuja Mukherjee, "Not So Regal Show-houses of Calcutta: Sub-cinemas, Sub-cultures and Sub-terrains of the City," in *Strangely Beloved: Writings on Calcutta*, ed. Nilanjana Gupta (New Delhi: Rainlight/Rupa Publications India Pvt., 2014), 146–54.

7. See Madhuja Mukherjee and Monika Mehta, "Detouring Networks" in *Industrial Networks and Cinemas of India: Shooting Stars, Shifting Geographies and Multiplying Media*, eds. Monika Mehta and Madhuja Mukherjee (London/New York: Taylor & Francis, 2021). See also Debashree Mukherjee's *Bombay Hustle: Making Movies in a Colonial City* (Columbia University Press, 2020).

8. Sudhir Mahadevan, *The Traffic in Technologies: Early Cinema and Visual Culture in Bengal, 1840–1920*, PhD dissertation (New York University, 2009).

9. See Anindita Ghosh, "Cheap Books, 'Bad' Books: Contesting Print-Cultures in Colonial Bengal," *South Asia Research* 18, no. 2 (1998): 173–94. See also Anindita Ghosh, "An Uncertain 'Coming of the Book': Early Print Cultures in Colonial India," *Book History*, no. 6 (2006): 23–55.

10. Amiya Kumar Bagchi, *Private Investment in India, 1900–1939* (New York: Taylor & Francis, 2000).

11. See Madhuja Mukherjee, "The Phantom of History: Figurations of the Dancing Body and the 'Sitara Devi Problem' of Indian Cinema," *South Asian History and Culture* 14, no. 2 (2023): 202–223.

12. See Madhuja Mukherjee and Kaustav Bakshi, "A Brief Introduction to Popular Cinema in Bengal: Genre, Stars, Public Cultures," in *Popular Cinema in Bengal*, eds. Madhuja Mukherjee and Kaustav Bakshi (London/New York: Taylor & Francis, 2020), 1–9.

13. See also Madhuja Mukherjee, "Of Bhadramohila, Blouses, and 'Bustofine': Reviewing Bengali High Culture (1930s–40s) from a Low Angle," in *Popular and Visual Culture: Design, Circulation and Consumption*, eds. Clara Sarmento and Ricardo Campos (Cambridge: Cambridge Scholars Publishing, 2014), 145–66.

14. See Madhuja Mukherjee, "When Was the 'Studio Era' in Bengal: Transition, Transformations and Configurations during the 1930s," *Widescreen Journal* 8, no. 1 (2019), https://widescreenjournal.org/archives/vol8-1/.

15. Madhuja Mukherjee, "Inside a Dark Hall: Space, Place and Accounts of Some Theatres in Kolkata," *South Asian History and Culture* (2017), http://dx.doi.org/10.1080/19 472498.2017.1304086.

16. Presented at the "Conceptual Paradigms in South Asian Film & Media Studies Symposium," Annual Conference on South Asia, University of Wisconsin-Madison, October 2019.

17. See Madhuja Mukherjee, "To Speak or Not to Speak: Publicity, Public Opinion, and Transition into Talkies (Calcutta, 1931–35)," in *Indian Sound Culture, Indian Sound Citizenship*, eds. Laura Brueck, Jacob Smith, and Neil Verma (Ann Arbor: University of Michigan Press, 2020), 268–96.

18. See also Gregory Booth, "A Long Tail in the Digital Age: Music Commerce and the Mobile Platform in India," *Asian Music* 48, no. 1 (2017): 85–113.

19. Tapati Guha-Thakurta, "From Craftsmanship to Commercial Art: The New Dispensations of "Art in Industry," *Marg* 68, no. 3 (2017): 24.

20. Asit Paul, "The Graphic Art of Almanac Advertisements in Colonial Calcutta," *Marg* 68, no. 3 (2017): 44–49.

21. Paul, 46.

22. See "Title Arts in Bangla Films," *Rahr*, September 27, 2010, https://blog.rarh .in/2010/09/bengali-films-titles-forever/.

23. Paul, 48.

24. Tapati Guha-Thakurta, "Artists, Artisans and Mass Picture Production in Late Nineteenth-and Early Twentieth-Century Calcutta: The Changing Iconography of Popular Prints," *South Asia Research* 8, no. 1 (1988): 5–6.

25. Tapati Guha-Thakurta, *Visual Worlds of Modern Bengal: An Introduction to the Pictorial and Photographic Material* (Kolkata: Seagull Books and Centre for Studies in Social Sciences Calcutta, 2022), 20.

26. Paul, 48.

27. See Madhuja Mukherjee, "Material, History, Arguments: Unidentified Publicity Images and Art-installations," *Inter-Asia Cultural Studies* 15, no. 1 (2014): 113–27.

28. Madhuja Mukherjee, "Cinemas Outside Texts: The Mise-en-scene in Publicity Images and Theaters of Spectacle," *South Asian Popular Culture* 9, no. 3 (2011): 327–34.

29. See Tapati Guha-Thakurta, "Women as 'Calendar Art' Icons: Emergence of Pictorial Stereotype in Colonial India," *Economic and Political Weekly* 26, no. 43 (1991): 91–99.

30. Guha-Thakurta, "From Craftsmanship to Commercial Art," 25.

31. Sabeena Gadihoke, "The Art of Capturing Stillness: Cinema Lobby Cards," *Marg* 68, no. 3 (2017): 108–109.

32. Mukherjee, "Material, History, Arguments," 113–27.

33. Gadihoke, 111.

34. Gadihoke, 112.

35. See Suvobrata Sarkar, "In Pursuit of Laxmi," *Archiv Orientální* 82, no. 2 (2014): 459–514.

36. See Madhuja Mukherjee, *New Theatres Ltd: The Emblem of Art, the Picture of Success* (Pune: National Film Archive of India, 2009).

THE CUBAN FILM POSTER

Revolution by Design

LAURA HATRY

Even before 1959, Cuba had a long tradition of graphic art, notably its advertising posters for tobacco or rum, such as Havana cigars and Bacardi. However, the pre-revolutionary poster focused mostly on tropical subjects like music or the sugar cane plantation, and it has been argued that it worked mainly in imitation of Mexican or US marketing patterns.[1] The same phenomenon may be observed in the realm of the film poster,[2] where influence derived first from European and later from US examples "meeting demands that were not precisely of an artistic nature."[3] It is during the revolutionary period when it becomes clear that the poster is the perfect vehicle for promoting political and social agendas, for reasons of economy, simple visibility, and popular interest. Speaking of the political poster, Susan Sontag states in her essay for *The Art of Revolution: 96 Posters from Cuba*:[4] "The birth of serious political graphics came right after 1918, when the new revolutionary movements convulsing Europe at the close of the war stimulated a vast outpouring of radical poster exhortation, particularly in Germany, Russia, and Hungary. It was in the aftermath of World War I that the political poster began to constitute a valuable branch of poster art."[5] The very first poster of the Cuban Revolution was designed by Eladio Rivadulla Martínez, depicting Fidel Castro beneath the words "26th of July," which refer to date in 1953 when Castro's homespun band of rebels attacked the Moncada army barracks in an attempt to overthrow dictator Fulgencio Batista. The poster was printed on January 1, 1959, the very day the Cuban Revolution was proclaimed.

While the original function of the poster, in general, is to advertise commodities and encourage consumership, in the context of Cuba, the fact that its capitalist purposes are the enemy of the Revolution called for an altogether different approach, and indeed poster art turned out to be "a critical feature of the Cuban Revolution itself, flowing naturally as a form of ideological persuasion from other revolutionary artistic traditions like the avant-garde art of the Russian Revolution."[6] Given its rejection of consumer society, Cuba sought not only to redefine but to upend the traditional purposes of poster art, regarding which Sontag writes, "[a]ny modern society, communist no less than capitalist, is a network of signs. Under revolutionary communism, the poster remains one principal type of public sign: decorating shared ideas and firing moral sympathies, rather than promoting private appetites."[7]

In Cuba, the poster's principal function is not to convince the consumer to buy a certain product, or in this case, to convince potential spectators to watch a certain film, but is intrinsically connected to the goals of the Revolution itself, chief among which was the education of the so-called "new man"—and, from a merely pragmatic perspective, there was no need to convince viewers to view a particular film, as attendance at Cuba's extremely low ticket prices was no concern and movie theaters were generally full. And the larger didactic program wasn't limited to movie theatres alone; with the creation of the mobile cinema program (*cine móvil*) in 1961 "mobile projection units [were sent] to remote areas of the countryside, where the illiteracy rate could be as high as forty percent and many lacked electricity."[8] With the whole island envisioned as one great school, the poster became part of that mission of public education—and what better medium to promote it, since poster artists needn't contend with the aesthetic requirements of a cultural elite, in fact, since the poster is automatically and virtually unconsciously consumed by every citizen, with no bias attached, it proved ideal for eliding such class differences as still persisted in the new society. Indeed, a poster intended only for an elite would defy its very purpose and could therefore be considered a "bad poster."

Although the educational agenda might have been served first and foremost by the political poster, it is easy to see the similarities between the two in the context of Cuba and perhaps even to argue a superior efficacy for the film poster, whose purpose would not have been so obviously propagandistic as its political counterpart. By eradicating the meaning of viewership as mere consumership, Cuban poster art also avoids treating the film as a commodity for commercial exploitation and, thus, opens itself to the creation of independent works of art. While the Cuban poster by no means shies away

from dialogue with the film itself, it succeeds, at the same time, in becoming artistically and culturally independent. In this vein, Kunzle argues that

> [t]hose visual media which continue in the commercial art of the bourgeois West to plumb new depths of moral and aesthetic abasement, have attained, by common consent of critics in bourgeois and socialist countries alike, a higher standard in Cuba today than anywhere else in Latin America. The very media which in pre-revolutionary Cuba were the most completely subservient to consumerism, have effected a dramatic transition for which there is no precedent anywhere. All the arts in Cuba—theatre, music, dance, literature—have undergone a radical transformation; but it is in the visual mass media which capitalism evolved to serve its own specific and historic needs, that the transition to socialist values appears the most extraordinary.[9]

The Instituto Cubano de Arte e Industria Cinematográficos (ICAIC, the Cuban Institute of Cinema Art and Industry), created on March 24, 1959, less than three months into the new revolutionary order, played an important role in forging the close relationship film posters bore to the revolutionary process. It established a department specifically concerned with designing film posters for both films of Cuban origin and for international films deemed suitable for viewing in Cuba, employing silk-screen printing techniques as opposed to lithography. The institute was also instrumental in determining a unique feature of Cuban film poster production. While Sontag avers that "much of the best work in the revolutionary poster was done by collectives of poster makers,"[10] the Cuban poster is signalized by the fact that, within an artist collective, the work of the individual creator remains salient, resulting in an interesting hybrid approach. On one hand, the ICAIC provided artists with the support system of a genuine collective and, one can assume, a set of rather well-defined boundaries, but in comparison especially to other state-socialist collectives, the stylistic character of the Cuban poster is often so idiosyncratic that one can readily identify its individual creators, a programmatic intention that is only underscored by the fact that each bears the signature of its maker. Whereas the normal marketing criteria of the Hollywood industrial combine has tended to favor stills from its films or the inclusion of images of members of the star system, it could almost be argued that the appearance of the star system in the Hollywood poster is replaced by the appearance of the star poster designer, with their distinctive recognizability. Furthermore, Sontag argues that

this eclecticism within the work of individual poster artists character-
izes, even more strikingly, the whole body of posters made in Cuba.
They show a wide range of influences from abroad which include the
doggedly personal styles of American poster makers like Saul Bass
and Milton Glazer; the style of the Czech film posters from the 1960s
by Josef Flejar and Zdenek Chotenovsky; the naïve style of the *Images
d'Epinal*; the neo-Art Nouveau style popularized by the Fillmore and
Avalon posters of the mid-1960s; and the Pop Art style, itself parasitic
on commercial poster esthetics, of Andy Warhol, Roy Lichtenstein,
and Tom Wesselman.[11]

During the years of its splendor, from 1961 to 1979, the "ICAIC produced
more than 1,700 original designs, which were printed on paper in runs of
100 to 300 copies each, depending on an exhibition's requirements."[12] As part
of this open air museum that everybody encountered in their daily lives, the
"[p]osters were displayed for no more than ten days over cinema doors or
stuck to structures known as *paragüitas*—umbrella-shaped constructions
specially designed to hold eight posters."[13]

Most of the artists who designed film posters for the Cuban Film Institute,
also designed political posters for, among other purposes, the OSPAAAL
(that is, the Organization of Solidarity with the People of Asia, Africa and
Latin America), which "utilized visual art campaigns to promote a particular
interpretation of the Cold War as ongoing colonialism, to generate trans-
national support for national liberation struggles in the Middle East and
Africa, as well as to promote the Cuban revolution itself."[14] As per Steven
Heller, in his introduction to *Soy Cuba: Cuban Cinema Posters from After
the Revolution*, while these political posters from Cuba "have been widely
exhibited and documented,"[15] it wasn't until Carole Goodman brought to
light its vast collection of more than 1,500 original silk-screens at the ICAIC
that the cinematic counterpart of the Cuban poster received the attention it
deserves. Heller argues that these posters present a "youthful revolutionary
zeal—not politically but aesthetically"[16] and due to the unique trajectory it
followed from its roots in then-contemporary European poster design, he
proposes that this distinct graphic orientation be identified as "Revolution-
ary Cuban Style."[17] The features that we find in the film posters can also be
immediately perceived in the posters that were designed in solidarity with
Vietnam, Angola, Palestine, Laos, Venezuela, or in opposition to Richard
Nixon:[18] a highly curated and thoroughly conceived typography, few and
specifically chosen colors in each poster, and the frequent prominence of a
single color, with very balanced designs. The animating distinction between

the two is that, while for political posters artists were issued instructions as to design and technique, for film posters they were free to experiment. Contrary to the case of the USSR, in which the Russian Constructivists were "eventually betrayed by Soviet leaders and their demand for greater social conformity (which became Socialist Realism),"[19] cinematic poster art in Cuba "exudes a sense of individual freedom [. . . which,] when compared to the more rigidly proscribed poster clichés dictated by Hollywood, suggests that creative liberty and stylistic playfulness had more support under the real dictatorial regime than an iron fisted movie industry,"[20] leading to conceptually striking and imaginative results that should be considered as works of art in their own right.[21]

Eladio Rivadulla Martínez, the designer who made the 26th of July poster of Castro, had already started making silk-screen film posters in the 1940s, many of them for Argentinian or Mexican films, but also for some non-Latin American productions. Examining the posters from the period before the Revolution, it becomes clear that the main difference between these and Hollywood-style posters was the fact that they were silk-screens, their content remaining essentially indistinguishable. The configuration of these posters is largely concerned with presenting the star of the film in a recognizable way, presenting the protagonist or protagonists, and, illustrative of its contents, with the depiction of one or even several significant scenes from the movie. The posters tend to be entirely filled, with no white or monochromatic space; they could even be described as over-crowded. The typography tends to be bold and hand-lettered with no common elements, mixing up to five different fonts in a single poster. Rivadulla was one of the main figures in the early days of the ICAIC, and his experience with silk-screen prints as film posters was certainly of immense importance during this period, opening the way for a generation of exquisite designers, among which an "elite group"[22] of five has been identified: René Azcuy, Antonio Fernández Reboiro, Eduardo Muñoz Bachs, Antonio Pérez (Ñiko), and Alfredo Rostgaard.

The first poster from the ICAIC was made for its inaugural feature film in 1960, *Stories of the Revolution*, by Tomás Gutiérrrez Alea, the Cuban director par excellence, which focused on the insurrection against Batista. The accompanying poster, made not with silk-screen but using off-set printing (it was a year later that the ICAIC switched to silk-screen printing), is still a bit different than the typical posters of the years ahead, but certain aspects that will be common to later efforts can already be identified, as, for example, the font, or the fact that the image makes up only a tiny portion of the poster, giving the text more prominence on a background that doesn't interfere with its reception, something rather unusual prior to that moment. It is a clear precursor to the way

Cuban designers became more resourceful in the face of dwindling funds and material by shooting their own photographs, drawing their own illustrations, and utilizing typography as imagery. Typography strayed from bold, commercial-style script to personalized lettering, along with mixing traditional serif and sans serif typefaces together on the same poster. Type also shifted from posing as bold labels for the film title and actors to being meaningful compositional elements.[23]

The symmetrical and minimalist way in which the text is positioned at the base of the poster will also be a recurrent feature, as well as not eschewing, and even embracing, empty space. Goodman argues, on the topic of white space surrounding an image, that it is intended to allow "the viewer to focus on the art and its meaning. Rather than the viewer understanding the plot line of a movie, one walked away with an intriguing image that referenced a single expressive element of the film."[24] In the poster for *Stories of a Revolution*, it could be argued that even though it is an actual still from the movie (taken from the interior of the armored train captured by Che Guevara's commandos during the Battle of Santa Clara), it constitutes a foreshadowing of posters to come that tend to give only a tantalizing glimpse of the film instead of trying to be as explicit as possible. The creator of the poster is Eduardo Muñoz Bachs, one of the most prolific designers for the Cuban Film Institute—this being the only instance in which he uses a still from a movie.

A very striking example of his design work is the poster for the short documentary *Missing Children*, by Estela Bravo (from 1985), about the children who went missing in Argentina during the dictatorship, in which the combination of the title, a forlorn-looking ball, and an almost entirely black ground instantly evokes parental horror at the realization that a child has disappeared. The work epitomizes the use of monochromatic space as both a central element of design and a signifier of the film's main theme. Bravo also designed many posters for Cuban animated films, both short and feature-length, with a surprising aesthetics for cartoons. If we compare the poster for *Vampires in Havana* (1985) to the DVD cover for distribution in England, the difference is unmistakable: while their descriptions might seem superficially similar, as they follow comparable patterns over a red background and a focus on the main character and its vampire fangs, the English version includes a typical cartoon-like gesture, with details from the film superimposed on the vampire's body, various slogans and typefaces, and a second, smaller character in the background. The Cuban poster, on the other hand, uses the red background as a frame for a cigar-smoking vampire character, with a well-balanced color pattern, repeating certain colors in various points

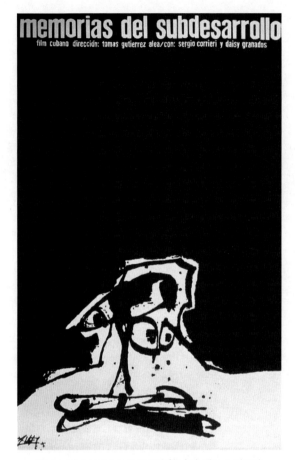

Figure 5.1. Antonio Saura, *Memories of Underdevelopment* (1968).

of the poster (his shirt and teeth, as well as the details on the cigar are of the same yellow, giving the picture chromatic continuity), and incorporates only the title and minimal credits at the top. The way in which the character fills almost the entire space of the poster is a strong example of the design imperative to "focus the eye," one of the fourteen subsections of a special exhibition of the Smithsonian Design Museum's Cooper Hewitt collection, entitled "How Posters Work."[25] The same poster was redesigned by another famous Cuban graphic designer, Nelson Ponce, in 1999, and was among the winners in various competitions of Cuban film posters, becoming one of "these recently produced posters [that] have become almost as well known as their golden age predecessors."[26] It echoes, again, the spirit of minimalism, the economy of integrating text into the content, giving it meaning by graphically including the vampire fangs, as well as a very limited use of color

and a lot of black, exemplifying an "enormous capacity for synthesis, adaptability, and bold visual impact, making possible its reproduction in a variety of media."[27] It also highlights Ponce's typical way of working, as he himself has explained: "The message usually passes from the image and subject to the typography, but the message must be whole. Sometimes I can separate the image from the type, but I usually envision the whole."[28]

The ICAIC poster division also collaborated with foreign artists such as Tadeuz Judkowski from Poland, José Lucci from Italy, and Antonio Saura from Spain. The latter designed the poster (see figure 5.1) for *Memories of Underdevelopment* (from 1968), a film by Guitérrez Alea that many consider to be his masterpiece. The film focuses on an aspiring writer from a wealthy background who chooses to stay in Cuba while his wife and friends go into exile in Miami, offering reflections on the Cuban Revolution, the missile crisis, and what it's like to live in an underdeveloped country. In this collaboration, Saura integrates his distinctive, individual style within the visual template of the Cuban Film Institute. He portrays Sergio, the main character of the film, observing the Cuban panorama through his telescope. In Saura's semi-abstract presentation, the device can easily be read as a displaced warhead, thereby melding the personal life and thoughts of the protagonist with the tortured political reality of the country. And Sergio's prominent—elevated—vantage point, implicitly a consequence of his education and erstwhile privilege, subtly hints at fissures within the social fabric of the newly egalitarian island. In contrast, the English and French versions of the poster, as one might expect, are far more explicit, employing stills from the film in a way that elides ambiguity. The telescope is front and center in the English version, as if seeing, and especially technologized vision, is an entirely straightforward matter, and the French poster is also rather blunt, with the Cuban flag in the background and portraying a scene that indicates the viewer can expect a complex but entirely personal drama of love thwarted by political difference.

Another sort of collaboration came from Cuban artists on the island, such as Raúl Martínez, who, though he wasn't part of the main team at the Cuban Film Institute, collaborated sporadically in its designs. This was the case with the documentary film *David* (from 1967), in whose poster the 26th of July motif can be seen, or the feature film *Desarraigo* by Fausto Canel (from 1965), one of his most celebrated designs (see figure 5.2). "Desarraigo" means "Uprooting," and the poster visually transmits the idea of instability using the image of an industrial gear tearing through the poster's text. Cadel explained his visual strategy thus: "The disarray that was already being felt in the industrial infrastructure of the island—the essential axis of

Figure 5.2. Raúl Martínez, *Uprooting* (1965).

the film—is expressed by the gear disarranging letters that should make up words, symbolizing parts that may not be replaceable. That was enough for a prospective viewer to feel the drama and become interested in the film."[29]

His most famous poster, however, is probably the one he created for *Lucía* by Humberto Solás (from 1968). Exemplifying a very different style, this poster became a cultural symbol every bit as much as the movie itself. The film is about subverting the stereotypical position of women in a patriarchal society. Visually, Martínez's poster is patently reminiscent of the silk-screen images of pop art, both in style and palette and on account of the repetition of the face—even though three different women are portrayed, their similar presentation implies a unity of experience and of meaning. Although they are juxtaposed on the poster, the background of which ties them together, they don't appear simultaneously in the movie, which is comprised of three

episodes taking place at different historical times, each focused on a different Lucía. The first is set during the Cuban War of Independence against the Spanish Empire in 1893, the second under the government of Gerardo Machado, fighting against political repression, and the third, which is accorded most space on the poster, is the Lucía who lives during the revolutionary era and struggles against her husband's chauvinism. The poster also seems to suggest that the Cuban woman as a symbol is a mixture both of these historical determinants and of the mixed racial heritage of the island by depicting three women of different backgrounds, the one with the reddish skin on the left representing the Hispanic heritage, the one with purple skin representing the European heritage, and the woman with brown skin representing the African heritage. Taken as a whole, they amount to a representation of Cuba as a whole.

Generally speaking, the golden era came to a close with the end of the 1970s, when, after two very productive decades, quantity and quality declined. This was probably also related to the fact that during the 1980s poster designs were made almost exclusively for Cuban fictional films, while design for foreign films dwindled down to a virtual halt. Sara Vega has argued that, after 1979,

> [w]ith few exceptions, most did not reach the graphic impact or communicative effectiveness of previous periods. Almost everything had changed by then. During the first half of the 1990s, the material shortages in the country worsened to extremely high levels and started to have repercussions on the visual arts in Cuban. They affected all sectors of life, notably the decrease in national film production and, consequently, that of its posters. The few posters that were produced suffered from [the loss of] a distinctive resource: color; and coherence and continuity in film promotion were lost as well. The Cuban visual sphere suffered from the absence of images that in other times had resulted in its constant renewal.[30]

Even though with the beginning of the Special Period, "the production of posters dropped precipitously,"[31] there are still very striking examples of a continuous employment of similar approaches, as for example the poster for *Fresa y chocolate* (*Strawberry and Chocolate*) by Gutiérrez Alea (from 1993). When focusing on the difference between the posters made in Cuba and outside of Cuba, the results seem to confirm once again that designers in Cuba had more freedom (or latitude, or imagination) than their Hollywood or European counterparts, among whom the figural approach is universal.

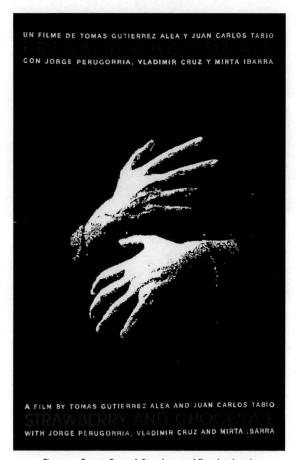

Figure 5.3. Ernesto Ferrand, *Strawberry and Chocolate* (1993).

The film is about two men who couldn't be more different: one is gay and a freedom-loving individualist, the other is straight and a communist. The film portrays how they gradually accept each other and become friends. There were two Cuban designs, one by Ernesto Ferrand and Manuel Marcel, in which the shape of the ice cream cones figuratively depicts the two protagonists; whereas the chocolate cone is rigid and spotless, as if stamped out in the shape approved by the regime, the strawberry cone is literally not "straight," and its contents are melting. The other poster is by Ernesto Ferrand alone (see figure 5.3) and comments on the other significant aspect of the film, concerning friendship and acceptance, represented, again metaphorically, by arms hugging an invisible subject. On the other hand, in the international poster versions that were made for *Strawberry and Chocolate*, one readily observes that the literal approach is not only the universal solution

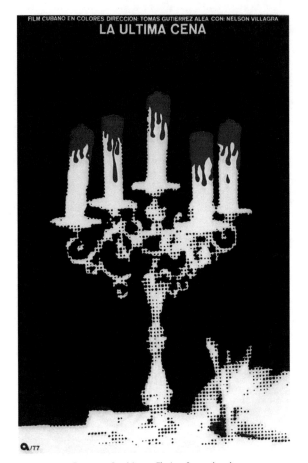

Figure 5.4. René Azcuy, *The Last Supper* (1977).

but the "easy" one as well, the Cuban engagement striking the visually liter-
ate viewer as self-evidently sophisticated and conceptually motivated where
these others are rather shallow if not entirely frivolous. Its visual and meta-
phoric complexity sparks communication with the spectator that aims at
deeper a significance than its mere advertising purpose.

Probably the most obvious exemplar of the school, and a master when
it comes to visual metaphor, was René Azcuy Cárdenas, who was also
one of the design teachers at the Institute. He created some of the most
extraordinary film posters, in Cuba or the entire world, known for their
visual distillation of complex thematic and narrative information and pref-
erence for an austere black-and-white palette, though often incorporating
a small amount of therefore all-the-more striking red. The posters for two
Cuban documentaries, *Rita* (from 1981), and *Testimonio* (*Testimony*, from

Figure 5.5. René Azcuy, *Stolen Kisses* (1970).

1970), illustrate the means by which he manages to say a lot about the films themselves using minimal graphic information. Both seem to have been prepared from photographic stencils, but given the difficulty of obtaining photographic chemicals on the island, even the half-tone dots were meticulously cut by hand.[32] Two examples of how Azcuy incorporates red into his designs, in this case to invoke or symbolize danger or oppression, are the posters for the Cuban feature films *Puerto Rico* (from 1988), by Fernando Pérez and Jesús Díaz, and *La última cena* (*The Last Supper*, from 1976. See figure 5.4), by Gutiérrez Alea. In the first, Puerto Rico, the last US colony, is portrayed as its captive, the red stripes of the "American" flag representing its bonds. But in the attempt to subjugate the island, cracks appear in the flag, announcing that the chains of oppression are about to burst. The second is a satirical film in which a Cuban slave-owner reenacts the Last

Supper using his slaves and then beheads them the following day, bringing "into sharp focus the religious and ethical hypocrisies used by the ruling class to justify slavery."[33] In the poster image, dripping wax is disturbingly substituted with red blood. The visual presentation mimics newsprint, as if a crime scene had been photographed and subsequently distributed. Apart from creating intrigue, "[t]he candelabrum that Azcuy selects as the primary symbol of the film features prominently in the central scene of the Last Supper reenactment, framing the protagonists throughout. The addition of the bleeding candles in the poster evokes the film's violent closing scene and serves as a stark representation of the brutality upon which the Cuban sugar plantation system was founded."[34]

The aforementioned film posters were all made for Cuban films, but another important aspect of ICAIC's production were international film posters that were redesigned in Cuba. In this department, we can observe the same process that transpired with Cuban posters in the international film arena but in reverse—that is, while their original posters were not used outside of Cuba to promote Cuban films, international film posters were completely redesigned on the island for the presentation of foreign works to a Cuban audience. For example, a comparison of the original poster for the 1971 English film *The Go-Between*, by Joseph Losey, as well as its Italian and Spanish versions, with the one Azcuy made for the film, reveals once again the precise and thoughtful minimalism of the latter in its contrast with the detail-heavy, protagonist- or star-orientated European efforts. Another example is the poster for Truffaut's *Stolen Kisses* (from 1968). The original French version had already received a minimalist reconception for the English release, and the Spanish version was basically an interpretation of the latter. In this case, the Cuban version (figure 5.5) is also based on the English but takes the minimalist approach one step further, in what might be Azcuy's "best expression of his technique. By overlapping red color over the lips of a barely recognizable face he invites multiple associations deriving from the title of the François Truffaut film."[35] The artist has recounted the story of how he came up with the design during a bus ride:

> I was standing, and next to me were two young women, also standing. They were elegant, but were having very stupid conversations I wasn't interested in. But I had a lucid moment when I tried to understand the meaning of the dialogue of these two girls. That's when I heard how one of them said to the other: I think my lipstick is running. I heard that, that something wasn't staying in its place, that

it had shifted. And I realized that the girl's expression had gotten me intrigued. And it was connected to the issue that I was trying to resolve, which was to depict the movement that's implicit in the title *Stolen Kisses*.[36]

The same treatment is also evident in US films, as in Antonio Fernández Reboiro's poster for *Moby Dick* (1956), as well as for Asian films, such as Azcuy's for the Chinese film *Red Sun* (1971) or Reboiro's for the Japanese film *Harakiri* (1962), which "is astonishingly simple, incorporating the graphic representation of the act itself—Japanese Seppuku. The title and film credits are balanced by a red circle on the top right-hand side as a direct reference to the Japanese flag,"[37] and it was the first instance of a Cuban film poster receiving international recognition in the form of a honorable mention at the International Film Poster Exhibition in Ceylon in 1965.[38] Both of these designs clearly integrate elements of an Asian imaginary, so that the spectator can immediately understand, without needing to read the details, where the films were made, and, again the predominantly red and black palette over a white background, makes conceptual as well as visual sense.

After the downturn of the 1980s and 1990s, "a new wave of graphic designers has refreshed the messages and taken up new challenges and risk. In the new millennium a renewed policy of poster production, as well as the gradual financial recovery of ICAIC, has favored the revamping of this graphic tradition."[39] There have also been plenty of exhibitions of the Cuban film poster, both on the island and internationally, that attest to the cultural importance they exude. The posters that were made for older movies during the last decades by a new generation of Cuban designers indicate a clear drive to keep the style and spirit of the Cuban post-revolutionary poster alive, and to continue what the Cuban writer Alejo Carpentier, referring to the film posters on the island, has called an "art gallery accessible to everyone."[40] Outstanding examples of these more recent posters are some of Nelson Ponce's creations, like the previously mentioned *Vampires in Havana*, or the poster for the first Academy Award-winning Argentinian movie, *The Official Story* (from 1985), featuring the unmistakable white head-scarves of the Mothers of the Plaza de Mayo, as well as, in the international realm, his design-proposal for *A Clockwork Orange* (1971). Contrary to the situation during the first decades of the Cuban poster, when "the presence of women in the production of film poster design was scarce; [in recent times,] there are a number of women who [. . .] have come to bulk up the list of graphic designers. Laura Llópiz, Michelle Miyares, and Giselle Monzón are among them."[41]

All the previously discussed posters show a strong tendency towards minimalism and a clear differentiation from Hollywood-style design, as well as, for example, European-style design of the same period, while still incorporating a variety of artistic orientations and influences. We can also see how they successfully incorporate the identity of the films that they advertise, but at the same time, and most importantly, the political identity, propaganda interests, and social intentions of the Cuban Revolution while exemplifying the prevalent maxims of the Cuban school of graphic design. Of course, some design choices were dictated by extraneous factors, notably the embargoes imposed on Cuba, which forced artists to improvise practical solutions to exigency. Their limited budget and dwindling ink-supply would have posed serious problems for typical Hollywood poster production, however, without wanting to deny material-based considerations, the enormous diversity and sparkling creativity of the Cuban film poster demonstrate that this was never the main issue. Regarding the resurgence of the poster in the 1990s, López Hernández has explained that

> [t]he traditional silk screen printing studios at ICAIC did not have enough supplies, including ink and paper. It was not the first time that graphic designers experienced a shortage of supplies. In the 1960s, they had undergone a similar situation, so they understood that ingenuity was the best weapon for overcoming a lack of resources. The Cuban film posters are a demonstration of how much can be done with so little. Inventiveness was the key to finding excellent solutions—two- or three-color posters were printed on never before used materials, such as craft paper and even newspapers.[42]

Defying technical and material limitations, Cuban designers managed to visually convey a national identity through careful montage and produce a distinctive collective signature in the use of primary colors, concise design, and a minimalist aesthetic. In so doing, they raised an often indifferent commercial medium to the level of art, providing the artist-designer with the freedom to incorporate their own understanding of the film in their work, which therefore often serves as a "poetic accompaniment to the film itself [with the aim of training] the viewer to interpret visual symbols and compositional cues. Perhaps inspired by the campaign to spread literacy across Cuba, ICAIC artists were invested in educating the public in *visual* literacy, especially the ability to interpret abstract rather than literal representations."[43] The effect these posters have had on their viewers has, accordingly, sometimes been even more intense than that of the film itself.[44]

NOTES

1. Manuel Morales, "Al son del cartel de cine de Cuba," *El País*, February 5, 2017, https://elpais.com/cultura/2017/01/31/actualidad/1485865517_220031.html.

2. Carole Goodman, "An American in Havana: Becoming Acquainted with Cuban Graphic Design," in *Soy Cuba: Cuban Cinema Posters from After the Revolution*, eds. Carole Goodman and Claudio Sotolongo (México, D.F.: Trilce Ediciones: 2011), 12–21.

3. This and all following translations are mine. Original text: "respondió a imperativos que no fueron precisamente artísticos," Sara Vega, "Soy Cuba, de cierta manera," *Cuban Studies*, no. 41 (2010): 69.

4. The essay was originally published in Dugald Stermer, ed., *The Art of Revolution: 96 Posters from Cuba* (New York: McGraw-Hill, 1970).

5. Susan Sontag, "Posters: Advertisement, Art, Political Artifact, Commodity," in *Looking Closer 3: Classic Writings on Graphic Design*, eds. Michael Bierut et al. (New York: Allworth Press, 1999), 201.

6. Jessica Stites Mor, "Rendering Armed Struggle: OSPAAAL, Cuban Poster Art, and South-South Solidarity at the United Nations," *Jahrbuch für Geschichte Lateinamerikas | Anuario de Historia de América Latina*, no. 56 (2019): 43, https://doi.org/10.15460/jbla.56.132.

7. Sontag, "Posters," 204.

8. Maeve Coudrelle, "Revolutionary Design: The Cuban Film Poster," 2019, https://www.cooperhewitt.org/2019/10/08/36082/.

9. David Kunzle, "Public Graphics in Cuba: A Very Cuban Form of Internationalist Art," *Latin American Perspectives* 2, no. 4, supplement issue, Cuba: La Revolución en Marcha (1975): 89.

10. Sontag, "Posters," 201.

11. Sontag, 207. Steven Heller, in addition to Saul Bass, has also pointed out influences by the "American book jacket designer Roy Kuhlman [and a] George Guisti look—he, too, was known for his book jackets." Steven Heller, "Recalling a Forgotten Treasure," in *Soy Cuba: Cuban Cinema Posters from After the Revolution*, eds. Carole Goodman and Claudio Sotolongo (México, D.F.: Trilce Ediciones: 2011), 11.

12. Claudio Sotolongo, "Introduction," in *Soy Cuba: Cuban Cinema Posters from After the Revolution*, eds. Carole Goodman and Claudio Sotolongo (México, D.F.: Trilce Ediciones: 2011), 25. To illustrate this, in the year of 1972 alone, "an estimated total of five million posters were printed." Kunzle, "Public Graphics in Cuba," 92.

13. Emphasis is in the original. Sotolongo, "Introduction," 25.

14. Jessica Stites Mor, "Rendering Armed Struggle," 2019, 43.

15. Heller, "Recalling a Forgotten Treasure," 9.

16. Heller, 9.

17. Heller, 9.

18. The website www.ospaaal.com has a vast collection of these posters available for viewing, neatly organized according to their geographic regions, identifying each designer, year and size of print, as well as the employed technique. There is also a movie section, which at the time of writing did not include the identifiers yet.

19. Heller, "Recalling a Forgotten Treasure," 9. Similarly, Kunzle quotes Fidel Castro, who asserted "our enemies are capitalism and imperialism, not abstract art." Fidel Castro, qtd. in Kunzle, "Public Graphics in Cuba," 90.

20. Heller, 9.

21. In her essay for her book *Soy Cuba: Cuban Cinema Posters from After the Revolution*, Carole Goodman includes a telling anecdote about the interaction with Claudio Sotolongo, her collaborator on the project, which sheds some light on how this paradox could not be more alive today: "Different economic views also played a role in our collaboration. On one visit, I discussed the book publishing process, including the input a publisher might want on the content or design of our book. He thought that was crazy: As authors and designers, we should have complete control over our project. For a moment, I was amazed that he did not understand that a publisher puts up a lot of money to print and distribute a book. In return, they want to ensure that the book would sell many copies, so they could recoup their costs. After hearing my explanation, he felt that I was not a real artist, which I suppose I am not as a designer of things that are mostly commercial and not considered fine art in my culture" (Goodman, "An American in Havana," 19).

22. Goodman, "An American in Havana," 26.

23. Goodman, 15.

24. Goodman, 15.

25. The exhibition was on view from May 8 to November 9, 2015, and was "organized into 14 subsections: focus the eye, overwhelm the eye, use text as image, overlap, cut and paste, assault the surface, simplify, tell a story, amplify, double the meaning, manipulate scale, activate the diagonal, make eye contact and make a system." Laurie Bohlk, "Cooper-Hewitt to Present Special Exhibition «How Posters Work,» Press Release," February 10, 2015, www.si.edu/newsdesk/releases/cooper-hewitt-present-special-exhibition-how-posters-work. Many of the techniques exposed in each subsection can be found in an array of the Cuban posters. The accompanying catalog is also very illuminative as far as the vision process that is part of poster viewing is concerned.

26. Flor de Lis López Hernández, "Cuban Film Posters and the Newer Generation," in *Soy Cuba: Cuban Cinema Posters from After the Revolution*, eds. Carole Goodman and Claudio Sotolongo (México, D.F.: Trilce Ediciones: 2011), 34.

27. López Hernández, "Cuban Film Posters and the Newer Generation," 34.

28. Nelson Ponce Sánchez qtd. in Claudio Sotolongo, "The Phenomenon of Contemporary Cuban Design," interview with Nelson Ponce Sánchez, in *Soy Cuba: Cuban Cinema Posters from After the Revolution*, eds. Carole Goodman and Claudio Sotolongo (México, D.F.: Trilce Ediciones, 2011), 254.

29. Original text: "Los desbarajustes que ya se sentían en la producción industrial de la isla—eje esencial de la película—eran expresados por aquella rueda a la que se le saltan letras que van a conformar las palabras: simbolizando las piezas que apenas conseguirán repuestos. Y eso bastaba para que el posible espectador sintiese el drama y se interesase por la cinta" (Fausto Canel, "Raúl Martínez: el cartel de «Desarraigo» y el mural de la Cinemateca," *Gaspar, El Lugareño*, July 12, 2010, www.ellugareno.com/2010/07/raul-martinez-el-cartel-de-desarraigo-y.html).

30. Original text: "Salvo excepciones la mayoría no alcanzó el impacto gráfico ni la eficacia comunicativa de los períodos anteriores. Casi todo había cambiado para entonces. En la primera mitad de los anos noventa, las carenicas materiales en el país se agudizaron a niveles altísimos y lograron repercutir en la visualidad cubana. Las afectaciones abarcaron todos los sectores de la vida por lo que resultó notable la disminución de la producción cinematográfica nacional en primer lugar y, por consiguiente, la de sus carteles. Durante la primera mitad de los anos noventa, las carencia materiales en el país se agudizaron como consecuencia del derrumbe del campo socialista. Los escasos carteles producidos adolecieron de un recurso que resultaba distintivo: el color, y se perdió la coherencia y continuidad en la promoción cinematográfica. La visualidad cubana se resentía ante la ausencia de imágenes que en otros tiempos resultaban habituales para su renovación" (Sara Vega, "Soy Cuba, de cierta manera," 76).

31. Laura Susan Ward, "A Revolution in Preservation: digitizing political posters at the National Library of Cuba," *IFLA Journal* 31, no. 3 (2005): 261. According to Ward, "the majority of the posters date from 1963 to 1989, during which Cuba's socialist government had an ongoing policy of communicating its messages through poster art. The poster genre gained currency early in the Revolutionary period, since posters were easily made, cheaply produced, and held the possibility of almost unlimited reproduction and consumption by a mass audience" (Ward, "A Revolution in Preservation," 261).

32. The same goes for the layering of colors, as Goodman affirms: "They are silk screened with screens that are individually and painstakingly cut by hand (photo chemicals are not readily available in Cuba), with some posters requiring up to 12 screens, depending on how many colors are necessary to print the piece" (Goodman, "An American in Havana," 15).

33. Coudrelle, "Revolutionary Design: The Cuban Film Poster."

34. Coudrelle.

35. Sotolongo, "Introduction," 26.

36. Original text: "Yo estaba de pie y al lado mío había dos jovencitas que también viajaban de pie. Eran muy graciosas, pero sostenían unas conversaciones muy tontas que a mí no me interesaban. Pero hubo un momento de lucidez por parte mía y fue tratar de encontrarle significado al diálogo de estas dos muchachas. Escuché entonces que una le dijo a la otra: Creo que se me corrió la pintura labial. Yo oí esto que se refería a algo que no está en su lugar, que se ha desplazado. Y me percaté de que la expresión de esta chica me había intrigado. Entroncaba además con una cuestión que yo intentaba resolver, y que era dar la evidencia del desplazamiento, de acuerdo al título de *Besos robados*" (René Azcuy qtd. in Carlos Espinosa Domínguez, "El diseño gráfico como creación y profanación," *cubaencuentro.com*, December 16, 2016, https://www.cubaencuentro.com/entrevistas/articulos/el-diseno-grafico-como-creacion-y-profanacion-328094).

37. Sotolongo, "Introduction," 27.

38. Kunzle, "Public Graphics in Cuba," 92.

39. Sotolongo, "Introduction," 28.

40. Alejo Carpentier qtd. in Manuel Morales, "Al son del cartel de cine de Cuba."

41. López Hernández, "Cuban Film Posters and the Newer Generation," 35.

42. López Hernández, 32.

43. The emphasis is in the original. Coudrelle, "Revolutionary Design: The Cuban Film Poster."

44. "Sometimes artists will illustrate film themes in a broad sense and produce an attractive abstract or semi-abstract design which may be inherently superior to the film itself (example: Reboiro's jazzy poster evoking the effect of fire, for a worthless English film about a pyromaniac called *El Camino al Infierno*)." Kunzle, "Public Graphics in Cuba," 92.

MEANINGFUL POSTERS AND POSTCOLONIAL MELANCHOLIA

Black Girl, Touki Bouki, and Cuties

VLAD DIMA

This chapter explores the diegetic and extradiegetic meanings created in and around the promotional poster of the first "African"[1] film, Ousmane Sembene's *La Noire de . . .* (*Black Girl*, 1966), and then briefly considers the relevance of two more posters, for Djibril Diop Mambety's *Touki Bouki* (*The Journey of the Hyena*, 1973) and for Maïmouna Doucouré's *Mignonnes* (*Cuties*, 2020). First, in Sembene's case, the promotional Senegalese poster acts as a semiotic negotiator between the original short story, film, personal identity (for character, actor, and director), melancholia, and postcolonialism. Second, between June and October 2018, Beyoncé and Jay-Z—two of the world's biggest stars—performed their latest world tour, titled *On the Run II*. Intriguingly, their marketing poster and the promotional video offered an almost identical copy of the poster for Mambety's *Touki Bouki*. Third, and most recently, Doucouré's *Mignonnes* created an enormous controversy on social media, when Netflix decided to change the original French poster, going from an innocent photo of the preteen heroines running around happily to a hyper-sexualized image from one of their dance competitions. While, to reiterate, the focus of the chapter will be on Sembene's poster, as well as on the groundbreaking film and original short story, the other two images will be used as concluding support for the continued persistence of a multi-faceted postcolonial melancholia into the twenty-first century.

In other words, by focusing on these posters, we can trace the creation of melancholic meanings that travel back and forth between Global North and Global South, thus exceeding the boundaries of the films, while also retroactively affecting the meanings within the films.

Ousmane Sembene's *Black Girl* is adapted from the eponymous short story first published in the collection entitled *Voltaique* (1962).[2] The plot in both versions revolves around Diouana, a young Senegalese woman, who takes a job as a nanny working for a white French family; she moves to the south of France, but following months of mistreatment, and after becoming increasingly disillusioned with the reality of postcolonial France, she takes her own life. I intend to connect the two versions through an extradiegetic visual element—the promotional Senegalese poster—that acts, to reiterate, as a semiotic negotiator between short story and film. Thanks to this poster, meanings are created through three different mediums (literary text, film, and poster), all of which work together to build up a unique version of postcolonial melancholia. It may be worth noting that oftentimes, Sembene's films showcase intradiegetic posters that carry a double semiotic value: they signify internally, within the frame of the film, and they also *mean* externally, when placed in a larger social context. I believe that by focusing on the "external" poster first we can trace a similar binary relationship, but in reverse. In other words, we begin with the wider historical context and then uncover the internal meaning of the poster in relation to the film and short story. As a result of this reversal, the intrinsic melancholia of the three mediums is itself externalized and projected back onto a broader sociohistorical context, which in essence creates a closed loop—an apt metaphor for the ongoing condition of the postcolonial Subject.

Let us begin with the *Black Girl* promotional poster, which is a relevant venue of discussion because of an undeviating insistence in Sembene's films to focus on what we find on the walls, in the rooms, and in the houses of the diegetic characters. Normally, these posters include remarkable historical figures of the colonial past or of the (post)colonial confrontation. In *Black Girl*, while in the room that belongs to Diouana's boyfriend, we see a poster of Patrice Lumumba (Congolese independence leader), which anticipates the film *Emitai* (1971) and its depiction of the colonial army. In *Xala* (1975), the character Rama has posters of Amilcar Cabral (Guinea-Bissau) and Samori Touré (Mali). She also possesses a poster of Charlie Chaplin, but unlike the previous images, all of which are on the walls, the Chaplin poster is glued to Rama's door, making its appearance dependent on whether or not the character closes the door. When she does, the image of the Tramp surprises the audience—a joke, if you will—because its relation with the

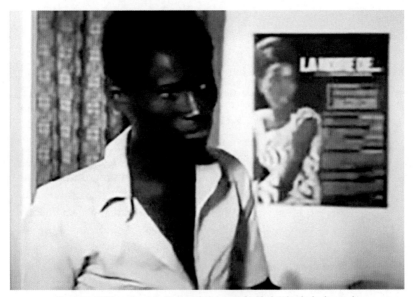

Figure 6.1. Still from the end of *Xala*, with the poster for *Black Girl* in the background.

colonial/postcolonial historical figures is not immediately clear. Yet Chaplin has had a significant cultural and cinematic influence on several sub-Saharan directors, Mambety and Mahamat Saleh Haroun (to mention but two others). Given the placement of the poster on a literal door, one could make the argument that Chaplin opened the (metaphorical) door for these directors to consider careers in filmmaking. Perhaps also as an "inside" joke, at the end of *Xala*, Sembene clearly showcases the exact poster discussed in this chapter (see figure 6.1). Moreover, El Hadji's son makes a very deliberate *second* gesture to push the door wider open, in order to reveal another kind of surprise: the "external" poster of *Black Girl* turns out to be intradiegetic. This unusual intertextual inclusion solidifies the argument that the poster carries significant semiotic value at several levels. Within *Xala* it functions as a reminder and a melancholy return to the director's first feature-length film. It also serves as a humorous interruption and as a counterpoint to the very tense ending, perhaps lending support to the idea that El Hadji's nauseating punishment is, in fact, a positive outcome for him and his family. On a larger level, the poster transgresses the diegetical limitations of *Xala* because it *is* a promotional poster, and therefore it belongs to the public, to the community. In other words, it brings forth a collective type of (postcolonial) melancholia. Even if it was not Sembene himself who created it, there is a good chance that he had agreed upon it because the production and distribution company that released the film, Filmi Doomireew, was actually owned by Sembene

himself.[3] This material connection with the poster further justifies its inclusion in this analysis.

The examples of intradiegetic posters really abound throughout Sembene's films. In *Faat Kiné* (2001), the title character's house is adorned with portraits of Mandela (South Africa), Thomas Sankara (Burkina), Kwame Nkrumah (Ghana), and Amilcar Cabral again. The list could continue, but the focus here is the poster for *Black Girl*, which, given this quick background on Sembene's relation with posters, becomes more than a simple marketing device meant to enumerate the film's festival prizes and reviews. All the posters mentioned above amount to a running motif throughout Sembene's work. Their presence links the majority of his films extradiegetically, generating additional meanings meant for both real-time audiences and for the wider public. These posters have meaning individually, in the moment (e.g., an homage to Mandela), but also when taken together (i.e., they generate a tapestry of the colonial and postcolonial struggles). Moreover, when it appears in *Xala*, the poster for *Black Girl* becomes the only self-referential example in Sembene's oeuvre, as the director jokingly "winks" at the people who may be familiar with all of his work. As a result, this poster must not be "consumed" only for its marketing value, but also for its melancholic value and for the gaps of meaning that it might be trying to fill.

In the poster for the film, we see the main character, Diouana (played by Mbissine Thérèse Diop), to the left of the frame. She is looking off to the right with a vaguely melancholy expression on her face. She is wearing her Sunday dress, white, with vertical strips made up of black leaves. The whimsical and suggestive play elicited by the alternation of black and white is a running motif in the mise-en-scène of the film. In this particular case, the dress takes on a figurative meaning because of its vertical lines that resemble prison bars. Furthermore, it is sadly ironic that Diouana's best outfit, her fancy dress, also carries the connotation of enclosure (this interpretation makes more sense in the short story, which explains that the dresses are gifts from Madame—a poisoned gift). The Sunday dress is matched by her white earrings, as well as the obvious attention dedicated to the hairstyle. The relevance of the dress becomes even more apparent at the beginning of the film, when we see Diouana wear a similar outfit, but bearing a crucial, different detail. There are no black lines on the dress; instead, it features black polka dots, which are far less aggressive than the lines, and could suggest happiness, maybe even lightheartedness and freedom. However, she loses that freedom when Madame demands that she change her outfit, which she had been wearing for three weeks while doing house chores. In fact, her refusal to take off the fancy dress further suggests imprisonment. She may be stubborn, of course, but the

dress that was supposed to be the symbol of her financial freedom becomes instead a symbol for her repetitive work as a maid. After three weeks wearing the same outfit, the outfit becomes more of a uniform, a prison uniform. The dress seen in the poster does eventually appear in the second part of the film when it has already been established that she is unhappy and trapped in an unfortunate situation. In sum, the subtle changes in Diouana's dress further underline her perceived inferior social status.

Besides the telling gaze in the poster, there are a few more facial details worth mentioning. Diouana's lips are barely open, not quite in a smile, not quite in a frown, but enough to see her perfectly white teeth, which create yet another contrast between white and black, between her skin and her mouth. The same contrast is at play in her eyes, and also stemming from the spot-lights focused on her face (although the light coming from her left appears to be natural). It is not quite a chiaroscuro effect, but it is established unequivo-cally that the race issues at the core of *Black Girl* surface even through a still picture. Given that the short story and the film are both concerned with these sensitive issues of race and the rapport between the (ex)colonizers and the (ex)colonized, the poster also addresses these tensions, and not quite so subtly. I have already mentioned the placement of Diouana in the poster, to the side of the frame. Sembene's characters are often decentral-ized, framed either to the right or the left of the shot in order to underline that they dwell at the margins (the main characters of *Xala* and *Guelwaar*, 1992, are good examples of this practice). Diouana fits the same profile, and Françoise Pfaff observes that, in the film version, she encounters hostility almost everywhere she goes except for her own neighborhood, which is her private space.[4] Nevertheless, she is rarely seen in that space, so she is further pushed to the margins. These could be the margins of a neighborhood, a city, or furthering the metaphor, the margins of society. Almost naturally, then, the placement of the film character to the left side of the poster frame echoes her actual position in a French society, as opposed to what and where she imagined she would be.

The poster also raises an intriguing issue because it is split right down the middle between the actual character on the left, and a block of written accomplishments on the right. Toward the top we have the title, with its vague possessive preposition "de" (the English translation, *Black Girl*, loses this ambiguity), and the ellipsis meant for the viewer to decide to whom or to what she belongs. If we make abstraction of the written word, the text printed on the poster, then we could discuss the negative space of the photograph/poster. In photography, negative space is really empty space, the space that engulfs the actual subject of the photograph, and it is meant

to emphasize said subject or to become a subject in its own right. In this case, the obscurity that surrounds Diouana points clearly to the dark path on which she has embarked. Another important observation here is that Diouana lacks a physical background, which is replaced by the negative (black) space. This lack generates the impression that the woman emerges from nothingness, that she levitates somehow in a void (or sinks into it).[5] The placement in the void, along with a plethora of other connotative signs, elevates her to the status of a myth reminiscent of, but not quite equivalent to, Roland Barthes's famous reference to the *Paris Match* cover photo of a young Black soldier in French uniform saluting.[6] That photo's symbolic message, what Barthes "sees," is that France is a great empire that does not discriminate, an empire united under the faithful service of its children, regardless of race. Naturally, Barthes considers the photo to be propaganda because in reality the sociopolitical actions of the empire are diametrically opposed to the symbolic message of the photo. The poster of Diouana, then, could offer a glimpse into actual reality: people of color, and Black women even more so, are not really a contributing part of the empire, and they are not the sons of a nondiscriminatory empire. The split between the written words on the right representing the imperialist culture (the poster lists the film's accolades, so in other words, what it has conquered, symbolically), and Diouana as a colonial subject on the left clearly separates empire and its subject unlike the photo from *Paris Match*.

Speaking of (Barthian) myth, we also cannot completely ignore the writing on the wall (on the poster), as it were. "The Text is a methodological field," wrote Barthes,[7] and perhaps "forced" meanings should be avoided, or at least one should avoid what structuralist Gérard Genette called unity at all cost.[8] However, to me, there is a strange, subtle unity at work here between the negative space beneath the words and the positive message of all the accomplishments above the black background. There are many ways in which to analyze this juxtaposition, but the meshing of negative space with the writing, which renders the writing itself negative space, must be taken as significant. In other words, the writing takes on a negative connotation, it is superfluous, and not the "parasitic on the image"[9] type that alters the meaning of the photo. The negative association with the words on the right further emphasizes my claim that Global North (represented by the writing and archiving of history) and Global South (represented by Diouana) are being separated on this poster; this clear-cut dichotomy is very much in line with Sembene's early work, *Black Girl* certainly, but also *Borom Sarret* (1963), which constructs a narrative out of juxtapositions (poor vs. rich, outskirts of Dakar vs. the *Plateau*, life vs. death, Mozart vs. the *xalam*, etc.). Ultimately,

and by elimination, the only thing that matters on the poster is the (postcolonial) object-subject paradox: object because she is on display, and (seeing) subject because the woman looks off toward an unknown destination.

However, the lack of suture (the audience does not see the unknown destination either, so to whom agency belongs is less clear) prevents Diouana from becoming a full-fledged subject. Like her gaze, the subject is suspended, and it levitates. The direction of the gaze toward the unseen and unknown and the ensuing state of the subject are what triggers a melancholy element. Once the gaze gets lost somewhere outside of the frame, it foreshadows the subsequent trajectory of Diouana's story. What she searches for is not real, it does not exist to us, the spectators, or the people looking at her poster. Diouana has an impossible (is there any other kind?) ideal, which traps her in an unforgiving melancholy phase.

On occasion, Diouana's gaze does have a target, as in one of the more telling moments of the short story. Diouana, still in Dakar, looks out the window and is suddenly lost ("transportée")[10] in thoughts and in the beauty of the view. Sembene brilliantly connects the figurative meaning of the term "lost" (or "transported") with a subtle image of Gorée Island, barely visible at the horizon.[11] The link between Diouana's momentary loss and the island suggests that she is to be literally transported away, as slaves were during the Middle Passage, through the (mental) hub of Gorée, and in the end, that is exactly what happens. Gorée Island is one of the archetypal symbols of slavery, an island off the coast of Dakar from whence thousands of future slaves were sent to the Caribbean.[12] The island can function also as a sort of trigger for an entire nation, bringing forth collective melancholia. In this instance, we have one of the clearest examples of Sembene externalizing melancholia, which permeates the fabric of the Senegalese society and by extension that of West Africa, and perhaps of the entire continent.

Paul Gilroy unifies melancholia (in the case of Britain) under what he calls "postcolonial melancholia," which suggests that the colonizers have yet to face and accept the fall of the empire following the rise to independence of the African countries in the 1950s and 1960s.[13] It is by considering Gilroy's groundbreaking work that Cameroonian philosopher Achille Mbembe comes up with the word "horizontalité," meant to express the need for "horizontal thinking" across the world (i.e., Global North and South should be on equal, intellectual footing).[14] Furthermore, and somewhat in opposition with Gilroy as she shifts the focus away from the colonizer, Ranjana Khanna's work on the Algerian female postcolonial subject, violence, and representation identifies melancholia as a presence in the everyday life of the postcolonial subject,[15] which then extends to the collective, giving everyone

critical agency. In Diouana's case, the island fills in the role of a constant hovering presence, but it is a paradoxical presence: on the one hand, it may fill her heart with positive emotions as she thinks about her "home," the home she is about to trade for France, and on the other hand, it reminds us all of the unrelenting colonial past and of the emotional and historical gaps that need to be filled.[16]

Gaps or emptiness, as it so happens, may already partially define the postcolonial subject. At the beginning of his fundamental study *Critique of Black Reason*, Mbembe describes the "Black Man" as "powerfully possessed by emptiness."[17] Later in the book, Mbembe returns to the idea of emptiness, which he attaches to uttering the word "Africa" out loud. In his words, this pronunciation "identifies a certain litigious figure of the human as an emptiness of being, walled within absolute precariousness."[18] To reiterate, on the poster for the film, Diouana faces emptiness too, as she gazes off "transportée" to an unidentified spot off-camera and in the extradiegetic. Perhaps the object of her gaze is still the island—a historical lens through which she glances into the past—or perhaps it is simply emptiness, as her point of view cannot be revealed (this being a still photograph). In the film, too, as she turns increasingly exasperated with her situation, Diouana stares at unidentified spots off-screen, and she especially gazes at the ceiling, as if trying to invoke a higher power. Those largely unidentified targets of her gaze seem to further increase the feeling that she finds herself in a literal prison. Moreover, a wider metaphor for the (post)colonial subject takes shape now: there is no material target or place for where one might be headed and there is no option to extricate oneself from the (post)colonial prison.

Even though he was mostly concerned with the theory of cinema, André Bazin's ideas about the temporal quality of photography may indirectly underline the ongoing postcolonial struggle: just as photography "embalms time,"[19] the memory of colonialism might also be "frozen" and thus preserved forever. We can always return back in our own history and revisit an old image of a lost self. In the case of the postcolonial, that old image is nefarious—an image of slavery. The memory of past times is embalmed in photos, impossible to escape, and Sembene's poster, too, acts like a specter.[20] Susan Sontag also mentions history in her famous analysis of photography by suggesting that it became so popular in the United States, for example, because it was able to replace things, historical things that the Americans never had.[21] In the case of the postcolonial, photography does not replace but rather reinstates painful historical realities. During this repetitive process (a closed loop, once again), a relentless and punishing type of melancholia ensues.

The historical and temporal aspects of photography are quite distinct in the context of a colonized country like Senegal that attempts to first erase the memory of the colonizers' presence, and then second to reconstruct history from the (ex)colonized people's perspective. In his recent book, *How the Word Is Passed, A Reckoning with the History of Slavery across America* (2021), Clint Smith interviews the Gorée House of Slaves curator, and the latter expresses the desire to "use education to deconstruct, in order to reconstruct . . . Africans have to know that the starting point was Africa."[22] The goal of reconstruction has been a laborious process that began in 1960, the year of Senegal's independence, and it is a fight carried out on several levels. In intellectual and representational terms, though, that goal of reconstruction has only recently gotten more vocal support in academic writing about the Global South, as we are finally learning to listen more intently to indigenous scholars.

Not only has the continent's history started well before colonization, of course, but in the eyes of thinkers such as Achille Mbembe or Felwine Sarr it is really about to partially overcome the trauma of colonization and come into its own, perhaps even becoming a new economic and intellectual center for the world. In *Sortir de la grande nuit* (*Out of the Dark Night*, 2013) Mbembe places Africa at the center of the world, and sees the continent as a catalyst for change.[23] Moreover, this is from where a "pensée-monde" (a thought-world) begins to take shape, as the continent positions itself as an intellectual powerhouse. Obviously, his intimation is that the best is yet to come for Africa. Economist-turned-cultural-writer Felwine Sarr also considers the bright potential of Africa to turn into the "future Eldorado of global capitalism."[24] While both theorists anticipate a better future for the continent, Ousmane Sembene had long before staked a claim on the value of his intellectual and artistic production. In the documentary *Caméra d'Afrique* (1983), Tunisian filmmaker Férid Boughedir asks Sembene if Europeans understand his films. In response, the latter adamantly declares that the Old Continent is "not my center. . . . The future does not depend on Europe." Moreover, Sembene uses a beautiful metaphor to reject the idea that he needs to follow the "light" of Europe, as he is not a "sunflower." Instead, he proudly and bombastically puts himself (and by extension, the continent) not only at the center of the world but at the center of the galaxy: "I myself am the sun."

Nevertheless, the process of building up the continent into a true peer of the Global North (i.e., having this be accepted as a fact in the Global North, rather) has been unfortunately slow. Furthermore, this process should not rely on drastic separations. Instead, sporadic exercises in horizontality may still be needed—exchanges and dialogues between Global North and South voices. In Senegalese history, then, photography and Sembene's poster

in particular function as temporal markers (in the way meant by Bazin, a Global North writer), but they do not replace historical things (as suggested by Sontag, another Global North writer). Instead, to reiterate, they are actual historical indicators themselves and constant reminders of a tumultuous past and the process of decolonization that has led to severe spatial fragmentation.[25] Sembene's writing and filmmaking sensibilities are both affected by the fragmented framework of this space, which is extremely conducive to the nurturing of melancholia because it thrives on loss (the space between fragments). Sembene's literary and cinematic melancholia(s) are indeed symptoms of the contemporary historical conditions. This is a reprise of Ross Chambers's argument on early French modernism,[26] which obviously has little in common with Sembene. However, a comparable (political) disillusion to the one that plagued nineteenth-century France had to burgeon in postcolonial Senegal, particularly during the contentious Senghor years.[27]

Melancholia's pervasive presence in Diouana's life underlines the fact that it is the appropriate link between the three texts, written, photographed, and filmed. The photograph/poster brings together the two other texts through its intrinsic quality of an "elegiac art" form.[28] The elegy is the poetic form quintessentially dedicated to death and to the dead, which in turn, circle us back to melancholia. In the short story, it is suggested by the French family that Diouana was depressed because of melancholia, and in fact the little excerpt from the paper that announces her death says it quite bluntly: "A Antibes, une Noire nostalgique[29] se tranche la gorge."[30] The short story has a flashback ("sombra dans ses souvenirs"[31]) early on that also suggests a return, a melancholy search for the lost object. In the film there are two flashbacks, but they both occur once Diouana is already settled in France, and she begins to miss her city. During the first flashback we learn that she was a nanny and how she came to be offered the job; in the second one, we revisit her brief love story with a young man right before her departure. The question of whether or not that is true in the case of Diouana is not easily answered. In fact, I think one could argue that she suffers simultaneously from concepts that Freud actually split, mourning and melancholy. The former is the "normal" way of dealing with loss, while the latter is the pathological response of the patient. More in depth, Freud describes mourning as "the reaction to the loss of a loved person, or to the loss of some abstraction which has taken the place of one, such as one's country, liberty, an ideal, and so on."[32] Khanna's analysis of postcolonial Algeria is centered around loss, too: "Both mourning and melancholia involve the ingestion of a lost object."[33] In this case, the loss stems from an "accumulated loss: the loss of the national ideal."[34] Diouana never formulates a national ideal pertaining

to Senegal. Instead she constructs a foreign ideal, and as a result she ends up facing two distinct losses. On the one hand, she is completely removed from her country, and on the other hand, she also loses the French ideal, which she never really possessed, and yet loss becomes an intrinsic part of her, of her *as* the Postcolonial Subject. One final note here: another element that underlines the idea of loss is the use of voice-over. The nature of the voice-over, as a quintessential disembodied presence, is to float and essentially disappear right away, never fully materializing. Through the ephemeral medium of the voice-over, Diouana constantly reflects on what France really is, but also on her own life and destiny, on who she is, and what her role is in the world. These thoughts lead her to melancholy, depression, and ultimately her death.

Contrary to the film, which follows a more linear pattern, the short story begins after the death of Diouana. The first paragraphs begin slowly with a description of the setting, then of the street, and of the house belonging to the French family. The reader eventually enters the private space of the family when the words "inside the villa" mark the start of a new paragraph. This progression from general to very specific reads as quite cinematic. It mirrors very closely the practice of going from an establishing shot to an extreme long shot, to a long shot, and eventually all the way to a close-up, as a way of situating the cinematic subject in a proper context. Once we are inside the house, in the living room, we finally learn that the "bonne"[35] had killed herself in the bathtub, and someone had just found her body. During our cinematic descent into the private space of this family, nothing out of the ordinary announces this death, so then to the reader, it comes as a shock. A series of words in the family of crying, though, begin appearing on the second and third pages of the short story: "sanglotaient," "larmes," "se moucha," "s'essuya," "pleurait."[36] Eventually, the drastic narrative fall is completed in a violent swoop: "la gorge tranchée d'une oreille à l'autre."[37] This fall provides us also with an opportunity to link the beginning of the story to the poster for the film. I want to advance the theory that Sembene uses a literary negative space technique in order to surprise the readers. The entire beginning of *Black Girl* is perfectly unassuming and quiet, much like the black negative space of the poster. The result is that the gory conclusion is further accentuated through the sharp contrast that was just created. On the poster, the negative visual space helps direct our attention onto Diouana, while in the short story the negative narrative space achieves a similar effect concerning her death.

Going back to Diouana's (empty) ideal, the short story directly addresses her desires, when she decides to leave Senegal: "Diouana voulait voir la France et revenir de ce pays dont tout le monde chante la beauté, la richesse,

la douceur de vivre. On y faisait fortune. Déjà, sans avoir quitté la terre d'Afrique, elle se voyait [. . .] riche à millions."[38] The dream is the same in the short story and in the film; however, an important difference is that in the film we can follow Diouana's inner voice, which doubles as a voice-over, and this choice by the director brings us closer to the character, even though the character herself ends up split across visual and aural planes as a result. In the short story, the omniscient narrator allows himself to even pass judgment on the gullible maid, and that undertone may keep the readers a little removed from the character. The ideal is slowly but surely lost as her happiness dissipates and a metaphorical poison (matching Madame's poisoned gift) begins to ail her heart, and her reaction is to "fuyait en elle-même."[39] This retreat is very similar to Freud's devouring melancholia, a devouring of the self in an attempt to retain the lost object/ideal and, naturally, failing. In the film, her ideal (to find a better life in France) remains the same, but Madame destroys it immediately. After showing Diouana the French Riviera from the window, she abruptly declares "maintenant nous allons voir la cuisine."[40] Diouana descends rapidly from the (utopic to her) beauty of the French coast, to the reality of the job, and to the enclosure between four walls, in which she is shown on several occasions. The content of the scene is fully supported by the visual construction of the mise-en-scène and the artistic choice of a wipe. The right-to-left wipe effect used as a transition between shots supports the eradication of Diouana's dream and ideal, which are quite literally then, erased.

The mise-en-scène setup of the scenes in the kitchen and in the bathroom continue the trend of playing off the contrast between white and black, which the poster underlines and which is heavily present throughout the short story, too. In the film, the slight high-angle shots, and also steeper high-angles employed when Diouana cleans the kitchen floor, suggest the main character's subaltern societal position. Diouana is thus rendered physically smaller. She is also described by the white friends of the family in a demeaning way, as they call her an animal who understands and speaks the French language only "instinctively." Furthermore, the floor in her room is painted in black and white stripes, so the subliminal message is once again that Diouana is imprisoned in that house. This prison mirrors the metaphorical enclosure already discussed in the analysis of the poster, and the role that the striped dress from Madame plays. In fact, as mentioned above, Diouana finally changes into the dress seen in the poster while in her room. So, when she gets up to leave the room, we can observe both the vertical lines on her dress and the horizontal ones on the floor, which brings together the two semiotic elements that suggest imprisonment, just in case we had missed

their individual meanings. The camera pans down to her feet, and as she walks out, it tracks her movement focusing solely on the shoes. She is no longer human, as the weight of the postcolonial crushes her, and Sembene's camera reduces her to an object, in this instance, the shoes. Toward the end of the film, Monsieur pays her monthly wage, but when she receives the money, she suddenly collapses to the floor. She sobs on her knees, and again, she is shot from a high-angle, which allows the audience to revisit the horizontal lines of the floor. Diouana has been vanquished, reduced to the fetal position (i.e., moving backward in one's history, from adulthood to birth) in her French prison. Several other details contribute to the ongoing black and white dichotomy: even the whisky consumed by the head of the house is labeled "Black and White," and of course, in the final shot of dead Diouana, her black body contrasts sharply with the white bathtub. The constant reminders of the opposition between black and white are in place to sustain a racial discourse that is not even attempting to be subtle; Sembene goes back repeatedly to the extradiegetic importance of this meaning to make sure that the audience is hyper aware of it.

Sembene's filmmaking and writing are seldom subtle, as he favors directness, and in the case of *Black Girl* that quality steadily aligns the feelings of the author with those of the character. According to Julia Kristeva, there is an intrinsic relation between melancholia and specific writing about melancholia because this type of writing must have emerged from or have been generated by the same melancholia.[41] Ross Chambers also supports this particular view: "writers naturally asked themselves how to write and what kind of work to create that would convey the feeling of dislocation and lack of center, the dispersion of being, the haunting sense of failure, error, and wasted opportunity. Such writing could only be a work of melancholy."[42] The lack of center in the poster and Diouana's general sense of failure were both noted above. Her failures and wasted opportunities must mirror the writing and filmmaking of the author himself. Sembene's writing also comes from suffering, and returns to suffering in the form of Diouana. According to Kristeva suffering can be understood as a form of power, too,[43] and in this context the power comes from Sembene's ability to manipulate suffering. He first internalizes it, and secondly, he externalizes and projects it onto the character.

A similar type of melancholia can be traced at the beginning of the film version. If melancholia can materialize out of the writing itself, then it should emerge equally strong from the act of filming. The first shots are of the famous *Ancerville* ship[44] that travels between Dakar and the south of France, but, immediately following the credits, the audience finds themselves in the harbor and the camera tracks two men docking the ship. Among a variety

of jobs, Sembene famously worked as a *docker* in Marseille, and his first novel was born out of that particular experience (*Le Docker Noir*, 1956).[45] The beginning of the film then could be construed as a melancholy attempt to re-appropriate the director's lost memory, or lost object, a melancholic residue, as Khanna expresses it.[46]

Another melancholy return, perhaps verging on the nostalgic, is Sembene's cinematic homage to the Lumière brothers. In two different episodes, the camera follows Diouana's gaze as she observes a sprinkler going off, once manned and once unmanned. In the first instance, she is in the yard at Madame's house in Dakar, and her eyes twice move away and then back to the sprinkler. The repeated gesture and POV shot of the sprinkler mimic the rotatory movement of the latter, which turns into an inventive copy of the rotational, early movement of the Lumière *cinématographe*. In the second instance, Diouana and her boyfriend look at a man watering a lawn in downtown Dakar. The three total shots of (narratively irrelevant) sprinklers amount to a veritable visual spotlight, as Sembene invokes the first comedy in the history of cinema, the Lumière film *L'Arroseur arrosé* (1895, *The Sprinkler Sprinkled*), in a reflexive cinematic moment that echoes the beginnings of cinema.

Nevertheless, Sembene's melancholic residue might actually be best observed in the last shot of the film, as Diouana's young brother reveals himself from behind the mask that Monsieur had brought back to Dakar (he brings back Diouana's suitcase, too, as she might re-materialize in two other objects besides the shoes—mask and suitcase—the latter literally containing everything she had owned). Perhaps Sembene saw himself as the young boy, or as the young voice of "African" cinema (at the time), or perhaps the last shot points to a futile attempt to reclaim what was lost, namely, youth. So, at the end of the film we have yet another attempted return. The last shot, as the mask disappears below the frame, is also quite static, which could be an implied return to photography, and an attempt to dissociate from the moving image. The effect of this artistic choice strengthens the connection with melancholia, which is no longer fleeting but rather fixed and captured. The film is down to its last frame: a photograph that functions like a (melancholia) net. So, the three elements that construct the narrative structure of *Black Girl* and the attached melancholia come together in this last shot. Photograph, moving image, and writing tell the same story, but they filter various melancholies associated with Diouana, Sembene himself, the colonized subject, and ultimately, Senegal and postcolonialism.

In lieu of a traditional conclusion, it may be worth addressing two extradiegetic "stories" that might prove the continued influence of the colonial into the new century. The first is connected to the poster for Mambety's

Touki Bouki, which shows the two main characters, Mory and Anta, on a motorbike, looking off to an unspecified target (not unlike Diouana) to the left of the frame. The second is about the changes that Netflix made to the promotion of Doucouré's *Cuties* (2020). Both yielded controversies, or "viral stories," that show how the postcolonial has found new ways to stay ever relevant into the twenty-first century. Setting aside the pointless debates between "neocolonial" vs. "postcolonial," the creation of a film such as Mati Diop's *Atlantics* (2019), a film that represents an original kind of the return of the dead (symbolizing the unrelenting trauma of colonialism and slavery), is a strong signal that post/neocolonialism is still a source of interest to filmmakers.[47] If anything, the postcolonial has simply extended its spatial reach and had engulfed the rest of the world (i.e., it is no longer localized, or restricted only to spaces that had been colonies). According to Laila Amine, postcolonialism in France occupies a "peculiar place,"[48] and the confusion elicited by the academic convergences and divergences over terms such as "Francophone" and "postcolonialism" have led to "the absence of a postcolonial Paris."[49] Amine's brilliant book *Postcolonial Paris* (2018) aims to rectify this omission and "it resists the idea that colonial analysis is relevant only to other colonial contexts."[50] The result, then, is that the city of lights is an eminently postcolonial place and revisiting it with this perspective in mind may "produce new vantage points on stories we thought we already knew."[51]

In Mambety's *Touki Bouki*, the city of Paris is referred to on several occasions thanks to the haunting chorus of Josephine Baker's song "Paris, Paris, Paris." To remind us, the two main characters want to emigrate to France, but in the denouement of the film, Mory stays back, while Anta embarks on the *Ancerville* headed to Marseille, as Diouana once was, too. Baker's song, a melancholic tune if there ever was one, punctuates four crucial moments in the plot of the film—the beginning, the theft of a "treasure" chest from the stadium, buying the boat tickets and then entering the Dakar harbor, and the ending—but its purpose is far more nuanced and complicated. The song seems to address the characters directly, and they appear to actually listen to it, although it is clearly a song meant for the nondiegetic space of the soundtrack. In other words, the song and by extension Paris directly *affect* the characters. It should be noted that the image of the poster is taken at a moment when Baker's song is heard on the soundtrack. In fact, Mory and Anta may be looking off *at* the song they are hearing, which materializes for them the vision of Paris.[52]

It is the connection to music that generates an internet scandal. To reiterate, between June and October 2018, the Carters performed a world tour, titled *On the Run II*. The marketing poster and the promotional video offered

an almost identical copy of the most memorable frame from Mambety's *Touki Bouki*: Anta/Beyoncé and Mory/Jay-Z on a motorcycle whose handles are adorned with large zebu horns. The only perceivable difference was that the Carters opted for stylized black-and-white rather than color, which is a nostalgic return to earlier forms of representation. It was not immediately clear why they would opt for this reference.[53] One could speculate that it was simply the choice of their marketing team and the singers blindly approved it. However, when critics called the use of the image into question,[54] the two stars explained that they wanted to increase the awareness of Americans about film from the African continent. Of course, this would not be the first time Beyoncé has made African references in her work: she alludes to Yoruba culture from time to time, her backing vocalists speak Swahili at the very beginning of her lead single "Spirit" for the *Lion King* (2019) soundtrack, and she wears outfits made in Dakar in the video for the same song.[55] The concert itself showcased a video component that broke off the singing segments. In these videos that seemed to be fragments from a longer film, Jay-Z and Beyoncé are "on the run," much as the characters of Mory and Anta are in Mambety's film. The complications of the Senegalese couple (i.e., Mory stays back and Anta leaves) mirror those in the real life of the Carters, made vividly explicit by Beyoncé's *Lemonade* (2016). Diegetic and extradiegetic clash once again, and, looking backwards, one could also reconsider the original meaning of the poster for *Touki Bouki*, which may have now changed: perhaps Mory and Anta look off in different directions and the poster foreshadows their eventual split.

A much more problematic story develops when Netflix's choice of a poster for Doucouré's debut film caught the attention of right-wing politicians. The controversy had to do with the over-sexualization of young female bodies, when in fact, for those who actually watched the film, Doucouré offers a strong critique of media's influence on young minds. To be certain, there are moments in the film when the camera might linger too long on intimate parts of those bodies and thus objectify them, but taken as a whole, the film is a coming-of-age story that places girls at the center of the narrative and sheds light on several problems we all face as a society. The main character, Amy, who is only eleven, becomes enthralled with a group of equally young twerkers who hope to win a dance competition. The beauty of the film lies in Amy's paradoxical odyssey: she may live in a world that seems more open, full of possibilities (at least as the internet constantly reminds her), but she is simultaneously bound by the religious traditions of her family and by the gender-normativity of the society at large (including those right-wing American politicians, extradiegetically speaking).

Doucouré beautifully sets up this contrast by showing Amy and the other girls in wide-open spaces, as they practice their dance moves, but also by framing Amy very tightly in close-ups, as she hides herself in several different instances: under the bed, in the closet, in the bathroom, and most memorably right in the middle of a prayer session led by her Muslim mother. In this instance, while the women around her sway to the prayer, Amy draws the cloth over her head, and then the camera moves with her inside this tiny space. In here, she watches a video of professional dancers twerking, while listening through headphones, which, in turn, further limit the space around her, because they are faintly heard by the audience, too. Then, Doucouré exits this small private space to show the entire group of women one last time, with Amy placed right in the middle. Everyone sways, but importantly, it is to different tunes. Diegetically, the Global North (represented by what the young girl watches and listens to—a truly new kind of Postcolonial Subject) and the Global South (represented by the tradition of the elder women) coexist in the same space and in seemingly harmonious swaying, yet they might not quite be functioning on the same frequency extradiegetically. This twentieth-century problem of "disjuncture," to use Arjun Appadurai's famous theorizing word, certainly continues to plague the reality of the twenty-first century.

NOTES

1. Elsewhere in my writings I engage with the debates around the adjective "African" at length, as well as with the discussions stemming from the genesis of "African" cinema or from the thorny, Global North understanding of "authenticity." I do not intend to revisit these areas. It should also be noted that the widely used expression "African film," while less cumbersome than "francophone sub-Saharan film," may be too general, especially when considering the three films on which this chapter focuses. The expression "sub-Saharan" is itself worthy of debate, since it is not one of the "classic" demarcations of the continent (i.e., North, South, Central, West, and East).

2. In this chapter, I am revisiting portions of a previously published essay: "Ousmane Sembene's "La Noire de . . . : Melancholia in Text, Photo and Film," *Journal of African Cultural Studies* 26, no. 1 (March 2014): 56–68. It would be worth noting that this article over-relied on Global North thinkers. My hope is that the new version encourages more horizontality with voices from the Global South.

3. David Murphy, *Sembène: Imagining Alternatives in Film and Fiction* (Oxford: Oxford University Press, 2000), 99.

4. Françoise Pfaff, *Focus on African Film* (Bloomington: Indiana University Press, 2004), 102.

5. This void anticipates Jordan Peele's terrifying sunken place from the film *Get Out* (2017).

6. Roland Barthes, *Mythologies* (Paris: Editions du Seuil, 1957), 181–233.

7. Roland Barthes, *Image, Music, Text*, trans. Stephen Heath (New York: Noonday Press, 1997), 157.

8. Gérard Genette, *Figures III* (Paris: Editions du Seui, 1972), 272.

9. Barthes, *Image, Music, Text*, 25.

10. Ousmane Sembene, *Voltaïque* (Paris: Présence Africaine, 1971), 168.

11. Gorée Island is referenced quite often in Senegalese cinema, particularly in the films of Djibril Diop Mambety. Mambety always seems to emphasize this presence, a spectral presence really, a postcolonial version (a "shadow" of the colonial version) of the Foucauldian panopticon. Sembene himself comes back to this image occasionally, as evident in *Faat Kiné* (2001), for example, although it is often referenced by characters rather than shown. The character of Faat Kiné expresses dismay that she had never been travelled "beyond Gorée."

12. Clint Smith's recent book, *How the Word is Passed, A Reckoning with the History of Slavery across America* (2021), dedicates an entire chapter to visiting the island of Gorée. While meeting with the museum curator of the *Maison des Esclaves* (House of Slaves), the author pushes back against the accuracy of the numbers of slaves: instead of the usual millions, "[s]cholars now estimate that it was closer to 33,000 enslaved people who passed through Gorée" (251). Eloi, the Senegalese curator, pushes right back: "the slave house crystallizes all of the slave trade. . . . It's *symbol* of the slave trade. . . . The number of slaves is not important when you talk about memory. . . . When we talk about memory, we have to stand in the principles. One slave is too much" (252).

13. Paul Gilroy, *Postcolonial Melancholia* (New York: Columbia University Press, 2005), 102–110.

14. "à la recherche d'un centre doit se substituer la construction de sphères d'horizontalité. Il s'agit donc d'une pensée horizontale du monde" (the construction of horizontal spheres needs to supplant the search for a center. We are talking here about a horizontal thinking of the world) (Achille Mbembe, *Sortir de la grande nuit* [Paris: Découverte/Poche, 2013], 71). All translations from French are mine, unless otherwise noted.

15. Ranjana Khanna, *Algeria Cuts: Women and Representation, 1930 to the Present* (Stanford: Stanford University Press, 2008), 168.

16. Here's a very recent example expressing a similar desire: "There are the *gaps* that sit at the edge of Gorée Island, a place attempting to tell a story that some feel has been forgotten, grappling with the tension that exists at the nexus of fact and truth, a place that still holds the ghosts of thousands and remains a symbol for the plight of millions" (Smith 269, my emphasis).

17. Achille Mbembe, *Critique of Black Reason*, trans. Laurent Dubois (Durham: Duke University Press, 2017), 11.

18. Mbembe, *Critique of Black Reason*, 49.

19. André Bazin, *What is Cinema?* (Berkeley: University of California Press, 1971), 14.

20. Roland Barthes connects photography and specter twice in *Camera Lucida*. Roland Barthes, Camera Lucida. *Reflections on Photography*, trans. Richard Howard (New York: Hill and Wang, 2010), 14, 89.

21. Susan Sontag, *On Photography* (New York: St. Martin's Press, 1977), 68.

22. Smith, 250.

23. "Le temps de l'Afrique viendra" (Africa's turn will come). Mbembe, *Sortir*, 252.

24. See Felwine Sarr, *Afrotopia* (Paris: Editions Philippe Rey, 2016), 10, and also Mbembe's *Critique*.

25. They are (symbolically of course) "the terrible thing which is there in every photograph: the return of the dead" (Barthes 2010, 10). Mati Diop's film *Atlantics* (2019) proposes such a return, which aims to settle unpaid debts.

26. Ross Chambers, *The Writing of Melancholy: Modes of Opposition in Early French Modernism* (Chicago: University of Chicago Press, 1993), 23.

27. Chambers, *The Writing of Melancholy*, 29–32. Moreover, for a discussion on President Senghor's legacy, see Elizabeth Harney's book, *In Senghor's Shadow: Art, Politics, and the Avant-Garde in Senegal, 1960–1995* (Duke University Press, 2004). For a discussion on Senghor's intellectual contributions see my own work, *Meaning-less-ness in Postcolonial Cinema* (Michigan State University Press, 2022).

28. Sontag, 15.

29. While not the same, nostalgia and melancholia are in the same affective register. Gilroy refers to both simultaneously when building his argument for political critique, 2.

30. In the Antibes, a nostalgic black woman cut her own throat (Sembene, 184).

31. Sank in her memories (Sembene, 162).

32. Sigmund Freud, "Mourning and Melancholia." *The Standard Edition of the complete works of Sigmund Freud, Volume 14*, trans. James Strachey (London: Hogarth Press, Institute of Psycho-analysis, 1953–1974), 234, 243–58.

33. Khanna, *Algeria Cuts*, 147.

34. Khanna, 168.

35. The maid, but also a play on the dual meaning of the word—bon/bonne being the French adjective for "good."

36. Wail, tears, clean her nose (twice), crying (Sembene, 158–59).

37. The throat cut open from one ear to the other (Sembene, 160).

38. Diouana wanted to see France and return from this country that everyone sang the praises, of its beauty, riches, the sweetness of life. Already, before having even left the land of Africa, she saw herself [. . .] a millionaire (Sembene, 165).

39. Flee within herself (Sembene, 176–77).

40. Now, we are going to see the kitchen (Sembene, 177).

41. Julia Kristeva, *Black Sun: Depression and Melancholia* (New York: Columbia University Press, 1989), 3. This is another example of a closed loop.

42. Chambers, 33.

43. Kristeva, 177.

44. This ship is often referenced in Senegalese cinema, not just by Sembene, but also by Djibril Diop Mambety for example (in most of his films but most poignantly in *Touki-Bouki*, 1973, and *Hyenas*, 1992).

45. The main character of *Black Docker*, Diaw, is a writer who suffers loss: a white female writer, Ginette Tontisane, whom he had trusted to help his literary career, actually steals his manuscript about slavery and publishes it under her own name.

46. Khanna, 148.

47. In yet another extradiegetic connection, Mati Diop is Mambety's niece, and her first film, *Mille soleils* (*A Thousand Suns*, 2013), revisits the actors from *Touki Bouki* in a melancholic attempt to deconstruct the tensions of that film and to explore the human nature of old Mory and of the actor who played him, Magaye Niang (the film focuses especially on "their" love for Anta).

48. Laila Amine, *Postcolonial Paris: Fictions of Intimacy in the City of Light* (Madison: University of Wisconsin Press,2018), 29.

49. Amine, *Postcolonial Paris*, 29.

50. Amine, 31.

51. Amine, 29.

52. For more on the materiality of sound and music, please see my book *The Beautiful Skin* (2020).

53. Most journals considered the poster to be "inspired" by Mambety's film. For more, see http://www.africanews.com/2018/03/13/senegal-film-classic-inspires-beyonce-and-jay-z-tour-art//.

54. Mati Diop actually expressed consternation at their using of the image. See, https://www.theguardian.com/film/2018/jun/17/beyonce-jay-z-put-visionary-film-touki-bouki-africa-spotlight, accessed October 3, 2018.

55. The last detail comes from a CNN article by Aisha Salaudeen, from July 17, 2019: https://www.cnn.com/2019/07/17/entertainment/beyonce-lion-king-album-intl/index.html.

AMERICAN
POSTER CULTURE

Chapter 7

SILENT RUNNING

Art and Eco-Memory

MICHAEL L. SHUMAN

First-time director Douglas Trumbull, who earned distinction for super-
vising the innovative special effects for Stanley Kubrick's 1968 film *2001: A
Space Odyssey,* was planning *Silent Running,* a 1972 science fiction movie
combining the rebellious spirit of the 1960s with the newfound interest in
the 1970s in ecology and the environment. The spaceship, Trumbull decided,
should visually resemble the futuristic-looking 1970 Expo Tower in Osaka,
Japan, a spidery network of metal rails supporting a series of geodesic domes.
Trumbull and crewmember Wayne Smith traveled to Osaka and climbed the
three-hundred-foot structure, meticulously photographing it from every
angle to produce reference photos of the tower's spindly construction. The
planet Saturn, featured prominently in many of the completed film's front-
projection scenes of outer space, would be created by streak photography
using a rotating machine with a six-foot radius, while the planet's rings
would be made by photographing colored reflections of light from a track-
mounted spinning drum, a unique process of slit-scan cinematography
requiring crinkly reflective material, a selsyn motor, and lots of patience.
Trumbull would set up the world-building machine and let it run, night after
night, until he had the rings for a perfect Saturn, complete with ethereally
diaphanous, multicolored surface effects. The robot drones, squat metallic
creatures without human features yet still evoking warmth and empathy,
were easy for Trumbull to imagine but tougher and more controversial to
execute. These three drones, predating the funny robots of George Lucas's

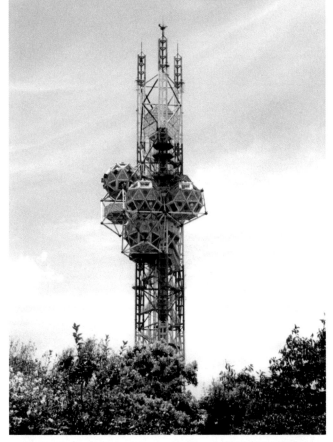

Figure 7.1. The Expo Tower. https://en.m.wikipedia.org/wiki/File:EXPO_TOWER.JPG

Star Wars (1977) by half a decade, would be operated by bilateral amputees, young volunteers who provided the fluid movements of human beings while enclosed in robot-like shells.[1]

Trumbull was developing the singular visual landscape of a futuristic film and doing it the hard way, without modern F/X tools or even an established culture of realistic science fiction special effects production. He easily could have appropriated the traditional winged-spaceship design familiar from movies made a decade earlier, or a matte painting of Saturn, or a humanoid robot emulating Gort from the 1951 feature film *The Day the Earth Stood Still*. But Trumbull, awarded one million dollars and complete creative control by Universal Studios in a short-lived initiative to capitalize on the low-budget success of *Easy Rider* (1969), was determined to express his vision without relying upon previous science fiction methods or tropes. He developed his

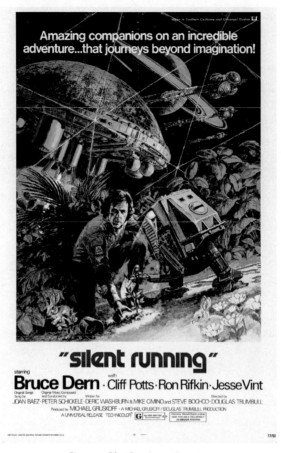

Figure 7.2. *Silent Running* movie poster.

own spaceship, Saturn, and drone, thereby fabricating not only the mise-en-scène for his drama but also the visual elements for that essential ancillary to every modern film, the movie poster.

The primary function of movie posters is to sell a commercial product, a momentary encounter with celluloid technology that, while being perhaps entertaining and educational, will generate a profit. Film is a collaboration predicated upon the visual image, so the poster artist, as one of the collaborators, must translate those moving images into a single panel that will both convey the notion of the film and solicit viewers to watch the production. Stefan Sharff, in his overview of Alfred Hitchcock's *Rear Window* (1954), compares motion picture production to the art of musical composition, maintaining that films have their own composers who establish the aesthetic and stylistic elements of their visual narratives. "The design

is most essential," Sharff writes, "[and] from it comes the cinema language and tonality guiding all the moves to the most minute parts; every shot has consequences both forward and back, and all components play."[2] Although Sharff is commenting on the structure and content of films themselves, the same principle of interacting images and detail similarly apply to movie poster design. Posters thus have their own language for communication, their own established conventions of representation and persuasion, and succeed or fail based upon the artist's understanding of a film and their ability to remediate the celluloid experience into a single image. James Carreras, managing director of Hammer Film Productions throughout the studio's midcentury prominence, understood the visual impact of a poster to solicit not only the finished film's audiences but the initial production finance as well. "Carreras was a charismatic salesman," writes Marcus Hearn in *The Art of Hammer*, a book devoted to the studio's visually provocative posters, "and the only British producer to strike distribution deals with every major American studio. He was often able to do this without a script or a promise of major stars, but he rarely went into negotiations without provisional poster artwork and a title."[3] As novelist Stephen King points out in his introduction to *Graven Images*, a compendium of science fiction and horror illustration and movie poster art, American International Pictures producer Samuel Z. Arkoff used much the same approach when identifying prospective movie projects for production. Arkoff would first circulate imaginative titles for the distributors' consideration. "If the response was positive," King writes, "an artist did a poster treatment and the artwork was sent out to the same buyers with the title attached. If enthusiasm remained high, the film was made."[4]

In the early days of filmmaking, the uniquely flashy experience of watching a movie was enough to attract ticket sales. "Print shops across the country," writes Mark Fertig in his history of the Western movie poster, "offered exhibitors stock posters that promoted moving picture shows in general, but not any single movie in particular.[5] As the film industry became more competitive, promoting individual movies was essential, and actors became more prominent in the promotional process. "Whereas posters once showed a scene with no credits," Ian Haydn Smith points out in *Selling the Movie: The Art of the Film Poster*, "audience interest in performers resulted in popular actors being named and demand grew for films that featured them. Subsequently, an actor's billing on a poster charted both their rise and fall."[6] Bruce Dern, in his midthirties when Trumbull cast him as the lead actor in *Silent Running*, was known mostly for his supporting roles in 1960s television shows such as *Stoney Burke*, *The Big Valley*, and *The Fugitive*, and would not have had the poster-ready box-office draw of a major film actor. But Dern

had a brooding, slack-jawed intensity that evoked the 1970s hippy-centric environmentalist sensibility that Trumbull envisioned for the role. "I was immediately taken with him," Trumbull tells interviewer Pamela Duncan in a 1982 issue of *Cinefex* magazine, "because he had a terrific presence on the screen, and he had the right sort of offbeat face and voice for the role."[7] Dern, wearing a loose-fitting spaceman jumpsuit sporting distinctive mission patches, indeed provides the right stuff necessary to become a human artifact among all the other visual elements of a science fiction movie poster.

The plot of *Silent Running* supports both the poster-worthy visuals and the environmentally conscious context of the film. Trumbull, along with screenwriters Deric Washburn, Michael Cimino, and Steven Bochco, envisions a dystopian earth where forests have been eradicated and just eighteen specimens of natural terrain are preserved in domes attached to a fleet of spacecraft roving near Saturn. One crew member aboard the spacecraft Valley Forge, Freeman Lowell (Dern), is genuinely dedicated to preserving these natural resources and consequentially is ostracized by his three disengaged companions, all anxious for the termination of the preservation program and the return to their barren yet temperature-controlled home world. When authorities on Earth announce the end of the project and order the nuclear destruction of the domes, Lowell resolves to save two forest specimens and confronts his crewmate John Keenan (Cliff Potts), as Keenan begins to plant explosive charges. Lowell kills Keenan and traps the other two crewmembers, Marty Barker (Ron Rifkin) and Andy Wolf (Jessie Vint), aboard a dome as it is ejected into outer space and destroyed by the nuclear blast. Lowell, injured in his encounter with Keenan, attempts to evade detection by ejecting supplies from the Valley Forge and navigating into the rings of Saturn, hoping that observers on other fleet spacecraft will believe that the dangerous flight path and scattered supplies would indicate the Valley Forge's destruction. Three robotic drones—Lowell eventually personalizes them as Huey (Steven Brown and Cheryl Sparks), Dewey (Mark Persons), and Louie (Larry Whisenhunt)—help Lowell maintain the forest, but are reduced to a pair when Louie, disobeying Lowell, is lost in the run through Saturn's rings. Radio communications from Commander Anderson (Roy Engel) aboard the fleet ship Berkshire reveals that the Valley Forge has been found and a rescue team is on the way. Lowell realizes that his injuries are severe and, consumed with guilt over his actions, resolves to remain onboard the Valley Forge with Huey, damaged through Lowell's bored carelessness, and to destroy the spacecraft using one of the nuclear devices. He directs Dewey to maintain the forest in the remaining dome, launching it free from the Valley Forge, leaving Dewey

Figure 7.3. Confrontation in the forest.

the immortal caretaker of a forest specimen—a legacy artifact of a declining planet—heading for interstellar space.

Silent Running's narrative, socially conscious and perhaps uniquely cerebral for science fiction films of the day, nevertheless provides plenty of action, suspense, and gee-whiz special effects astonishment to attract theatregoers, especially those impressed with the grandiose spectacle of Kubrick's cosmic precedent. The underlying tension between Lowell and his crewmates aboard the Valley Forge, persistent throughout the film's early scenes, anticipates the eventual deadly confrontation with Keenan if not the narrative impact of the exploding dome and the death of his crewmates that leaves Lowell alone, confronting the consequences of his actions and the fate of the remaining preserved forests. Lowell's reckless service vehicle drive through the cargo bay of the Valley Forge, prompted by his anxious attempt to save the dome forest from dying due to lack of sunlight, not only maims Huey but leads to further disintegration of his physical and mental well-being. And the Valley Forge's intrepid plunge through the rings of Saturn—a rugged episode charged with impending disaster—is a convincing special effects triumph relying upon a twenty-six-foot spacecraft model fashioned from steel, wood, plastic, and parts appropriated from eight hundred Japanese model kits purchased on the cheap. "We could make those things now extremely inexpensively, rapidly, and cleanly," Trumbull tells Duncan in the *Cinefex* article. "But that was ten years ago, and we had all kinds of problems. . . . So there was a tremendous amount of handiwork in those that we wouldn't have

today."[8] While *Silent Running*'s conflict and physical action may not match that of more traditional films released in 1972—say, Francis Ford Coppola's *The Godfather* or Sam Peckinpah's *The Getaway*—there is enough brawling intensity to sustain any advertising campaign, while the extravagant, carefully crafted in-camera special effects are unique for their day. John Bartholomew, in a prescient review published in *Cinefantastique* just months following the movie's release, attests to the film's F/X accomplishments. "The model work and special effects in *Silent Running*," he writes, "are absolutely breathtaking and, more importantly and most difficult to achieve, flawlessly incorporated into the body of the film, a feat Kubrick sporadically failed to accomplish with the same quality of effects in *2001*."[9]

The action and outer space visuals of *Silent Running* indeed may have been important for selling tickets to the youth-oriented moviegoers of the early 1970s—the target audience of Universal's innovative financing project—but the impact of the first Earth Day in 1970 and the fomenting concern with ecology and the environment remains a primary part of the film's marketing appeal. Trumbull, in a sly evocation of our happy-sad appreciation for all things nostalgic, presents a world where natural flora and fauna are already lost, an ever-dimming memory for the planet's nature-impoverished population. Filmgoers thus experience an eerie sense of nostalgia-by-transference, a proxy version of Lowell's own environmental memories as he gazes at the environmental pledge poster beside his bed and sings about Smokey the Bear. Robin L. Murray and Joseph K. Heumann, in their article on environmental nostalgia in science fiction films of the era, call this sensation *eco-memory*, noting that *Silent Running*, *The Omega Man* (1971), and *Soylent Green* (1973) embrace "the memory of an environment and ecology that no longer exists on their earth." Nevertheless, the authors maintain, "these films reflect a nostalgia for a world that does still exist for its viewers, both in the 1970s and today."[10] Film critic David Ingram sees a similar tendency to rely upon eco-memory in environmentally themed Hollywood movies of any genre or era, but relies upon Trumbull's film to illustrate his cynicism about any supposed technological fix for the destruction of our natural resources. "*Silent Running*," he writes, "is typical of many of the environmentalist movies . . . in its uneasy combination of nostalgia for a seemingly lost authentic relationship between human beings and non-human nature, before the despoliations of modernity, with a reliance on a technological fix to solve environmental problems." While human ingenuity and applied science, such as the Valley Forge domes, may provide a comforting illusion of apolitical resolution consistent with mainstream environmentalism, Ingram argues that "the optimism of these movies remains muted, and the narrative resolution demanded

by the melodramatic mode does not close off a sense that environmental problems are ongoing, and not totally amenable to such fixes."[11] Bartholomew, also skeptical of technological solutions to environmental crisis, sees the film's narrative end as a melancholy sense of loss for both characters and audience. "The final effect of Silent Running," he writes, "is one of a special dark kind of sadness, not the uplifting tragedy of a man who has succeeded though it cost him his life, but the more useless, wasted sadness of a noble endeavor gone awry."[12] Thus the audience members' environmental nostalgia, served through the film's narrative events by proxy, emerge as the portent for real loss at some indeterminant future date.

The essential narrative artifacts of Silent Running—the robotic drones, the planet Saturn, the rebellious astronaut-hero, the gangling space freighters with their precious forest domes—unite in the film's poster to emphasize the underlying environmental themes while attracting an audience anxious to experience a socially conscious message amid majestic special effects. Joe Smith, a prolific commercial artist who developed the provocative poster art for films such as The Incredible Shrinking Man (1957), Ben-Hur (1959), and Earthquake (1974), developed the preliminary poster design, translating the foundational elements of the film into a concise visual representation. "I was known as an innovator," Smith tells Gary Gerani in a volume dedicated to Smith's artwork, "an experimenter, someone who could come up with a fresh approach for a campaign."[13] The final version was completed by first-time poster artist George Akimoto, a Japanese American artist who developed a dramatic style by drawing comics while interred in wartime relocation camps in Arkansas and California. His work as a commercial artist in the aviation and space industry no doubt contributed to his effective representation of spacecraft and other technology in Trumbull's film, and Akimoto continued a modest career in movie poster art throughout the 1970s. Notable posters by Akimoto include those for the films The Italian Connection (1972), Dillinger (1973), and Crime and Passion (1976), as well as other films typical of the era, including blaxploitation movies and two Edgar Rice Burroughs science fiction blockbusters.[14]

Commercial artists such as Smith and Akimoto depend upon commissioned projects for their income, often working under deadlines and studio constraints to produce effective illustrations that will market a film. "Instead of only dealing with an art director," writes Art Scott in The Art of Robert E. McGinnis, "they must also satisfy the producer, the director, associated suits from the studio and the distributer, talent agents, and the stars themselves—who will be carefully monitoring the proofs to make sure their images properly reflect their star status." Scott similarly observes that, unlike designers

Figure 7.4. Akimoto commercial space art.

who specialize in other commercial media, movie poster artists must design their work to fit a variety of poster sizes, "not only the classic 27" x 41" one-sheet poster, but also the three-sheet, the six-sheet, the half-sheet, the insert, the soundtrack LP jacket. . . . Everything from a small newspaper ad to a gigantic billboard looming over Sunset Boulevard."[15] The poster artwork does indeed appear on the soundtrack album, first released by MCA in 1971, and as the cover of a slim 1972 Scholastic Book Services mass-market paperback novelization by Harlan Thompson, an author most commonly associated with juvenile Westerns. Akimoto's artwork is uncredited in both instances but, with the exception of some extra cloudlike brushwork at the bottom of the paperback cover to accommodate the elongated, pocket-friendly format, the major elements of the composition are retained for these associated marketing commodities.[16]

Aside from the restrictions confronting illustrators who create commercial works to sell a product, most artists personally aspire to express an aesthetic context for the film, an illustrative, interpretative vision of the movie's content and meaning that may, too, attract audiences. Often that ancillary conception of the movie depends upon the poster artist's own background and aesthetic vision. Drew Struzan, poster artist for such seminal films as *Star Wars* (1977) and *Blade Runner* (1982), acknowledges that he primarily works to generate income for his family but insists that even commercial artists have their own aesthetic vision and are compelled to express that vision in their art. "We are, after all, artists at heart and the goal of every bona fide artist is to make art," he writes in the foreword to the Joe Smith volume. "Although I have never been asked to make 'art' for advertising, my private goal remained to make 'art' out of advertising. Looking through [Joe Smith's] oeuvre, I expect this was his goal, too."[17] Robert McGinnis, who created the poster art for over sixty films, including iconic images for the James Bond franchise, similarly emphasizes the importance of personal artistic aspirations and maintains that an experience with cartooning and caricature is important for the successful creation of film posters. McGinnis essentially sees the unique aesthetics of poster art as an exaggeration of physical reality that in some respects reflects the audience members' need for escapism, one of the many rewards that filmgoers enjoy. McGinnis considers his poster for *The Odd Couple* (1968), a wacked-out representation of the uptight Felix Ungar (Jack Lemmon) and the loutish Oscar Madison (Walter Matthau), as his best Hollywood work. "It was a loosely done thing with a lot of spirit; it went back to my cartooning beginnings," he says. "I always wanted to be a cartoonist, and I think that cartooning is important."[18] Thus, the *Silent Running* poster artists, both Smith with his conception and Akimoto with the final, color version of the poster, really are recontextualizing the events and meaning of *Silent Running* both to sell the movie and, perhaps more subliminally and mysteriously, to offer their own personal and intellectual visions. Akimoto becomes a translator of both the film's import and of Smith's initial artistic notion, a cultural cryptographer who knows the film but also understands commercial aviation and space art and its compelling presence in the postwar social order.[19]

Roland Barthes, a French philosopher and semiotician, provides a theoretical foundation for describing the dual motivation of commercial artists and, hence, the social and cultural importance of the resulting movie poster. Barthes's semiotic notion sees artistic construction as an intertextual relationship between *Work*—a concept of production that has changed under the influence of Marxism, psychoanalysis, and other modern intellectual

constructs—and *Text*, an ethereal locus of expression that attempts to signify objects, ideas, or experiences in our existence. "The difference is as follows," Barthes explains. "[T]he work is a fragment of substance, it occupies a portion of the spaces of books. . . . The Text is a methodological field. . . . [T]he work is held in the hand, the text is held in language: it exists only when caught up in a discourse." Barthes further maintains that Text "practices the infinite postponement of the signified" and "fulfills the very plurality of meaning: an *irreducible* (and not just acceptable) plurality." These are remarkably abstract concepts perhaps further obscured in translation, but fundamentally Barthes considers Text as expression which has limitless interpretations and may exhibit meaning differently in particular contexts or for specific people. Consequently, Text would be the language of film and the complex, constantly simmering meaning of *Silent Running*; in Barthes's terms, the film would be a linguistic construction of plural and irreducible meaning. Work, however, Barthes describes as an aspect of expression that has an ultimately definable meaning despite any perceived enigma it may possess. This Work, for us, is George Akimoto's finished poster with its mercantile intent. While the poster may contain its own implicit expression, Barthes insists that it might contain "mysteries" but ultimately is a product that, as he says, simply "closes on a signified" as a work-for-hire—a rendering or a reinterpretation of the film in another media.[20] Thus, a film and the poster art created to promote that film have an intertextual relationship where both a Text—in this case, the film—and an art-for-hire Work—in this case, Akimoto's poster rendering—interact to provide additional areas of meaning to each other.

As a product of Work, movie posters have a defined set of elements and communicate their concepts of films in relatively standard ways. Artists create poster images with the understanding that descriptive information will be included before distribution: the film's *title*, a name that both implies the movie's essence and serves as a branding mnemonic; a *tagline* to further promote the film through a catchy phrase indicative of the plot or action; and *credits*, in condensed font, providing information about the film that is generally less effective at promoting ticket sales, including the names of actors, producers, directors, and musical contributors, along with a list of other creative personnel and production details unlikely to attract public interest.

Johannes Mahlknecht, in his article on movie poster taglines, maintains that this short-form description of a film is an important yet underappreciated element of movie poster design. "Of all the possible paratextual elements and sub-elements that encircle and frame a film," Mahlknecht writes, "the movie tagline is perhaps the one that leads the most marginalized existence."[21]

Akimoto's poster for *Silent Running* includes a tagline that, following certain unwritten rules of film promotion, promises bombastic narrative and visual appeal combined with a tolerably twisted notion of the movie's plot. Superimposed over the top of Akimoto's painting, in stark white letters contrasting with the darkness of outer space, the tagline does its stuff: "Amazing companions on an incredible adventure . . . that journeys beyond imagination!" The exclamation point may be expected as a rhetorical method of invoking excitement and awe in the viewer, and indeed there is a journey supplied in the film's plot, but we wonder if the result really will take us "beyond imagination," and if so, to where? The tagline apparently refers to Lowell and the orange drone, Huey, as buddies in some perilous exploit, but what about Lowell's crewmates, missing from the poster, the crews of the Berkshire and the Sequoia, or even Dewey and Louie? Other companions may be implied, of course, but the poster audience is compelled to associate the tagline only with the visual representation of the main image and without elucidative access to other characters or plot incidents. While taglines are paratextual devices important in film promotion, such direct tagline references to the poster's main image have become rare since the release of *Silent Running*. "Historically speaking," Mahlknecht writes, "we may say that direct links between tagline and image are a phenomena encountered mostly on posters for films made before the 1980s and especially within the period of Classical Hollywood cinema."[22] While Akimoto's image may contain little of the exaggerated cartoon sensibility recommended by McGinnis, the tagline makes up for that omission with hyperbole of its own, supplying nearly a caricature, in words, of the movie's content. Filmgoers may expect over-the-top enticements in movie poster taglines as they do in all advertising media, so the designers working with Akimoto's image would be committing industry malpractice had they composed a tagline with an insufficient complement of balderdash.

The film's title, in a distinctive lowercase red font and surrounded with quotation marks, similarly pops out from the white background that forms the bottom of the poster immediately below Akimoto's image. "I made the title up," Trumbull tells Kay Anderson and Shirley Meech in a 1972 *Cinefantastique* interview, "and everyone says it sounds like a submarine movie. Well, that's exactly what it sounds like. 'Silent Running' is a term in submarine warfare, a desperation maneuver in which all the engines and everything that makes noise are turned off so the sub can't be detected."[23] Trumbull thus appropriates cultural associations with earlier submarine films such as *Run Silent Run Deep* (1958) and *The Enemy Below* (1957) not only to reference Lowell's evasive escape through Saturn's rings but to promise an element of

wartime strategy and combat in his outer space narrative. This contextually roguish yet somehow effective title suggests calculated, wily evasion from an unknown adversary and perhaps the prevalence of courageous action over talkative quiescence. In an expressive instance of visual gymnastics, the bright letters slide above the poster's credits and invite the viewer, through contrast, to focus on the darker visual representation of characters and action in Akimoto's painting, just above, thus further emphasizing the adventure promised by the film's tagline. The quotation marks, while not uncommon for titles represented on movie posters, have an intriguing and provocative presence, appearing to cite the title rather than to introduce it, moving it away from the physical form of the poster into a realm of primacy, thus announcing the irreducible nature of the film as Text. The quotation marks also serve to transform the title into an invocation or command, further reinforcing Trumbull's notion of the title as reference to an intentional military maneuver, a call-out to the whiz-bang action involving spaceships and robots that the film promises.

The film credits, immediately below the title, emphasize Dern's name but also list the other crewmembers of the Valley Forge in tall, thin font: Potts, Rifkin, and Vint each possesses less box-office appeal than the relatively more familiar Dern, but as the three other prominent characters in the film's small cast, they deserve mention and, aesthetically, their names provide balance and visual appeal to the poster's composition. Musical contributors Joan Baez and Peter Schickele are there, too, along with the film's screenwriters and producer Michael Gruskoff, a former talent agent whose first production assignment, Dennis Hopper's *The Last Movie* (1971), also was part of Universal's low-budget, youth-oriented initiative. The studio's name is dutifully credited on the last line of text, along with the Motion Picture Association film rating and an announcement of the soundtrack's availability, the latter two enclosed in the tiny graphical boxes that we, as prospective audience members, have come to ignore.

The main image or visual representation of the film, often the most compelling motivational asset of a poster, establishes a visual context for Trumbull's narrative by depicting the intersection of man, nature, and technology against the darkness of outer space. This composition indeed reflects the cinematography of the movie, and Bartholomew's contemporaneous review notes that *Silent Running* is "excellently photographed by Charles F. Wheeler in rich resilient color with somber tones of green and blue predominating."[24] The image also slopes toward the bottom left-hand corner while the main dome of the Valley Forge, closest to Lowell and the robot drone, leans toward the upper right-hand corner. There, Saturn and the other two

Figure 7.5. Spacecraft with forest domes.

spacecraft in the fleet seem to pull the viewer's gaze upward and away from the cooperative effort of man and drone as they plant a fragile sapling in the nearly glass-smooth earth. The sloping angles and the observer's diverted visual interaction with the image produces a disorienting effect, emulating Lowell's own disorientation and mental instability following his injury and the evasive tactic he uses to avoid detection while navigating through Saturn's rings. The spacecraft and their cargo-domes filled with microcosmic forests—along with a representation of Saturn matching both the pale-blue metal framework of the domes and the planet we see in the film—would attract potential theatregoers looking for a science fiction film about space travel. Akimoto's depiction of the spacecraft and the rather intricate underpinnings of the dome, apparently being ejected from the Valley Forge, match what we see in the film itself, as we might expect from a commercial artist specializing in paintings of aviation and space technology.

The lush forest in the foreground of the painting encroaches upon Lowell and the drone, nearly embracing them in a protective manner, while a few flowers and even cuddly bunnies decorate the lower margins of the poster in such an integral way that they risk being ignored by the viewer altogether. This earth-centric element of the poster would attract the environmentally conscious, socially concerned, and youthful audience that Universal was looking for when funding such an innovative project with an unproven director. There is a sinister aspect to the vegetation, though, a reactive quality to the surrounding foliage that implies want for a better place than the darkness of outer space surrounded by cold and sterile technology. The plants may well be

trying to crush Lowell rather than protect him, and indeed even the attitude and posture of the two rabbits, with their ears up, suggest fear of an impending tragedy. This duplicitous aspect of the poster—green vegetation engendering a sense of doom—effectively represents scenes from the film involving Lowell's solitary despondency after learning of the government's orders ending the preservation project and authorizing nuclear destruction of the forests.

The abundant special effects artifacts populating Akimoto's poster attract attention within the poster's boarders, but the one human present, Dern as Lowell, along with the yellow robotic drone with distinctively human mannerisms, compel the viewer to identify the poster's artistic focal point. On first approach an observer may think that the robot's spade and the sapling—highlighted by the robot's spotlight—would be the real focal point, and indeed it might be if you consider the printed textual credits at the bottom of the one-sheet. Akimoto may have anticipated this bottom-heavy block of credit text when he developed the poster concept. But as the viewer looks at just the poster image itself, it appears that the spotlight, instead of casting down to the ground, actually serves to emphasize the bright yellow drone, a contrivance of technology that seems curiously out of place in this immediate environment by size, shape, and color. Looking further, the viewer will notice that Lowell is visually understated, almost blending into the background of the forest, until the observer notices that the left-hand side of his face is illuminated by the robot's light.

Ultimately, we identify a focal point that seems to show an intersection of man, plant, and robot, an aggregation that both foreshadows the bittersweet conclusion of the film and implies the essential earned humanity of the drones. In fact, following Lowell's renegade run through Saturn's rings, the robots tend to gain human personalities as they interact with the lonely astronaut. The robots have no real facial features—no eyes, nose, or mouth—but still project expressions and emotions in a physical way. Lowell's names for the three drones, Huey, Dewey, and Louie, give them a curiously Disneyesque mystique, a humanity implied by their cultural association with cartoon characters and Carl Barks comic books.[25] In the 1982 *Cinefex* article, Trumbull admits his intent to humanize the robots. "I've been very involved with machines and special effects and technology for a long time," he notes, "and it bothers me that technology is so often considered to be inhumane and worthless."[26] Trumbull presents several scenes that both humanize the drones and add gentle humor to the film. Lowell teaching the drones to play poker, for example, reveals the astronaut's growing isolation and boredom assuaged by the card-shark Huey, who knows a winning hand when he sees one. With a change of programming and some encouragement from

Figure 7.6. Drones plant a sapling.

the patient, Huey—not yet named but responding to commands as Drone #2—becomes a surgeon as he skillfully operates on Lowell's injured leg. While the drones are less successful in their initial attempt to plant a sapling, Dewey's whimper of disappointed despair has a humanizing aspect all its own. "These drones will break your heart," Dern tells Anderson and Meech in the *Cinefantastique* article. "They make little movements—when I yell at them, they tilt over as if to hang their heads. When they're impatient they tap their feet. Their creativeness really helps the picture, because it endears them to you all the more."[27] Bill Cooke, in a 2003 *Video Watchdog* review of the film's initial DVD release, credits Dern's "trademark combination of insanity, passion and humor" for engendering a sense of humanity into the drones' squat metal bodies. "Dern deserves credit," Cooke writes, "for sealing the illusion of perceived personalities whenever he interacts with the drones."[28] Ingram, unsure of the revitalizing capabilities of technology, confirms the essential humanity of the drones but suggests that the cautiously optimistic conclusion of *Silent Running* is little more than dramatic illusion. "Wild nature has been restored," he maintains, "by the interventions of a benign technology. The robot to whom the care of nature is entrusted is a convivial technology, childlike and endearingly clumsy. Machines have become intelligent and sentient, but are also fantasized as benign, unthreatening and reassuringly humanized."[29]

Akimoto's subtly troubled bunnies are decidedly nonhuman and, along with a few squirrels and Lowell's fist-perching raptor, one of the few major specimens of animals represented in the film. But the rabbits' alert looks

visually replicate the expression of apprehension on Lowell's face, a sense of suspicion and impending tragedy that is central to the film's action. In a remarkable revision of Smith's preliminary artwork, Akimoto transforms Lowell's posture from the workmanlike downward gaze toward the drone's shovel and the sapling to a concerned expression of consternation directed just outside the poster's border. The astronaut's left hand, too, changes from a helpful nudge aimed at the sapling, in Smith's draft, to an open-fingered grasping pose in Akimoto's, as though Lowell were prepared to rise up and throttle some approaching menace. The quiet, nurturing process of teaching a robot to plant a tree becomes secondary to Lowell's sense of an impending violent encounter. This unsettled attitude would invite an audience looking for conflict, or adventure, or perhaps the deadly duel to the death that indeed happens in the film and sets Lowell's renegade actions into motion.

Some important elements of *Silent Running*'s narrative and subtext simply cannot be communicated within the limitations of a visually static representation. Lowell's wide-eyed, over-the-top excoriation of his fellow crew members on ecological issues, for example, may seem outlandishly histrionic to some viewers but remains a fine embodiment of eco-memory and of the extraordinary environmental passion just taking hold in the early 1970s, particularly among young people and their elder supporters. The alternately booming and reflective orchestral score, composed and conducted by Schickele of whacky-classical P. D. Q. Bach renown, similarly eludes translation into poster art, although his name is there, floating in small font with the credits, just below Dern's larger name in bold type. And folk singer Baez's soprano vocals, enriching the soundtrack with the original song "Rejoice in the Sun" during Lowell's moments of introspection and remorse for a paradise lost, are decidedly representative of their own time and may be perceived, by modern audiences, as cloyingly affected with back-to-the-earth sensibilities and 1960s-era hippie hopefulness. Viewers nevertheless may struggle to think of any other song, any other voice, that so emotionally embodies that scene, or that time, or an eco-memory of an era when wild things were growing and life seemed uncomplicated. Baez voice returns, at film's emotion-charged end, as Dewey dutifully waters the dome's forest plants with Lowell's battered watering can, an isolated caretaker in a vast field of stars. But just as film, in Shariff's estimation, replicates music in composition and form, so does Akimoto's poster have a distorted harmony that, in some ineffable way, embodies Baez's idiosyncratic vocal style and Schickele's triumphant and brooding score.

The *Silent Running* screenwriters, young professionals who would go on to impressive Hollywood careers, certainly introduce some haywire flubs

Figure 7.7. Preliminary poster art by Joe Smith.

into the film's narrative, but as with Dern's passion and Baez's era-bound voice, these troubles graciously evade representation in the advertising vehicle of the poster. "Script flaws abound," Cooke observes in his *Video Watchdog* review. "More backstory is needed to explain Earth's condition and why these ships are so far out in the solar system; the trip through the rings is built-up as most certain death . . . but other than a shaky camera, the ordeal doesn't amount to much at all."[30] A few questionable situations, such as expert-forester Lowell's failure to immediately realize that the flora in his dome is dying from lack of sunlight, may be explained as an artifact of the astronaut's mental decline. But why do authorities order the nuclear detonation of the domes in the first place, when simply releasing them, unattended, into the cosmos would have ensured their destruction? How will Dewey maintain the remaining forest dome in perpetuity when the

plants and trees rely upon artificial light bulbs, consumable resources with an exhaustible supply? Akimoto's poster, a masterful representation of the themes, storyline, and action of the film, does its job selling movie theatre tickets and, after all, doesn't most advertising somehow overstate the product or even intentionally deceive the potential buyer in some way? Regardless of any narrative flaws, large or small, *Silent Running* still emerges as a powerful statement of the intersection of nature, technology, and humanity and of the society and culture that the film reflects. "[While] the narrative may be scientifically questionable," writes Mark Kermode in a 2014 British Film Institute monograph on the movie, "the story itself . . . rings unerringly true. In the best possible sense, the film speaks to its audience, drawing them in, understanding their emotions, touching their hearts, winning them over."[31] And the *Silent Running* poster, as a product of Barthes's notion of Work, communicates the essence of this engaging and sensitive narrative in its own spooky way.

Fifty years have passed since *Silent Running*'s release in March of 1972, and Douglas Trumbull regrettably passed away one month prior to the film's half-centennial. Akimoto's poster, however, remains an artifact both of Trumbull's celluloid accomplishment and the unique era that engendered it, surpassing, through time, its commercial intent as a product of Work to become an aesthetic Text with its own irreducible import. "Time has put distance between the commercial reasons for [Joe Smith's] creations and the art that was incorporated into them," Struzan writes. "The art now speaks without the burden of the advertising. We may well have seen the films that correlate to the art Joe created, but that does not diminish our ability to enjoy the art for its own sake."[32] *Silent Running*'s poster art—spaceship, astronaut, Saturn, drone—now emerges not only as a representation of a commercial film but as an expression of 1970s aspirational culture, a desire to solve the immediate problems of our planet and, perhaps, continue on to comprehend the nature of the natural world around us. The painting itself advances from workaday function, presenting merely Barthes's "mysteries," to become an irreducible, complex and inexhaustible fabric of meaning. Even the title, tagline, and film credits merge with Akimoto's image to become part of the poster's ineffable vision, losing their commercial intent and becoming inseparable from the artist's expression of 1970s culture. Film critic Gary D. Rhodes notes this transformational process of posters from commercial products to self-contained representations of creative art, and also celebrates the cultural import of film posters as well. "Poster designs have become indelibly linked with the movies they advertise," Rhodes maintains. "often to the degree that their images act as embodiments of their films for collective memory. Long

after their initial marketing responsibilities conclude, the posters remain iconic images in film history and culture at large."[33]

Movie posters based upon illustrations such as Akimoto's, since the advent of sophisticated computer software, have been replaced by machine-produced graphics that, while effective at marketing a twenty-first century entertainment product, further removes artists working in traditional media from the creative process. Marketing becomes the sole intent of poster development, a short-term solution to attract audiences, while aesthetics are relegated to the province of a corporately produced software package. "In the old days," writes Fertig, "some aptitude at rendering an image by hand—artistic talent, if you prefer—was necessary to enter the creative industry. After the computer took over, software competencies . . . replaced traditional 'hand skills' in the designer's portfolio."[34] Struzan is similarly critical of modern technology's displacement of traditional artists, maintaining that computer graphics have marginalized movie posters as aesthetic representations of the pervading culture. "Art simply ceased to be," Struzan maintains. "Illustration was targeted for extinction. It is not the few but the many fans and collectors of artwork who decry the 'non-collectible' and 'uninspiring' redundancy of computer-generated movie posters."[35] Computer graphics also are used to sell legacy films to new audiences, an apparent effort to appeal to generations nurtured on video games and bits-and-bytes technology. The 2020 Arrow Blu-ray release of *Silent Running*, for example, displays a digitally created graphic by Arik Roper on the slipcover and media case, relegating Akimoto's poster to the flipside of the case insert for those traditionalists intent upon preserving the film's original promotional image.[36] *Underexposed!*, a recent book by Joshua Hull, relies upon digitally created posters to represent fifty unproduced film projects, ironically creating posters that neither market films nor emerge as cultural expression.[37] Just as technology destroyed natural resources in *Silent Running*'s dystopic landscape, and then paradoxically was employed to preserve nature in a dome, so has technology displaced conventional movie poster art and preserved only a memory of traditionally developed, expressively illustrated posters.

The marginalized presentation of Akimoto's art in the otherwise-impressive Arrow Blu-ray package ultimately may signify the transition of Akimoto's illustration from a commerce-driven promotional artifact into an irreducible vocabulary of cultural representation. Akimoto's work, commissioned to attract film audiences in the early 1970s, may no longer be the best choice to solicit a home video audience. Yet the poster remains today an artifact of 1970s commerce and an aesthetic statement of an era excited with technological progress yet concerned with environmental annihilation.

The poster fulfills its primary mission to sell theatre tickets to midcentury audience members looking for adventure, or science fiction, or a visual statement of environmental concerns, but it also exists as an intertextual artifact, an artistic interpretation of the film's characters and events in another medium. Akimoto's Work, in Barthes's terms, gives us an ancillary view of the film's Text, illuminating Trumbull's vision while enriching and expanding the film's meaning. The poster attracts the viewer by representing essential themes and conflicts within the film itself, while offering a nearly nostalgic appreciation—*an eco-memory*—for an environment already lost to the movie's characters. Trumbull's ecological message, perhaps more relevant today than fifty years past, represents an important cultural expression of 1970s Earth Day sensibilities that may yet, if we listen, save some future mechanical Dewey from the rough work of cultivating, eternally, a forest inaccessible to humanity.

NOTES

1. Pamela Duncan, "Silent Running," *Cinefex: The Journal of Cinematic Illusions*, no. 8 (April 1982): 36–67. Duncan provides a comprehensive overview of the *Silent Running* special effects.

2. Stefan Sharff, *The Art of Looking in Hitchcock's Rear Window*, 2nd ed. (New York: Proscenium, 2000), ix.

3. Marcus Hearn, *The Art of Hammer: Posters from the Archive of Hammer Films* (London: Titan Books, 2016), 6.

4. Stephen King, foreword, *Graven Images: The Best of Horror, Fantasy, and Science-Fiction Film Art from the Collection of Ronald V. Borst*, ed. Ronald V. Borst (New York: Grove Press, 1992), 4.

5. Mark Fertig, *Hang 'Em High: 110 Years of Western Movie Posters, 1911–2020* (Seattle: Fantagraphics, 2021), 31.

6. Ian Haydn Smith, *Selling the Movie: The Art of the Film Poster* (Austin: University of Texas Press, 2018), 7–8.

7. Duncan, 55.

8. Duncan, 49.

9. David Bartholomew, "*Silent Running*," *Cinefantastique* 2, no. 3 (Winter 1973): 45.

10. Robin L. Murray and Joseph K. Heumann, "Environmental Nostalgia in Eco-Disaster Movies of the Early 1970s," *The CEA Critic* 67, no. 2 (Winter 2005): 15.

11. Ingram, David, *Green Screen: Environmentalism and Hollywood Cinema* (Exeter: University of Exeter Press, 2000), 180–81.

12. Bartholomew, 46.

13. Gary Gerani, *The Art of Joe Smith* (Modesto: Dreams and Visions Press, 2020), 18.

14. For information about Akimoto and his movie poster work, see "George Akimoto—Film Poster Guru," Voices of East Anglia, http://www.voicesofeastanglia.com/2013/07/george-akimoto.html.

15. Robert E. McGinnis and Art Scott, *The Art of Robert E. McGinnis* (London: Titan Books, 2014), 96. Books on movie posters generally contain some reference to the various types and sizes of posters common in the industry. Ian Haydn Smith, in *Selling the Movies*, provides one such succinct list: "In the United States, the one-sheet was set at 27 x 41 inches (69 x 104 cm). Outside a cinema, a three sheet, spanning 41 x 81 inches (104 x 206 cm) was the usual size displayed, but a poster could reach the scale of a twenty-four sheet (246 x 108 inches, 625 x 247 cm). In Britain, the single sheet or double crown measured 20 x 30 inches (51 x 76 cm), although the more popular size today is the quad, which comes in at 40 x 30 inches (102 x 76 cm). Specific sizes in other countries vary" (6). One of the most extensive and useful lists appears in the Glossary section of *Graven Images*, listing nine poster formats for the United States and Great Britain. See *Graven Images*, page xv (see n. 3).

16. Peter Schickele, *Silent Running Original Soundtrack Album* (n.p.: Decca, 1972), 33$\frac{1}{3}$ rpm. The 1971 soundtrack release was commercially distributed in Germany, Italy, and Australia and available in the USA as a promotional release without the Akimoto cover. The recording was first widely distributed domestically on the Decca label in 1972. See the soundtrack release history at "Peter Schickele—Silent Running Original Soundtrack Album," *Discogs*, https://www.discogs.com/master/128738-Peter-Schickele-Silent-Running-Original-Soundtrack-Album.

Harlan Thompson, *Silent Running* (New York: Scholastic Book Services, 1972). For a brief biography of Harlan Thompson, see "Thompson, Harlan, The Encyclopedia of Science Fiction," https://sf-encyclopedia.com/entry/thompson_harlan.

17. Struzan in Gerani, 5.

18. McGinnis, 96.

19. The significance of movie posters as examples of persuasive visual rhetoric is widely recognized not only in the field of film studies but in areas of research as widely diverse as robotics and linguistic theory. See, for example, Yuti Matsuzaki, et al, "Could you guess an interesting movie from the posters?: An evaluation of vision-based features on movie poster database," in *2017 Fifteenth IAPR International Conference on Machine Vision Applications (MVA)* (IEEE, 2017), 538–41; Yunru Chen, and Xiaofang Gao, "Interpretation of the representational meaning of movie posters from the perspective of multimodal discourse analysis," in *International Conference on Education, Language, Art and Intercultural Communication (ICELAIC-14)* (Atlantis Press, 2014), 346–50.

20. Roland Barthes, *The Rustle of Language*, trans. Richard Howard (Berkeley: University of California Press, 1986), 57–59.

21. Johannes Mahlknecht, "Three Words to Tell a Story: The Movie Poster Tagline," *Word & Image: A Journal of Verbal/Visual Enquiry* 31, no. 4 (2015): 414.

22. Mahlknecht, "Three Words," 419.

23. Anderson, Kay and Shirley Meech, "Silent Running or: Where Have All the Forests Gone?" *Cinefantastique* 2, no. 2 (Summer 1972): 14.

24. Bartholomew, 46.

25. The Internet Movie Database (IMDB) contains crowdsourced whimsical wonders. One such gratifying trivium involves linguistic alterations in a foreign release of the film. "In the Italian version," one anonymous user relates, "the three drones are named after

'Paperino', 'Paperone' and 'Paperina' ('Donald Duck', 'Uncle Scrooge' and 'Daisy Duck') because calling them 'Qui', 'Quo' and 'Qua' ('Huey', 'Dewey', 'Louie') would have been cacophonous: 'Vieni qui, Qui!' ('Come here, Huey!')." See "*Silent Running* (1972) Alternate Versions," IMDB, https://www.imdb.com/title/tt0067756/alternateversions?tab=cz&ref_= tt_trv_alt.

26. Duncan, 66.

27. Anderson and Meech, 11.

28. Bill Cooke, "*Silent Running*," *Video Watchdog*, no. 97 (July 2003), 67.

29. Ingram, 181.

30. Cooke, 68.

31. Kermode, Mark, *Silent Running*, BFI Film Classics (London: Palgrave; London: British Film Institute, 2014), 83.

32. Struzan, *Joe Smith*, 7 (see n. 12).

33. Gary D. Rhodes, "The Origin and Development of the American Moving Picture Poster," *Film History*, no. 19 (2007): 228.

34. Fertig, 43.

35. Struzan, 5 (see n. 12).

36. *Silent Running*, directed by Douglas Trumbull (1972; n.p.: Arrow Video, 2020), Blu-ray.

37. Joshua Hull, *Underexposed!: The 50 Greatest Movies Never Made* (New York: Abrams, 2020).

BEAUTY AND HER BEASTS

Creature from the Black Lagoon and Beyond

FRANK PERCACCIO

A well-worn Hollywood anecdote tells of author William Alland hearing a story at a party at close friend Orson Welles's home that told of a man who had gone missing in a remote part of the Amazon after encountering a mysterious creature. The creature was said to be half-man, half-fish, and completely terrifying. Whether fact or fiction, this tale resonated with Alland, and a decade later, he wrote the preliminary notes for a story initially called "The Sea Monster," which would eventually become the feature-length film, *Creature from the Black Lagoon*,[1] directed by Jack Arnold and produced by Universal International Pictures in 1954.

Alland has pointed out that he could not help but draw comparisons to Jean Cocteau's classic postwar film *Beauty and the Beast* (1946) while working on *Creature from the Black Lagoon*.[2] Perhaps Alland believed that similarities to Jean Cocteau's narrative would draw in audiences, or maybe the existing fairy tale helped provide a framework for his contemporary horror film with a taboo attraction. Regardless, Alland tapped into our more profound fascination with interspecies sexuality and covertly inserted the tantalizing subject of ATU425A tales—those centered on the animal groom[3] into the postwar film's script.

In "A Psychoanalytic Bestiary: The Wolff Woman, The Leopard, and The Siren," Jennifer Stone posits that "the fantasy of bestiality occurs regularly in the literary and sexual imagination."[4] The vast international body of ATU425 tales is a testament to humankind's fascination with interspecies

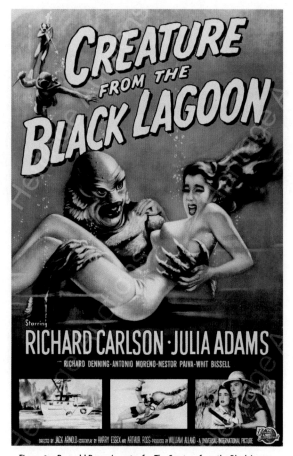

Figure 8.1. Reynold Brown's poster for *The Creature from the Black Lagoon*
(Jack Arnold, 1954).

sexual relations. The legends and folklore often bear out intertwined stories of romance and horror. This chapter focuses on how film poster art sexualizes relationships between human actors and their nonhuman romantic counterparts in *Creature from the Black Lagoon*, *Revenge of the Creature* (Jack Arnold, 1955),[5] *The Shape of Water* (Guillermo del Toro, 2017),[6] and other films.

I contend that no other horror film's poster art captures the subject's tension and taboo more strikingly than that for *Creature from the Black Lagoon*. This film art was so visually arresting that one could argue that moviegoers and poster art devotees were witnessing a gallery opening when approaching the marquee, viewing the glass-encased posters in cases, and taking in their local cinema's lobby. All of the promotional materials for this film touch upon

the vital tenets of horror film promotion. No wonder the movie's poster art materials have spawned such a vast body of interspecies film poster art. First, there is the wide variety of poster art materials produced for *Creature from the Black Lagoon*, hand-painted by Reynold Brown, the film poster artist for movies such as *Tarantula!* (1955),[7] *The Incredible Shrinking Man* (1957),[8] and *Attack of the 50 Foot Woman* (1958).[9] Later, long after the *Creature from the Black Lagoon*'s release, renowned film poster artist Drew Struzan was commissioned to paint a series of *Creature from the Black Lagoon* poster art pieces by Tony Calvert's company, Hollywood on Paper. Finally, the Gill-man was reimagined in the artistry of James Jean for Guillermo del Toro's *The Shape of Water*.

To thoroughly analyze *Creature from the Black Lagoon*'s comprehensive collection of promotional materials, each form of poster art should be examined. Perhaps the most recognizable of all film poster art is called a one-sheet. Before the 1980s, one-sheets were 27 inches by 41 inches and then rescaled to 27 inches by 40 inches. Of all traditional film poster types, one-sheets typically deliver the most information by combining multiple images with a considerable amount of text. In *Creature from the Black Lagoon*'s one-sheet, three shots set the scene and convey the action. The printed text on the poster informs us of the production's key players, but the viewer's gaze is inevitably drawn to the large central image of the Gill-man descending into the depths with female lead Kay Lawrence (Julie Adams). Carol Pollis's "The Apparatus of Sexuality: Reflections on Foucault's Contributions to the Study of Sex in History" analyzes Foucault's concept of "power as it penetrates and disciplines individual and social bodies, to denote the quintessential modern form of power-knowledge which objectifies while simultaneously creating subjectivities."[10] In the background, others are in pursuit, and the air bubbles escaping Kay's mouth express danger, but the Gill-man cradles Kay, holding her the way a groom may carry a bride. The Gill-man has the power in this image, and it is this sexually charged power that director Jack Arnold and the film's producers hoped would deliver results at the box office.

Not quite as popular as one-sheets, half-sheet posters were smaller than the one-sheets. At 22 inches by 28 inches, they were printed on card stock and displayed in theater lobbies. They first appeared in the 1910s and were essentially phased out by the 1980s. Sometimes half-sheets were produced with different significant images from the movie, adding to the variety of visuals designed to draw in audiences. *Creature from the Black Lagoon*'s promotional materials repeats the interspecies threat in two separate half-sheets. Both half-sheets provide stills of the film's action sequences and are seen in the pictures around the outer edge of the poster. The Gill-man looms

large in both, and Kay is clothed in her remarkably bright white bathing suit. Kay is seen in different poses, charging the posters with sexuality and emphasizing the Gill-man's apparent lust. While the Gill-man is inevitably posed as a menacing figure intent to deliver danger, he must also evince a desire for companionship. As the looming Gill-man reaches for Kay with his arms open, could his actions be interpreted as an embrace instead of assault and murder? Another consistent element in all of *Creature from the Black Lagoon*'s film poster art concerns the lack of blood and gore. While the Gill-man may appear menacing—consider the absence of blood, cuts, or scratches anywhere on Kay's body in any of the poster images—not all of the Gill-man's tendencies apparently lean towards physical acts of violence.

Movie promotional materials were not restricted to marquees or glass cases outside the theaters. Once filmgoers entered the theater, they encountered lobby cards, often emblazoned with attention-grabbing text and accompanied by a still of an important scene from the movie. Ronald Borst's *Graven Images* offers this description of lobby cards: "there were typically eight lobby cards to a set. The first card in the set was usually the 'title card.' . . . The other seven were 'scene cards,' usually photos of scenes from the movie that had been hand-tinted, with the film's title at the bottom of the card."[11] Nearly all of the lobby cards for *Creature from the Black Lagoon* feature the Gill-man. Still, one interesting choice excludes the Gill-man; instead, this lobby card focuses on an image of Kay from behind, in her bathing suit, as she climbs from the water to the perceived safety of the boat. The image presents Gill-man's point of view and offers a potential motive for his actions.

Borst presents a description and suggests a purpose for industrial insert cards: "This vertical poster is also made of heavier card stock. The slender frame that held it had an opening at the top, so the poster could be inserted and slid down until it reached the base of the frame—thus the name 'insert card.'" He goes on to say: "with extremely rare exceptions, there was never more than one style of insert card produced for any one film."[12] *Creature from the Black Lagoon*'s insert cards are notable for one critical reason. Much of *Creature from the Black Lagoon*'s poster art presents sexually suggestive images. However, in one insert card, text is used, in the case of the movie's title, to separate Kay from the Gill-man safely. Rather than relying upon an image to project the interspecies interaction, the message is directly stated across the top of the insert card: "Centuries of passion pent up in his savage heart," a statement that reinforces the interspecies relationship in an alternate format. By stating the Gill-man's intentions directly, the moviegoer is provided insight into motive, reinforcing the sexualized taboo central to the narrative.

Another form of *Creature from the Black Lagoon* poster art material is the 24-sheet. 24-sheets have been given their name because they have been described as 24 times the size of a one-sheet. 24-sheets are billboard posters, typically measuring 9 feet by 12 feet. A key feature of *Creature from the Black Lagoon's* 24-sheet relies on the long visual lines of the swimmer: Kay's lissome calf appears to be nearly in the Gill-man's grasp. Scenes from the film line the bottom of the 24-sheet and offer glimpses into the film. However, the frozen action, capturing a climactic yet unseen moment, is reminiscent of Keats's lover's "mad pursuit" in "Ode on a Grecian Urn."[13] There is, of course, a significant exception: the audience members of *Creature from the Black Lagoon* saw that colossal image armed with the understanding that in the film the action would be continuous, and the Gill-man might reach Kay in her "struggle to escape"—unlike Keats's trapped lovers. Similarly captured in their frieze, the hunter and the quarry are eternally caught in their tense, unresolved pursuit.

The focus on the sexual charge between Kay and the Gill-man in *Creature from the Black Lagoon* is ubiquitous, appearing in nearly every form of poster art and advertisement. It follows suit that the interspecies fascination went well beyond promotional materials in the United States, and similar motifs were employed internationally. In posters from Germany, Italy, Finland, and France, the Gill-man cradles Kay, furthering the hint of pursuit and capture and suggesting that the posters' images serve as a prelude to something other than evisceration. In "Listening to Krao: What the Freak and the Monster Tell Us," Theodora Goss includes the Gill-man as she reminds us that "we fear the monster, as we fear Frankenstein's creation, Dracula or the *Creature from the Black Lagoon*, but we are also attracted to it."[14] The point could be made that while repulsed by the fantastic creatures, we are simultaneously drawn to them and what they may represent. Goss notes: "That is because the monster allows us to escape from the categories of the world. We are attracted not only to the monster, but also to what it represents: the chaos underlying meaning."[15] The international promotional materials for *Creature from the Black Lagoon* offer little in the way of literally depicting scenes from the film. Yet each one assuredly capitalizes upon the interspecies sexuality, evidenced clearly in Kay's vulnerable, nearly nude depiction in the posters and in the grasp of the Gill-man. *Creature from the Black Lagoon* artist Reynold Brown's posters serve as memorable cultural artifacts, capturing what was relevant when it was produced.

Perhaps none of Brown's film posters are as historically significant to film poster aficionados as Nathan Juran's 1958 Woolner Brothers Pictures release, *Attack of the 50 Foot Woman*. In "Sexuality and Development: A Story in

Pictures" Sonia Correa states that "sex essentialism, that is (i.e.) the idea that sex is a given biological drive directed towards the reproduction of the species remains an underlying assumption of conceptual frames."[16] In *Attack of the 50 Foot Woman*'s poster, the gigantic, angry monster, Nancy Archer (Allison Hayes), is a dynamic sexualized image. As Nancy Archer straddles a freeway like a glamorous colossus with automobiles in her hand, she elicits excitement. Still, she also frightens us, pushing the limits of repulsion and attraction.

Director Jack Arnold, writer William Alland, and artist Reynold Brown reunited for *Revenge of the Creature*, Universal International Pictures' 1955 film. The sequel's poster art revisits familiar tropes from *Creature from the Black Lagoon*, replete with the Gill-man and a scantily clad heroine. In this film, the Gill-man's object of affection is Helen Dobson (Lori Nelson). In this film, the Gill-man is trapped and imprisoned in a Florida aquarium. The creature escapes from his enclosure to the safety of the open water, and eventually returns. He then finds and abducts Helen. The film's poster artwork takes a more aggressive stance than *Lagoon*'s, and Brown proffers a Gill-man with greater rage and sexual suggestiveness in much of the promotional material. In one poster image, Helen is shown unconscious, in a semi-sheer garment exposing much of her body and rendering an aura of vulnerability. However, as Helen is shown essentially lying across the Gill-man's abdomen, there is a conspicuous absence of a phallus. Stone notes "the absent phallus in a real object but which allegorizes it in a hybrid figure, despite the gender-neutral appearance."[17] In this case, despite the direct representation of arousal, the implication suggested in the poster implies planned sexual activity.

Revenge of the Creature brings the unknown, chaotic, and fantastic within the confines of an artificial environment where the Gill-man is studied and exploited. Within the narrative, tensions rise by bringing the wild unknown into the relative safety of modern society, thus increasing the potential for violence and danger. The message is further implied in another image in the *Revenge of the Creature*'s poster art. Helen is slung lifelessly over the Gill-man's shoulder to be carried away like a vulnerable trophy.

There is a long, international account of mythological creatures, deities transformed, and enchanted animals engaging in sexual activity with humans. Barbara Fass Leavy's *In Search of the Swan Maiden* delves deeply into interspecies romantic connections. In chapter four, titled "Animal Groom," she recounts several seminal tales in western culture that set up the archetype of the human/bestial relationship. In this chapter, Leavy discusses the Cupid and Psyche[18] tale and how it serves as a forerunner for interspecies

tales.[19] When critically scrutinized, we can see how that particular tale would become the starting point for so many tales that would come under what Swan labels as type 425 tales,[20] specifically tales with animal marriage as a central trope. In addition to the mythological story of Cupid and Psyche, myriad narrative center on a mortal pairing with a supernatural or animal husband. One such is the story of Leda and the swan, and another is Zeus and Europa. As in many seminal folklore tales, we observe the fusion of the supernatural and the bestial within a singular character. In these cases, Zeus, king of the gods, appears in the guise of a swan to Leda and as a bull to Europa. These mythological encounters reveal another common characteristic of tales of this type—and the potential for violence—during these predatory encounters. In *Creature from the Black Lagoon*'s film poster art, Reynold Brown effectively taps into our innate fear, a sense of repulsion when supernatural or bestial partners couple with human female companions.

When Jack Arnold first heard about the legend of the Yacaruna, a folklore legend from the Amazon River basin, he began to conceive the story that would eventually become the Gill-man from *Creature from the Black Lagoon*. Jack Arnold's *Creature from the Black Lagoon* taps into the ancient connection between humans and nonhuman and supernatural creatures. In the film art connected to the movie, we see first and foremost the creature who cradles the lead female character in his arms as he returns to the water, which is his realm. As the men within the group of exploring scientists seek to destroy the "monster," the monster intends to abscond with the female to be his lover. A vital element of the Yacaruna legend focuses on the figure seducing rather than merely overpowering a woman and ultimately leading her away to his underworld city.

According to Teresa Banes's *Encyclopedia of Demons in World Religions and Cultures*, the Yacaruna is also known as the river person and the patron saint or tutelary spirit of the Peruvian Amazon and of all lakes and rivers in that area. The Yacaruna can take the form of any amphibian. The Yacaruna's most common form is that of a toad. He is also known to live in a magnificent, inverted city on the bottom of a lake or river.[21] William Alland undoubtedly wove a component of the Yacaruna legend into his story, which would be realized in the promotional materials—whether it was an insert card stating the Gill-man's intentions or the striking visual of him cradling Kay in his arms as he contrives to take her back to his underwater home—and the elements of folklore would be evident in the movie's narrative and advertising.

Piscine and aquatic humanoid figures appear in many cultures and nearly every continent. For example, in Japanese folklore, the Kappa is often depicted as a quasi-humanoid toad with a turtle's shell on its back. The Kappa

is usually described as a mischievous creature rather than an amorous one like the Yacaruna. However, like the Yacaruna, the Kappa interacts with humans periodically and makes its home in rivers and lakes.

Just as William Alland worked the Yacaruna legend into his script, Jean Cocteau employed elements of folklore and romance in *Beauty and the Beast*, including Marie de France's "Bisclarvet."[22] This twelfth-century poem tells the tale of a nobleman who holds a terrifying secret. After much questioning on her part, he tells his wife that he is "lost to her" for three days each week because he is a werewolf.

One illustration from Marie de France's "Bisclarvet" features the scene in the poem where the betrayed werewolf/nobleman attacks his wife in revenge while still in wolf form. The action depicts the werewolf about to cover her entire body in his attack, leaving a viewer with a sense that in a moment, he will indeed be upon her, and perhaps not to merely inflict a wound.

Leavy's critical point is that nonviolent interactions often occur between supernatural/bestial males and human female partners, and a curse must be lifted for the romance to proceed. This motif is especially evident in "Bisclarvet." Each *Beauty and the Beast* installment explores this motif in-depth in its poster art.

Jean Cocteau's *Beauty and the Beast* uses several types of poster art as promotional materials. These posters are elevated to works of art. They were hand-painted and resembled portraits conveying a dramatic visual text. For instance, Cocteau's film's poster art illustrated an element of longing and romance in Belle's eyes, while the Beast looks at his beauty with forlorn love that despairs being realized.

While the images in some of *Beauty and the Beast*'s poster art are not actual stills from the photographed movie, they convey the intimate romance and attraction central to the narrative. However, other film poster art for *Beauty and the Beast* suggests a more representative image consistent with the narrative to the viewer. One key element of this film was Jean Cocteau's casting of Jean Marais to play the dual role of the Prince and the Beast. By having Marais play both roles, Cocteau could present the Prince's beastly elements and the Beast's princely aspects, an analog for the fluidity of human sexuality and longing. In the Danish *Beauty and the Beast* poster, Belle lies supine, eyes closed, a rose placed just to the right of her chin directly above her with his eyes closed. He looks very human, even in his beast form, and thus this is a much more realistic image of Marais in character.

Just as Leda and Europa are frightened by and ultimately traumatized by Zeus's brutality, *Creature from the Black Lagoon*'s Kay Lawrence (Julie Adams) is similarly shocked when the Gill-man shows an interest in her.

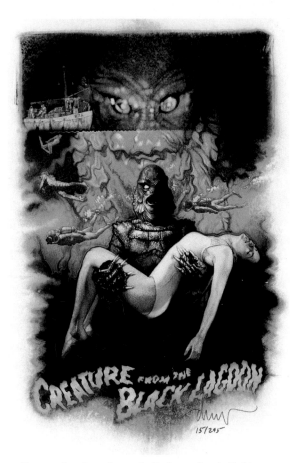

Figure 8.2. Drew Struzan's poster for *The Creature from the Black Lagoon*.

When the Gill-man and Kay meet, he shows an interest in Kay that, while threatening, is not murderous. Reynold Brown's gender-specific promotional materials reveal the sharp contrast between how the men challenge the Gill-man, while in each image with Kay, there are sexual strains.

In 2001, famed artist Drew Struzan revisited Brown's *Creature from the Black Lagoon* poster art when commissioned to create his vision of the film's celebrated one-sheet poster art. Struzan has often discussed his love for film poster art and Reynold Brown's influence on the genre. Brown had once been his art teacher, and Struzan wished to pay homage to his mentor's work in his *Creature from the Black Lagoon* poster art. Drew Struzan published a book of artwork, *The Art of Drew Struzan*, and Patrick Fahy offered this analysis of Struzan's style: "much imitated, remains distinctive: striking, often witty compositions lavished with detail; uncanny, Ingres

like portraiture; chunky outlines and bold brushwork."[23] Struzan was also given a "career retrospective at the Norman Rockwell Museum in Stock-bridge, Mass."[24] in 1999. And when interviewed, Struzan stated, "a poster becomes that one image that represents the entire film . . . If it's accurate and truthful and has good spirit, it resides with you forever."[25] In 2014, when interviewed by *Entertainment Weekly*'s Keith Staskiewicz, Struzan articulated the importance of movie poster art: "Movies are the art of our times. . . . I get to be the first thing out of the bag when it comes to a movie, the thing that sticks in people's minds and that they hang on their dorm room walls."[26] Known for creating poster art for movie series ranging from *Back to the Future*[27] to *Indiana Jones and the Raiders of the Lost Ark*[28] to *Star Wars: Episode IV—A New Hope*,[29] Struzan's recreation of *Creature from the Black Lagoon* poster art incorporated elements of his work along with motifs from Brown's poster art.

The most popular Struzan poster features the Gill-man cradling Kay. The poster has characteristics emblematic of Brown's original poster art. Still, Struzan's poster also features the Gill-man's illustrated bust, which appears to loom over the entire watery scene. Struzan also updated the medium by employing a different technical process. Struzan used a modern method called giclée. Giclée is relatively similar to ink-jet printing insofar as it sprays droplets of ink onto paper but differs in significant ways. For example, the print holds far more droplets of ink than typical ink-jet printers, and the paper the image is printed on must be a specific type of acid-free paper produced on a high-end professional printer. The color intensity, seamless-ness of the blending, and exceptional resolution allow Struzan to capture the watery scenes seamlessly, as the green and blue hues blend perfectly to create memorable and haunting scenes.

Released in 2017 by Double Dare You productions and Fox Searchlight Pictures, director Guillermo del Toro's *The Shape of Water* revisits the Gill-man's story. *The Shape of Water*'s narrative falls more in line with the plotline of *Revenge of the Creature* as the story takes place within the confines of a laboratory setting, far from nature or the Black Lagoon itself.

However, there is a significant break in this retelling of the earlier version. In del Toro's film, elements of menace, fear, the unknown, and interspecies contact. *The Shape of Water* updates this storyline by creating a reciprocal romance between the Gill-man, now billed as Amphibian Man (Doug Jones), and Elisa Esposito (Sally Hawkins).

Director del Toro has also sought, as Michael Uzendoski suggests, to serve as one of the storytellers "less concerned with cultural boundaries than they are with natural ones." [30] For example, in del Toro's 2004 Sony Pictures

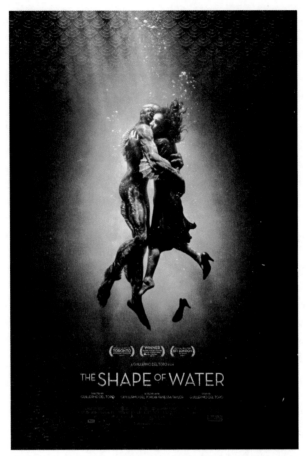

Figure 8.3. James Jean's poster for *The Shape of Water* (Guillermo del Toro, 2017).

release *Hellboy* the title character, the spawn of Satan, is conceived in a way that fuses popular culture ideas and visual images of what Satan might look like, along with direct elements of Mike Mignola and John Byrne's original graphic novel, *Hellboy: Seed of Destruction*.[31] Interestingly, del Toro called upon one-time *Creature* artist Drew Struzan to create the film poster art for *Hellboy*.

When Guillermo del Toro contemporized *Revenge of the Creature* in 2017, he again tapped actor Doug Jones, who played Abe Sapien (an aquatic amphibian-like humanoid creature) in *Hellboy*, to play the title role in *The Shape of Water*. Del Toro's Amphibian Man in *The Shape of Water* incorporates multiple aspects of the Yacaruna legend. In *Creature from the Black Lagoon* poster art, Jack Arnold's Gill-man may have romance on his mind, but the central image is menacing. A substantial element of the Yacaruna

legend and many other aquatic humanoid lover legends often attribute an element of romance and seduction to the aquatic creature. When we encounter del Toro's creature, the features of seduction and romance are firmly established and developed throughout the film. For *The Shape of Water*, del Toro turned to "fine art painter and sculptor, Taiwanese-American visual artist James Jean."[32] James Jean worked directly with del Toro to design the artwork for *The Shape of Water*. The impressionistic nature of interspecies relations in the dark, watery scenes is evident throughout the film's poster artwork. The passionate embrace between Amphibian Man and Elisa is the central focus of James Jean's designs.

James Jean discusses his creative process: "My approach was more subtle and sensitive"[33] he notes, as evidenced in his film poster where Amphibian Man and Elisa are locked in a tight embrace. When asked about how he created his finished artwork in "James Jean Covers Art," he stated, "The most challenging thing for me is the color, because in Photoshop you have a full spectrum to work with at the touch of a button and in painting, you have to mix your colors."[34] Jean's depiction sharply contrasts with Kay's protestations in Jack Arnold's *Creature from the Black Lagoon*. Jean's illustration breaks the tradition of human/creature encounters typically depicted in horror movies not only in his content and the message Jean intends to project but also in the way colors of the *Shape of Water*'s artwork convey a buoyant, weightless atmosphere as Amphibian Man and Elisa hold fast to one another in their watery realm. However, del Toro's film is not so much a horror film as it is a fable reflecting and amplifying the original Yaquinto legends of the Amazon basin and, along the way, exploring themes of romance.

While *Creature from the Black Lagoon*'s poster art and the film narrative may gingerly hint at an interspecies sexual encounter, *The Shape of Water* addresses the issue directly, which ties in closely with the poster art's romantic theme. In *The Shape of Water*, the matter of Amphibian Man's absent phallus is discussed between Elisa and her friend, Zelda Fuller (Octavia Spencer). In "Love in the Visual Field: Cinephiliac Moment, Truth-Event, Movement of Thought," Jeremy de Chavez points out, "Love thus attempts to work out the problem of sexual difference not through the concepts available within existing situations but through a transpositional truth that exceeds the two positions of nonrapport."[35] In many legends of the Amazon, the amphibious lover is a shapeshifter, becoming a pink dolphin. This dolphin's phallus is also an element of the myth. The mechanism of human and nonhuman sexual encounters is explored in del Toro's film. Specifically, in one scene, Zelda asks Elisa how they have managed to consummate their relationship. Using hand gestures, Elisa explains that a panel moves aside to make way for Amphibian

Man's genitalia to emerge. While this contemporizes the creature by sexual-izing Amphibian Man, del Toro returns to the haunting original legend.

In addition, Judy Adamson's "Source of Life" presents the concept of mul-tispecies ethnography. One of the critically significant historical figures she examines is Alexander von Humboldt, a scientist who explored the Amazon in the 1700s and interacted with its indigenous populations. After visiting the Amazon region, returning home to Europe, and sharing his viewpoints, Adamson points out that "Humboldt considered 'nature' as a 'planetary interactive causal network operating across multiple scale levels, temporal and spatial.'"[36] Apparently, the networking includes interspecies coupling and its discontents. In light of von Humboldt's work, along with the progression of interspecies integration from folklore to modern cinema, it follows that the interspecies motif in promotional materials will continue to develop and provide us with additional intertextual frameworks worthy of analysis.

Species[37] and *Avatar*[38] are two other films that serve as intertextual itera-tions of the interspecies motif. Director Roger Donaldson's 1995 *Species* stars Natasha Henstridge as Sil, an alien who has come to Earth specifi-cally to become impregnated by a human in order to subvert the terres-trial species. The trope is contemporized by incorporating the technology of the mid-1990s, a feminine lead as the central specter, and the threat of extraterrestrial invasion. The accompanying poster art reinforces the sexual aspect of the interspecies relationship in nearly every iteration. Natasha Henstridge is shown in various stages of undress. At times she is nearly nude in a semi-human, semi-alien form or posing in suggestive futuristic costumes. Regardless, the audience knows she is an extraterrestrial bent on destroying humanity yet sees her as a sexually compelling creature despite the dangers she presents.

James Cameron's *Avatar* may also be viewed as an intertextual continu-ation of the forbidden interspecies relationships motif serving as the core precept of the narrative. In *Avatar*, humankind is the invading species on the planet Pandora, and interspecies relations are not going well. Sam Worthing-ton's character, Jake Sully, is a person with paraplegia who employs futuristic technology to create an avatar and set his human self aside to interact with the native Na'vi on their terms in their world. As the narrative unfolds, a romance develops between Sully and one of the esteemed female figures in Na'vi society, Neytiri (Zoe Saldana). Their interspecies affair becomes a central component of the film and is highlighted in the movie's poster art. Lisa Sideris's "I See You: Interspecies Empathy and *Avatar*" asks, "What, for example, are the limits of human emphatic capacities (does empathy depend upon sameness and familiarity)?" The author later adds, "*Avatar* is

replete with themes of empathy and emphatic bonding, as well as spiritual and physical interconnection."[39]

Promotional materials for *Avatar* feature Sully and Neyriti, and the art-work suggests that there is a relationship between the two. One poster in particular has traits reminiscent of Jean Cocteau's *Beauty and the Beast* poster art, in which the Beast and Belle's faces are near one another in the image, but in reality, they are very far apart. Similarly, the details of Zoe Saldana's human physiognomy are scarcely visible underneath her makeup, much like Jean Marais's features could still be seen under his fur when he played the Beast.

At the exhibition of his movie poster art at the Norman Rockwell Museum in 1999, Drew Struzan reflected on how the industry has changed and said his work was "about a period in history that came and went, and my feeling is it is not coming back . . . for better or worse, the computer has changed the direction of image-making."[40] His lament is valid, and there is no doubt that we have lost many artisanal crafts to the digital arts. As the technology continues to develop, we see evidence of this intertextual landscape in promotional materials, video games, comic books, and graphic novels—much of can could be traced thematically to *Creature from the Black Lagoon*'s poster art.

NOTES

1. Jack Arnold, dir. *Creature from the Black Lagoon*; perf. Richard Carlson, Julie Adams (US: Universal International Pictures, 1954), film.

2. Jean Cocteau, dir. *Beauty and the Beast*; perf. Jean Marais, Josette Day (France: DisCina, 1954), film.

3. Barbara Fass Levy, "The Animal Groom.," in *In Search of the Swan Maiden: A Narrative on Folklore and Gender* (New York: NYU Press, 1994), 101–155.

4. Jennifer Stone, "A Psychoanalytic Bestiary: The Wolf Woman, The Leopard, and The Siren," *American Imago* 49, no. 1 (1992), 117–52.

5. Jack Arnold, dir. *Revenge of the Creature*; perf. John Agar, Lori Nelson (US: Universal International Pictures, 1955), film.

6. Guillermo del Toro, dir. *The Shape of Water*; perf. Sally Hawkins, Michael Shannon (US: Fox Searchlight Pictures, 2017), film.

7. Jack Arnold, dir. *Tarantula!*; perf. John Agar, Mara Corday (US: Universal International Pictures, 1955), film.

8. Jack Arnold, dir. *The Incredible Shrinking Man*; perf. Grant Williams, Randy Stuart (US: Universal International Pictures, 1957), film.

9. Nathan Juran, dir. *Attack of the 50 Foot Woman*; perf. Allison Hayes, William Hudson (US: Woolner Bros. Pictures, 1958), film.

10. Carol A. Pollis, "The Apparatus of Sexuality: Reflections on Foucault's Contributions to the Study of Sex in History," *Journal of Sex Research* 23, no. 3 (1987): 401–408.

11. Ronald V. Borst and Margaret A. Borst, eds., *Graven Images: The Best of Horror, Fantasy, and Science-Fiction Film Art from the Collection of Ronald V. Borst* (Grove, 1992).

12. Borst and Borst, *Graven Images*.

13. John Keats, *Ode on a Grecian Urn and Other Poems* (Whitefish, MT: Kessinger Pub, 2010).

14. Theodora Goss, "Listening to Krao: What the Freak and Monster Tell Us." *Conjunctions*, no. 59 (2012): 148–55.

15. Goss, "Listening to Krao."

16. Sonia Corrêa, "Sexualities and Development: A Story in Pictures," *IDS Bulletin* 37, no. 5 (2006), 12–20.

17. Jennifer Stone, "A Psychoanalytic Bestiary: The Wolff Woman, The Leopard, and The Siren," *American Imago* 49, no. 1 (1992), 117–52.

18. M. J. Edwards, "The Tale of Cupid and Psyche," *Zeitschrift Für Papyrologie Und Epigraphik*, no. 94 (1992): 77–94.

Edwards provides the following description of the tale, the following represents a significant summarization of the narrative: Psyche is a princess, so illustrious for her beauty that the people worship her as an earthly Venus (Metamorphoses IV.28). The heavenly Venus, here an imperial figure moved to wrath (IV.29), persuades the infant Cupid to ruin Psyche (IV.30-1), and the consequence is that, though she is revered like the simulacrum of a goddess (IV.32), she is never sought in love. In obedience to an oracle, she is exposed upon a mountain, where a monster is expected to devour her (IV.33-5); but instead she is conveyed to a gorgeous palace (V.l), and is served by unseen ministers in the daytime (V.2), while her unseen bridegroom sleeps with her at nights (V.3-4).

19. Barbara Fass Leavy, "The Animal Groom," in *In Search of the Swan Maiden: A Narrative on Folklore and Gender* (New York: NYU Press, 1994), 101–155.

20. Jan-Öjvind Swahn, "'Beauty and the Beast' in Oral Tradition," *Merveilles & Contes* 3, no. 1 (1989): 15–27.

Swahn notes the following on animal groom folktales: "There are more than 300 registered copies of version 425C, 'La Belle et la Bète,' from oral tradition, noted in scholarly investigations of type 425 or taken up in published or non-published folktale type indices."

21. Theresa Bane, *Encyclopedia of Demons in World Religions and Cultures* (Jefferson, NC: McFarland & Company, 2012).

22. R. Howard Bloch, *The Anonymous Marie de France* (Chicago: University of Chicago Press, 2003).

23. Patrick Fahy, "The Art of Drew Struzan," *Sight & Sound* 20, no. 11 (2010): 92.

24. John Kehe, "Master of the Movie Poster," *Christian Science Monitor*, September 9, 1999.

25. Kehe, "Master of the Movie Poster."

26. Keith Staskiewicz, "The Jedi Artist," *Entertainment Weekly*, nos. 1321/1322 (July 25, 2014), 50–57.

27. Robert Zemeckis, dir. *Back to the Future*; perf. Michael J. Fox, Christopher Lloyd (US: Universal Pictures/Amblin Entertainment, 1985), film.

28. Steven Spielberg, dir. *Indiana Jones and the Raiders of the Lost Ark*; perf. Harrison Ford, Karen Allen (US: Lucasfilm Ltd., 1981), film.

29. George Lucas, dir. *Star Wars: Episode IV—A New Hope*; perf. Mark Hamill, Harrison Ford (US: Lucasfilm Ltd., 1977), film.

30. Juan Carlos Galeano, *Folktales of the Amazon* (Westport, CT: Libraries Unlimited, 2009).

31. Michael Mignola, *Hellboy: Seed of Destruction* (Dark Horse Books, 2018).

32. "Complete Edition of Visual Artist James Jean," *Korea Herald*, April 10, 2019.

33. "The World of James Jean," *Manila Bulletin*, January 8, 2010.

34. "The World of James Jean."

35. Jeremy De Chavez, "Love in the Visual Field: Cinephiliac Moment, Truth-Event, Movement of Thought," *Journal of the Midwest Modern Language Association* 51, no. 1 (2018): 55–73.

36. Joni Adamson, "Source of Life: Avatar, Amazonia, and an Ecology of Selves" in *Material Ecocriticism*, eds. Iovino, Serenella, and Oppermann, Serpil (Bloomington: Indiana University Press, 2014).

37. Roger Donaldson, dir. *Species*; perf. Natasha Henstridge, Michael Madsen (US: MGM Pictures, 1995), film.

38. James Cameron, dir. *Avatar*; perf. Sam Worthington, Zoe Saldana (US: 20th Century Fox, 2009), film.

39. Lisa H. Sideris, "I See You: Interspecies Empathy and Avatar," *Journal for the Study of Religion, Nature & Culture* 4, no. 4 (2011): 457–77.

40. Catherine Applefeld Olson, "Film-Poster Exhibit Features Rockwell, Struzan," *Billboard* 111, no. 24 (1999): 47.

Chapter 9

SHUTTER ISLAND

A Doppelgänger's Dream

COURTNEY RUFFNER GRIENEISEN

Shutter Island, a 2010 film directed by Martin Scorsese, lures the audience to an island where a patient has gone missing. This film, dubbed by Arnaud Schwartz as a puzzling psychological detective story, toggles between the reality of mental health disassociations and the complexity of Hitchcockian noir tenants.[1] Suspense and crime are at the top of that criterion list marking Scorsese's film as one that situates itself within this genre of film study; however, the debt to the noir genre that *Shutter Island* owes is found in the psychology of the film's main character. Leonardo DiCaprio plays US Marshall Edward (Teddy) Daniels who is investigating a case where a patient has gone missing from a psychiatric facility on an island. It is within the characterization of Teddy that we find the essence of film noir and Scorsese's homage to the genre. Teddy is complex. As we know, Marshall Daniels is good at his job. He gets up close and personal in his zest to find the missing patient. Scorsese is able to situate DiCaprio's character in a way that shows the thriller aspect of the film through the psychology of the character. We come to find that Marshall is actually the patient Andrew Laeddis who has *escaped* from the facility. Laeddis has been sent to the facility because he killed his manic-depressive wife after she drowned their three children.

While *Shutter Island* does not take place within the specific years associated with noir film, it does master the psychological aspect that Cornell Woolrich suggests is the key difference between basic crime film and noir. The doppelgänger story stands as a strong element in the psychological

160

thriller. The film's quick cuts and use of montage along with flashbacks, shadows and, low-key lighting throughout heighten the intensity and suspense as we walk with Teddy through his case file to tackle the case of the missing patient. It is in these elements of the psychological thriller that we come to find that Teddy is Andrew, a shocking revelation for the audience. Even before we know of the duality in Teddy's character, we are compelled to pay attention because the film itself plays with us as audience. We are forced to pay closer attention because there are things about the character that lead us to believe that something is missing or unreal like the intermittent flashback scenes coupled with the many instances of shadowing of light and images leading to the feeling of entrapment and frequency of camera angle shifts. As a viewer, we are both entertained and captivated by these manipulative measures utilized by Scorsese. However, before the experience takes place, the actual viewing of the film, potential viewers are exposed to a glimpse of what to expect in the upcoming film, the film poster regarded as a paratext to the main event.

In determination of that which we come to understand as the precursor to the film, the very *thing* that excites us for the active viewing of the film, the poster, is the text that stands as a symbol of the vortex that the director has created. As Gérard Genette states,

> the paratext is for us the means by which a text makes a book of itself and proposes itself as such to its readers, and more generally to the public. Rather than with a limit or a sealed frontier, we are dealing in this case with a threshold, or—the term Borges used about preface—with a "vestibule" which offers to anyone and everyone the possibility either of entering or of turning back."[2]

With this single still framing, our desire to enter the portal that is the film, an abundance of pressure is forced onto the elements of the image so that the general public consumes the representation in so far as we want to invest time into the viewing of what stands on the inside of the poster. All this is to say that the film poster is the *vestibule* to the main event, and without this paratext, our little taste of what is to come, viewers are more likely to bypass the entire viewing experience simply because they did not have the pre-film experience to entice them into the main event.

As Thomas Stubblefield aptly suggests, in working with Roland Barthes's "The Responsibility of Forms," Barthes's concepts seize the still image, rendering it as a sort of "implied presence of a 'diegetic horizon'" which draws the central image forward without physicality in motion.[3] Essentially, the

idea of the still (here, the poster) acting as an utterance that serves as a vehicle for the viewer to experience the cinematic feature without actively watching the film the poster represents. Concentrating on the "paratext," the American film poster for Scorsese's 2010 film *Shutter Island* and by using Baudrillard's conceptualization of "use-value" and "the sign"[4] along with what Debord labels as the "spectacle,"[5] I am able to situate my discussion on the viewing audience as they buy into the sign which is a manifestation of the real and appears as a redoublement of the simulation of identity of the DiCaprio character leading us into a false sense of signification. In essence, the poster as text stands as a forced pre-read of the film muddling the viewer's conception of what will happen on the island and with Teddy's true identity.

One important object missing in the paratext that is key to the success of the film, and to the action that leads us to the island where most of the important activity takes place, is the boat that takes Teddy to the island. When the film itself opens, Teddy is on that boat. We have no reason to suspect that the boat is not real or part of the unreal we will be subjected to through the rest of the movie, because we have yet to experience any of the functions of the film genre that make us suspect to the thriller in the film. We have only to work with what poster designer Scotson Clark offers us in Gary D. Rhodes's article titled "The Origin and Development of the American Moving Picture," "the mission of the poster is to attract people . . . [it] must tell them in as few words as possible what they will see when they get inside . . . [it] must excite their curiosity" to make them pay to view the film.[6] Whenever we look at the poster, essentially we are supposed to see the encasement of what the film is about, except here in the official American poster, we are missing an extremely important piece of the film, the boat that serves as a vehicle for Teddy to gain access to Shutter Island and perhaps for the viewers to gain access to the essence of the film as well. It is impossible to view *Shutter Island* and not recognize the boat as a portion of Teddy's identity. Having this key symbol missing in the paratext to the film is like ignoring one of the main archetypes of a psychological thriller like this one offers its viewers.

In consideration of the *Shutter Island* American film poster, the Signifier is the phrase "Someone is Missing," which brings out the signified, the concept of Identity in the film. This concept then becomes a sign equaling a system. This sign/system influences what is perceived as the "real" Teddy/Identity. Essentially, the words associated with the product become part of the commodity of the image being sold as the doppelgänger figure in *Shutter Island*. The Signifier as tagline is placed in the darkest portion of the poster directing the viewer to associate the Signifier with mystery and intrigue.

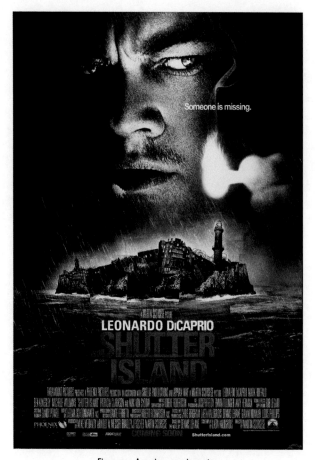

Figure 9.1. American movie poster.

Next, we have to take into consideration the subject of the viewer. The viewers of *Shutter Island* are watching layers of simulation, a sort of redoublement. The viewer is taking part in a doubling effect via a myth. In this case, the myth is the commodification of Leonardo DiCaprio's name and his fame brought on by his multiple roles in previous films. His identity is constructed as a product that sells the idea that we want to see him in the role of Teddy in this new film. Baudrillard asserts that myths "are not comprised of content. They are a process of exchange and circulation of a code whose *form* is determinant."[7] Because of this exchange and circulation process, the "identity" in question becomes form. In this version of the film's poster, the concept of the narrative has been skewed by the license taken in order to sell the film through the poster image with DiCaprio's name attached.

Follow this model:

The Signifier (the phrase "Someone is Missing") induces
The Signified (concept of Identity / Doppelgänger) and it becomes a sign
The Referent (the film itself) is the effect or rather a perception (of
 self and others)

The paratext as Gerard Gennette suggests "is a sub-text that supports a main text and shapes an audience's perceptions and knowledge of the main text."[8] Paratexts allow us to situate ourselves around the text. Here, our film poster acts as paratext for the film. It skews our perceptions of the DiCaprio character and situates us in a position that challenges our notions of what is real and what is part of the unreal. The real vs. the unreal can be seen in the film poster where the isolation of the island seated underneath the darkness of the main character sets us up for a dichotomy in identity throughout the film. This vertical balance, juxtaposed by the symbol of fire, illustrates the depth of secrecy and loneliness the DiCaprio character feels as he is brought through the criminal investigation untangling what is his reality.

In his essay "Rhetoric of the Image," Roland Barthes explains that the image can only be a collective "re-presentation" because we attach codes, meanings, and experiences to images. He points out that "the image is in a certain manner the limit of meaning."[9] Barthes's reasoning is pertinent to Baudrillard's discussion regarding the sign, because Baudrillard suggests that the phrase "Someone is Missing" can be viewed as a code that, conceptually, is a myth. Since myths are not "comprised of content, they are a process of exchange,"[10] leading to a consumerist bartering. The phrase becomes currency that can be sold to an audience as truth or depicted as a sense of authenticity. Barthes makes clear that he utilizes the advertising image because "the image is undoubtedly intentional."[11] He believes that in order to sell a product, certain signifieds of the product have been formed a priori so that the message of the product can be channeled to the consumer in a clear manner. Barthes's analysis is dependent on whether the image can truly shape meaning and if it can, how the meaning attaches itself to the image. Furthermore, his study requires us to believe that a representation is produced by a fixed and predetermined system of signs rather than by unconscious sentiments. Baudrillard sees the world as we know it now, constructed on the representation of representations, replicas of signs. These "simulations" exist to fool us into thinking that an identifiable reality exists, much like what is happening in the film with Teddy and his doppelgänger Andrew. In the movement of the successive phases of simulation, according

to Baudrillard, "[the image] is the reflection of a profound reality; it masks a profound reality; it masks the absence of a profound reality; it has no relation to any reality whatsoever; it is its own pure simulacrum."[12]

In *The Society of the Spectacle*, Guy Debord complicates Baudrillard's assumptions of the sign by bringing the idea of the spectacle into play. The spectacle is defined as "not a collection of images; rather, it is a social relationship between people that is mediated by images."[13] To clarify, the spectacle to which Debord refers is the world culture interpreted through partially false images. As we begin to recognize that consumerism can be referred to as spectacle, that which fights/competes for our attention in the marketplace, we begin to understand better Baudrillard's concepts of sign and use-value.

What does this all mean? If we are talking about the stage of the shadow, the first order of simulacra, we are focusing on counterfeits and false images. In this level, signs cease to have obligatory meanings. Instead, the sign becomes more important than the physicality of the film. It is important to remember our mention that the sign itself is the actual image of the poster. Our second stage of simulacra is dominated by the reproduction of the sign, the false image(s).

Later we will view different images of the same poster to illustrate this kind of redoublement, the main image and the falsities that are derived from the multiple images lend to the order of signs. The repetition in specific images and color within the varied paratexts lead the viewer to the differential between the initial represented paratext (original film poster), not to the reality of the Referent (the film itself).

The third order of simulacra rests on ultimate simulation. What is present in this order is the ultimate collapse between reality and the imaginary. It is no longer possible to tell the difference between what is real and its simulation. As we revisit the commodified phrase "someone is missing," the phrase becomes a referential to itself instead of being a referential to the film's narrative, so "someone is missing" is never really ultimately uttered in the way that the poster sets it up in terms of its immediate presence. Teddy becomes the doppelgänger to the phrase. He is missing.

THE BREAKDOWN

Signs are limited and fixed by rank, duty, and obligation. This is a social status linked to a sense of natural order. In this order, the symbolic order, the first order of simulacra (the tagline) implies that there is an absence in what is visible in the paratext. Teddy is absent, even though he looms, ultimately front and center, as the largest portion of the poster. Thus, the

phrase "Someone is Missing" becomes an equivalent for the social aspect of the film. This statement implies that there is absence in what is visible in the paratext (Teddy). To explain further, when we first view the poster, our eyes immediately are directed to the dominant in the image. In this version of the poster, the dominant is the flame that is placed center right in the image. From there we find ourselves following the subsidiary path to DiCaprio's eyes being half-lit by the flame and then over to the right side of the right eye that is silhouetted by the smoke coming off the match and finally to the Signifier "Someone is Missing." The creation of the eye path as an inverted triangle from flame to eyes to smoke and Signifier back to flame results in the absence of Teddy's ultimate identity on the island, as the island and the water surrounding it are an afterthought held below the dominant and subsidiaries forming the eye path. This composition of the paratext is balanced between Teddy's image at the top of the poster and the island itself and the title *Shutter Island* along with the actor's name. This balance illustrates the duality in the character and the complexity of Teddy's identity.

The second order of simulacra takes the sign (the phrase) and commodifies it by mass-production (here, the effect of the image itself). The sign masks the element of a basic reality and casts a pall over the obvious clarity that what is missing is found in Teddy. It is here that we see the start of redoublement happening and the formation of the doppelgänger. To understand the start of the redoublement we see in the second order, we need to have knowledge of who Leonardo DiCaprio is and what characters he has played in past films. Once we can associate his name with a concept of who he has been on-screen, we can begin our consumption of the paratext. We may associate DiCaprio with past film characters like Billy in *The Departed* (2006) or Amsterdam in *Gangs of New York* (2002), both films directed by Scorsese. The redoublement here relies on the viewer being able to make the links to popular characters that DiCaprio played so that his identity created only by his past successful acting jobs sells tickets to the new film. His engineered on-screen identity is what amplifies the hype for the new film. The formation of the doppelgänger in the paratext aids in the viewer's purchase of the film ticket because of the duality in the actor's persona, created in part by viewer's associations of the actor's name coupled with the perception of doubling in the image of DiCaprio on the poster.

The third order of simulacra (the simulation)—that is, the image of the DiCaprio character on the paratext—becomes the simulated image reproduced by other designers for global viewing audiences. Arguably the most accessible order in the theoretical system, the simulation of the image of DiCaprio on the poster is what global designers have used to help sell the film in their countries.

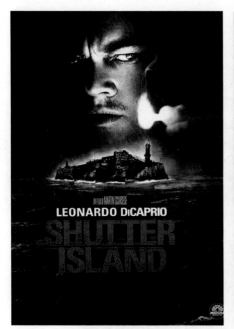
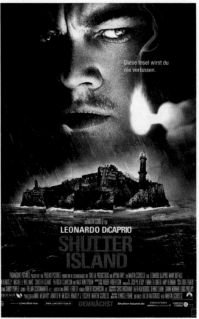
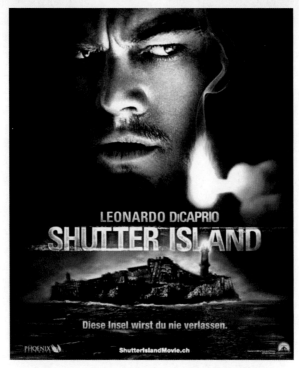

Figures 9.2, 9.3, and 9.4. Italian, German, and Swiss movie posters.

For example, if we view the posters that were marketed in Italy, Germany, and Switzerland, we can see the simulated image of DiCaprio as doppelgänger figure in all three. The designers capitalize on the image of DiCaprio changing his focus from the American poster, where he looks directly at the viewer, to an extremely agitated glare looking left beyond the flame and off the page. This change in eye contact might be explained in two of the posters, the German and the Swiss, because the character's eyes are leading the viewer to the phrase "Diese Insel wirst du nie verlassen," which translates to "You will never leave this island." The extreme intensity we see in the eyes of DiCaprio in these two simulations indicates the character's knowledge of confinement on the island. In contrast, the Italian and German posters draw in rain to show a connection to the significance of the water in the film where the American and Swiss posters do not; however, the Swiss poster shrouds the DiCaprio image all in black, adding blue to the color palate where water is seen. All of the posters share the flame, island, film title, large print, and all-caps, and DiCaprio's name directly above the title and also in all-caps. There are small variations in the four posters we've viewed thus far, but it is clear to see the simulation of the DiCaprio image aids in the commercialization of the paratext sold at the global level.

We know the doppelgänger element is being highlighted with the shading of the face to represent the reality of Teddy's dual world. Looking again at the original American poster, we see that there are shadows and low-key lighting to accentuate the flame. The fire I mentioned is a symbol of Teddy's sanity. The appearance of fire within the text (the film itself) indicates fantasy. On the poster, fire indicates a fantasy world for Teddy in the instance where he is holding the match in the paratext. The match lights a portion of Teddy's face unveiling his five o'clock shadow and one of his clear, brighter eyes as if to juxtapose his sanity with his insanity. The disparity between Teddy's eyes, one being lit by the flame made brighter and the other shrouded and dim, clearly indicates that a part of the character is complicated. We see that the poster presents as spooky with the grayscale overlay on the character's face, and we have this extreme close-up image of a man's head with the intense eyes leaving us to conclude that there is a duality in the character because the eyes are represented differently connoting the theme of good versus evil. We are immediately placed in a situation to consider the character as monster or hero based on the dichotomy the shadowing on his face creates. The head is looming over the island, so we assume going forward that something weird will take place on that island.

These shadows and low-key lighting are used as a convention of the psychological thriller. Both are used to add tension and to represent the inner

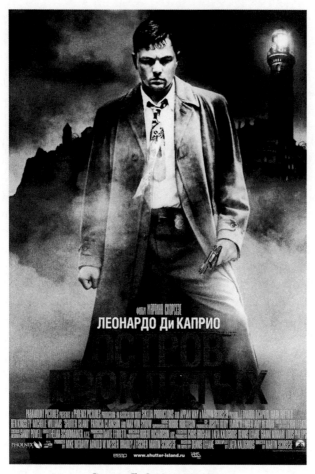

Figure 9.5. The Russian movie poster.

darkness within a character. We remember that the film opens with the hurricane and Teddy on the boat. The hurricane itself is real. We know the wife drowns their children. We know that the sea makes Teddy/Andrew sick. Throughout the film, we know that these are the things that are the "real" things that are rocking his world back and forth between the fantasy and the reality. We cannot ignore the fact that this is a psychological thriller. We recognize all the elements that psychological thrillers utilize to sell the product (the film) to us; therefore, if we are only looking at the poster, and we know nothing at all about Scorsese or what the film is about, we must take the paratext on its image value.

An interesting aesthetic point of view seen in the movie poster is the obvious balance between dark and darker as the poster is surrounded in black,

but the island is highlighted in the darkest blue. In fact, the color palate of the poster is shrouded in the dark only to be lit by the light of the slightly blurred flame and the accentuated letters in the title and DiCaprio's name in white and orange. This choice to use white lettering with hints of orange is consistent with the color of the flame and its white glow. The color here symbolizes the connection the DiCaprio character has to both fire and the idea that the flame will set him free as it lights the way around the island. The light from the flame also casts shadows of clouds through fog all around the island. The island is illuminated by a slight glow as if to suggest that all is not lost on the land imbued with darkness. Finally, it is important to note the color scheme that is used to project the title of the film, the Signifier (the phrase "Someone is Missing"), and the main actor in the film (DiCaprio). These three items, along with the commodifying alert of "Coming Soon," are written in white but imbued with the orange that is consistent with the flame just off-center to the right. This symbol of fire overtakes the paratext to suggest that fire is a thread that holds the film together, and of course, once we have viewed the film, we see that fire is a potent symbol of Teddy's (in)sanity.

In contrast to the other four movie posters viewed thus far in this analysis, two paratexts that run counter to the simulation of the American poster while keeping only a couple of the elements of the redoublement concept are the Russian and Japanese versions. The simulation of DiCaprio's identity finds itself on the Russian film poster, but the image is vastly different than the first four examples.

The marketers of the film in Russia change the shot of DiCaprio from an extreme close-up of his face to a full-frontal medium shot. He's dressed in a trench coat. Of importance in this poster, we see on the character's person the badge that shows his authority to carry the gun he holds in his left hand. He occupies the position of authority as everything that is simulated remaining on the poster except the title and DiCaprio's name is situated behind the character. We are left to wonder what the character hides with his body since we cannot make out the island or the sanitarium. We see the lighthouse which acts as a sort of redoublement from the previous posters. The fog in this poster version is thick, acting as a shield over the upper body of the character and what stands behind him. The title of the film is written in blood-red text with cracks of black peeking through to enhance the mystery that the poster creates by using the shadows of the fog to hide portions of the poster's clarity. The poster composition is balanced by the image of DiCaprio with the cross-image behind him of the island, creating a T-shape where the dominant contrast draws our eyes to the character's figure to rest. From there we are led to the brightest spot in the paratext, the lighthouse.

Finally, the path leads us to the bright red film title at the bottom of the poster. This poster creates intrigue with its use of heavy contrasts between light and dark. This contrast is what balances the poster and provides for the viewer the redoubling experience where we want to learn more about the identity of the character. We want to know what this officer will do on that spooky island. Who will he encounter and why? This poster version takes the doppelgänger identity of the DiCaprio character (as US marshall in entirety) and simulates it as the sign that will sell the film rather than using the phrase "someone is missing" as the signifier. Upon our pre-read of the film in the poster encounter, we are not privy to the fact that anyone is missing. Without the Signifier tagline, the induced signified conceptualization of identity can't become the sign that sells Referent (the film). In this example, the construction collapses because there is no repeated Signifier to construct the signified and sign.

In contrast to the other posters, we encounter in the Japanese version a paratext for *Shutter Island* where the pre-read is devoid of the image of DiCaprio completely.

The Signifier here comes in the form of a story rather than a phrase.

> Something is wrong on this island
> surrounded by sea
> the island whose only inhabitants are mentally-ill criminals
> from a locked hospital room
> without anyone noticing
> a woman disappears like smoke
> How on earth? Why?[14]

The mystery that is created by the limited textual details in the previous paratexts is eliminated in this poster, yet even though we are provided the story of what is happening in the film, we are still intrigued by what is *missing* in the poster. The association for the viewer is only to the naturalistic image of the land and sea rather than the association to the DiCaprio character and his contrived identity built by his previous film characters. In this version of the paratext, we are presented with a center focus on the island itself rather than DiCaprio's face. We see the same element of disjointed photo overlay behind the island like we see in the American paratext connoting the layers of complexity the film is sure to deliver. In this poster version, the color palate consists of black, off-white, and shades of brown and yellow to provide the feeling of impending disaster. Here, the dominant in the image is the island, itself with subsidiaries leading us to the lighted sky then to

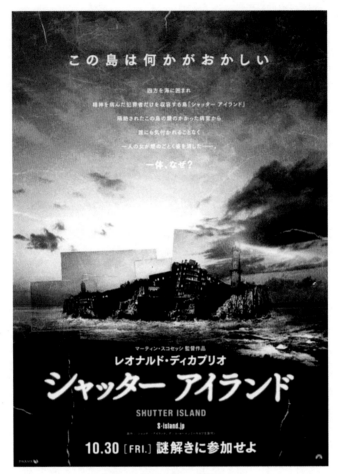

Figure 9.6. The Japanese movie poster.

the dark clouds that are crawling in from the right side of the image. This dark cloud formation along with the darkened edges of the top portion of the poster, which is the same color as the water about the island, creates a ring-effect around the island.

The poster is unbalanced unlike the previous four because this image fills over half of the poster leaving a jagged black bottom portion of the poster to announce the specifics about the film. The unbalanced poster continues with the heavy bottom portion white on black background and the remaining areas of the poster utilizing white lettering over the lighted sky. What makes this poster even more interesting is that there are two dominants. Our eye is drawn to the center of the poster due to the circle-effect of the coloring. We can see the light as the center dominant of the poster as our eyes are directed

to the lightest area of the paratext. Perhaps the double dominant is the Japanese marketing of the doppelgänger with the focal point being the darkest shades of the island or the lightest shadows of the sky. The foreshadowing in this poster is more difficult to read but could indicate the only way off that dark island is by way of the heavens. In any event, this paratext leads potential audience members to believe the film will concentrate on the disaster that happens *to* the island rather than what happens to the characters who find themselves *on* the island because of the concentration and placement of the island on the poster. There is no simulation of the DiCaprio face or the flame that foreshadows elements of the film nor is there a color palate that ties into the themes for the film like the other posters possess.

A final interesting note can be found at the bottom of the poster. The phrase "Help solve the mystery" is written to invite the audience to become part of the film experience. This invitation ensures the potential viewer realizes the film is, indeed, a mystery and challenges the viewer to become involved with the investigation that will most certainly take place involving the missing woman. In this international poster, we are led away from the DiCaprio character as Signified and pointed toward a missing woman. (Is that woman—Rachel, in the film—the one who is *missing* in the other paratexts?) The way in which the Japanese designer devised the layout of this poster and in determining what to exclude versus what to incorporate into the pre-read suggests an alternate consideration of audience. The poster is gender-neutral as it shows no identifiable individual in the image. The story text reaches an audience that might be interested in genres of film that incorporate the criminally insane (going beyond the psychological thriller) as well as a genre that solves the crimes of missing persons. In any event, the Referent (the perceived effect of experiencing the film) is complicated by the lack of the sign we never see because DiCaprio's conceptualized identity is never read in the paratext.

In short, we are reminded that once a popular replicated image has been launched—here, the image of DiCaprio with the attachment of the phrase "Something is Missing"—it becomes a sign of the use-value that acts as the condition by which the sign is sold. There comes a time in this process where the replicas become more real than the real, calling into question whether or not our viewing audience can distinguish between the real and the hyper-real. Susan Hayward explains that by "producing the real it reproduces the hyper-real." She further clarifies that "the real is not the real, is not what can be reproduced but, rather, that which is always already reproduced," which is essentially a simulation. The hyper-real, then, is a simulacrum of the real. Essentially, "there is loss of distinction between representation and the real."[15]

And this means that the audience walks away already understanding that what happens on Shutter Island is something that tears at DiCaprio's identity and makes us question reality of that which is missing. The designers and marketers of the film industry by way of the paratext appropriate the image of what society comes to know as Leonardo DiCaprio, and from this fixed idea of what it means to be DiCaprio comes the hyper-real reality that has begun to distort clarity and facts regarding the film *Shutter Island*. This draws the viewer into the film by creating the mystery of the character and the need to solve the question of what is *missing*.

NOTES

1. Arnaud Schwartz, "Shutter Island: Martin Scorsese face au face au dérèglement de l'esprit," archived April 10, 2018, at the Wayback Machine, *La Croix*, 23 February 2010, accessed on February 3, 2021.

2. Gérard Genette and Marie Maclean, "Introduction to the Paratext," *New Literary History* 22, no. 2 (1991): 261–72.

3. Thomas Stubblefield, "Disassembling the Cinema: The Poster, the Film and In-Between," *Thresholds*, no. 34 (2007): 84–88.

4. Jean Baudrillard, *The Consumer Society: Myths and Structures* (London: Sage Publications, 1998); Jean Baudrillard, *Selected Writings*, 2nd edition, ed. Mark Poster (Stanford: Stanford University Press, 2001).

5. Guy Debord, *The Society of the Spectacle* (New York: Zone Books, 1994).

6. Gary D. Rhodes, "The Origin and Development of the American Moving Picture Poster," *Film History* 19, no. 3 (2007): 228–46.

7. Baudrillard, *Selected Writings*, 91.

8. Jonathan Gray, *Show Sold Separately: Promos, Spoilers, and Other Media Paratexts* (New York: NYU Press, 2010), 25.

9. Roland Barthes, "Rhetoric of the Image," available at https://williamwolff.org/wpcontent/uploads/2014/08/Barthes-Rhetoric-of-the-image-ex.pdf.

10. Baudrillard, *Selected Writings*, 91.

11. Barthes, "Rhetoric of the Image," 270.

12. Baudrillard, *Selected Writings*, 173.

13. Debord, 12.

14. Translation provided by David Ewick at Tokyo Woman's Christian University and Andy Houwen at 東京女子大学.

15. Hayward draws upon work found in Bruno (1987) when she posits commentary on Baudrillard. Susan Hayward, *Cinema Studies: The Key Concepts* (New York: Routledge, 2000), 67. Giuliana Bruno, "Ramble City: Postmodernism and *Blade Runner*," October 31, no. 41 (Summer 1987): 61–74.

ABANDONED CARS AND BENDING SKYSCRAPERS

Architectural Disjuncture in M. Night Shyamalan's *The Happening*

LYNETTE KULIYEVA

Three contrasting scenarios are depicted in film posters advertising M. Night Shyamalan's 2008 film *The Happening*. The first and most widely recognized poster presents an apocalyptic preview of the film as it foregrounds a deserted highway in the countryside under a canopy of ominous, darkened clouds. In the midst of the clouds, the tagline reads, "We've sensed it. We've seen the signs. Now . . . it's happening!" Views of the city skyline are minimized far off in the distance, illuminated by a faint halo of light pushing through the clouds, reminiscent of the ethereal glow emanated after a nuclear explosion. Abandoned cars litter the highway, scattered randomly and parked askew with their doors wide open as if its occupants had to flee in a hurry. The absence of any people only heightens the tension for a potential audience as the poster clearly reveals an event—"The Happening," as the title clarifies—in which something has occurred of epic proportions that has likely succeeded in eliminating a massive portion of the population, at least in this particular part of America or even of the world.

This particular poster was also edited to sometimes include the enlarged figure of its main character, science teacher Elliott Moore (played by Mark Wahlberg), superimposed over the apocalyptic rendering. Even so, the premise offered by this poster and the effect on its audience remains the same: some obviously significant event has happened, few people remain.

Another film poster launched for the release of *The Happening* presents a different scenario, transforming the landscape from the countryside to

an urban park setting with its widened walking/biking trail, surrounded by trees, and freckled with dead bodies. A few people and even a child stand amidst the bodies, their faces turned away from the viewer and toward some perhaps beckoning light or sound, motionless in a seemingly trance-like state. This poster also features a tagline at the bottom—"Don't look for the answer . . . it's already too late"—increasing the sense of inevitability and hopelessness in the viewer. Though the landscape has changed and the scattering of abandoned cars has transformed into a scattering of catatonic people, the intended implication for the moviegoing public is that the film will present a major event in which humanity is threatened, culminating in loss of life and massive depletion of the population.

As it happens, the implication presented in these two posters is precisely what occurs in the film. These scenes are, indeed, played out within the context of the film as they are depicted in the two posters, providing a clear preview of the main points of the storyline to the audience. The threat, which is speculated initially to be some type of new terrorism or chemical weapon, is discovered to begin in parks in urban settings where lots of people congregate in the open air. Upon first contact with this unknown, unseen agent, an infected person briefly falls into a hypnotic trance and then moves to quickly and effectively commit suicide by whatever means possible.

Later in the film, Elliot, his wife, Alma, and a young girl, Jess, entrusted to their care attempt to escape the plague obviously targeting the urban areas and their larger collections of people by boarding a train out of the city. Soon after they board, however, the railroad personnel realize that there is no truly safe place to transport their passengers because the affected area has so greatly spread. So the train stops unexpectedly at an obscure town in Pennsylvania that does not even show up on most traditional maps, and the country setting reveals another opportunity to face the looming threat. When Elliott and his wife find themselves meeting other groups of people at a crossroads literally in the middle of nowhere with nowhere left to go, the realization that whatever is happening is systematically attacking smaller and smaller numbers of people propels the crowd to try to outrun the unknown enemy, which, they eventually conclude, is an airborne toxin produced by natural means to eradicate any threats to nature—the true threat being humanity.

While both of these posters incorporate very subtle hints of inaccuracies regarding "the happening"—namely, the halo around the city calling to mind ideas of nuclear holocaust and the people in the park staring into a bright light which hints at the possibility of aliens or of a bright light seen at one's

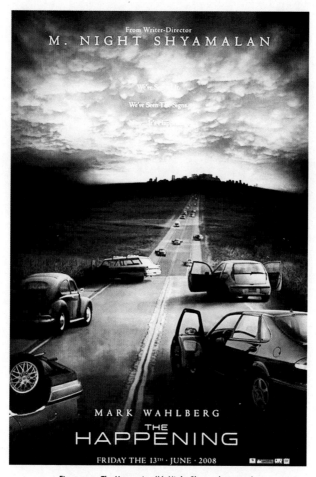

Figure 10.1. *The Happening* (M. Night Shyamalan, 2008).

death—the scenes depicted turn out to be accurate renderings of actual events that are seen in the film.

Though these two scenes are offered to the audience in advance by the preview exhibited on their respective film posters, a third poster for *The Happening* does not provide viewers with a glimpse, or a sneak peak, into the storyline. Instead, this third poster builds false expectations regarding its content by deliberately contorting the architectural landscape into something construed as paranormal. This poster actually does more to alter the audience's understanding of the film's plot by intentionally leading audiences away from the ultimate reveal of the threat as a natural occurrence and to an entirely different impression of the threat as something supernatural.

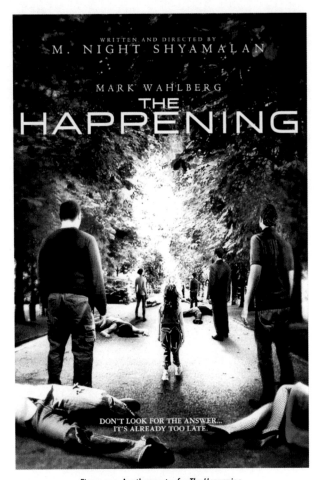

Figure 10.2. Another poster for *The Happening*.

In this alternate poster, the scene shifts to an empty street in a large city, most likely New York City, where tall skyscrapers bend ominously and unnaturally toward the cowering figures of Elliot, Alma, and Jess, resembling the "bending spoon" in the Wachowskis' 1999 film *The Matrix* or prefiguring a scene from Christopher Nolan's 2010 film *Inception*. The architectural disjuncture exhibited in this poster manipulates its audience to enter the theater or to begin the viewing by entertaining a perception completely different from what actually occurs in the film. The poster forces the viewer to believe that supernatural or otherworldly forces will be shown to be at work in infecting the minds of the population to somehow convince them to kill themselves—something powerful enough to bend skyscrapers into unnatural shapes. But in the course of the film, that perception is debunked, and "the

happening" is revealed to be biological and perfectly natural. According to Stefan Hall, "Shyamalan has never positioned himself as an expert on the fantastic, and perhaps he might better be understood as a director attempting to bring certain fantastic elements into more mainstream productions."[1] In typical Shyamalan fashion, the viewer experiences a "twist" by being convinced of one thing, only to be later surprised with the discovery that the reality is something completely unexpected. However, the unexpected usually is revealed as supernatural; by contrast, in this alternate poster, the supernatural is contrived to be the expected, and the natural is revealed by the film's ending to be the unexpected.

In his introduction of *Critical Approaches to the Films of M. Night Shyamalan*, Jeffrey Andrew Weinstock claims that *The Happening* is "a film that lacks the Shyamalan click entirely [because] its plot does not involve misdirection or an ironic twist."[2] He instead notes that the title itself is the ironic twist since a "happening" is defined as "an ambiguous occurrence—an undefined something that takes place,"[3] and yet something is definitely taking place, although it is spontaneous and inexplicable.

While I agree with Weinstock's notion of the film title as twist, I also point to this poster as incorporating the same "ironic twist." It leads the audience through misdirection to consider the concept of the supernatural as being ultimately responsible for "the happening," and yet the ironic twist results when the unexpected happens, at least according to Shyamalan fans, when the natural world spoken of early in the movie is revealed to be the unseen enemy threat to humanity—exactly what was suggested from the outset. The twist, according to Weinstock, is that there is no twist, and so the natural becomes more terrifying than the supernatural, at least in this film.

What gives equal credence to the concept of the supernatural being responsible for "the happening" is the fact that all of Shyamalan's major box-office successes up to that point boasted the supernatural and provided blatant indications of the supernatural on their film posters.

The poster for *The Sixth Sense* in 1999, for instance, implies the supernatural and higher powers beyond the five real senses that its title suggests, and the emblazonment around the number six, along with the figure of a young boy, cues audiences to the awareness that something extra-ordinary will happen or has happened to that child.

The poster for *Unbreakable* in 2000 includes a shadowy figure situated between two faces illuminated from opposite sides as the splintering of glass radiates across the picture, its images and its title hinting at the idea of a superhuman being who is completely unbreakable . . . and also gesturing to his opposite, one who is completely fragile.

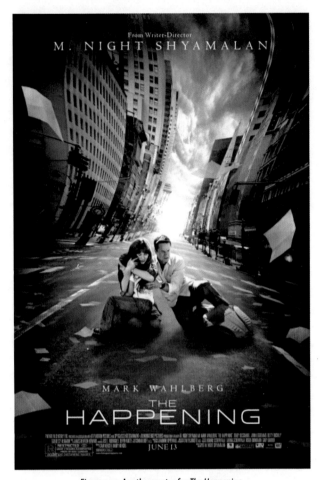

Figure 10.3. Another poster for *The Happening*.

The poster for *Signs* in 2002 again reverts to an emblazoned image, this time embellishing crop circles, which are mostly considered to be associated with aliens.

The poster for *The Village* in 2004 places a faceless, hooded figure right in the center of the frame to highlight the tormenters of those who do not follow the rules. And another poster for that film clearly lays out the rules for the villagers (and for the audience) so that they can keep the feared hooded figures away:

1. Let the bad color not be seen. It attracts them.
2. Never enter the woods. That is where they wait.
3. Heed the warning bell. For they are coming.

Figures 10.4a, 10.4b, 10.4c, 10.4d, and 10.4e. Posters for M. Night Shyamalan's major box-office successes prior to *The Happening*: *The Sixth Sense* (1999), *Unbreakable* (2000), *Signs* (2002), *The Village* (2004), and *Lady in the Water* (2006).

And finally there is the poster for Shyamalan's last film before *The Happening*—very poorly received, I might add: *Lady in the Water* in 2006, which features an angelic, fairy-like, unearthly female with very light skin and with piercing, icy eyes staring directly at the viewer, her hair fanning out around her head as if encased in thorns and entangled with images of wolves and skulls and dark silhouettes. The bluish tint to the picture denotes the water in which she lives and breathes.

Clearly, the design of this third poster for *The Happening* has more in common with the traditional design themes of film posters for other Shyamalan films, and their hints at the supernatural, than the first two posters discussed.

Along with the poster hinting at a supernatural occurrence that is not brought to fruition, the poster is also guilty of manipulating audiences to believe that the film's setting is that of a large city. The trio's huddle, seen in the center of the poster, was taken directly from the film, but that huddle as depicted occurred in the middle of a field, whereas the poster positions them in the middle of a city, suggesting that the artists creating the poster may have considered a city setting to be more frightening to audiences as opposed to a country setting.

The first poster illustrating the abandoned cars and highway was the initial teaser image to come out for the film in December 2007, and its reception may have been looked on with disdain because of the very unclear, ambivalent context of this poster. For instance, on reviewing the poster, blogger Alex Billington claimed that he was unimpressed and failed to see any clear connection with the themes and plots being thrown around by the film's publicists. Billington said, "What I'm most interested in with *The Happening* is just finding out what the . . . 'apocalyptic crisis' actually is! The only hint is that it was originally described as an 'eco-thriller' and the threat is a 'natural crisis.'"[4]

Five months later, in May 2008, the skyscraper-bending poster came out with only three weeks until the release of the film. Billington commented on the new poster with much more acclaim. His title reads "Twisted New Poster," and he says, "At this point, I'm considerably excited for *The Happening* and think that the more grungier, violent aspect that M. Night Shyamalan has taken will really make this more than just a boring thriller."[5] So it is very likely that other audiences and particularly younger audiences may have been more compelled to view the film because of the assumption—the false assumption—that the action would take place in the "grungier, violent" city rather than in the suburbs or countryside.

Though the second poster discussed depicted an urban setting, it was confined to the park from which the threat began. Instead, the majority of the film focused on the outskirts of big cities, rural areas where there would be less people. In fact, before the first fifteen minutes of the film had expired, the trio had left the city far behind. Furthermore, only brief glimpses of city scenes were shot, causing one to question why a film poster would go to such lengths to confuse the audience regarding inferences of the storyline and its assumed supernatural angle.

Interestingly, however, though they had escaped the contaminated big city early in the film, the scenes shot in the city as "the happening" began to affect people seemed to mirror the image on this particular poster, manifesting a visual distortion which only occurs in the beginning of the film in the brief period while the story is still focused on the big cities.

The film opens in New York City with its first shot providing a brief view of several skyscrapers above the tree line. The skyscrapers stand straight, tall, and majestic as they peek out above the trees. The film then cuts to Central Park at 8:33 a.m., moving quickly to two women reading on a bench in the park.

The women share only a couple of lines of dialogue before the effects of "the happening" begin to occur. A scream is heard in the distance, and a close-up shows one of the women jerking her head up to look around for the

Figure 10.5. Opening shot in *The Happening*.

source. The sounds of the wind grow louder as the sounds of the park begin to fade away. The woman then looks around at the crowded park to discover that everyone around her has become stationary, motionless, in some kind of trance-like state staring straight ahead, and she begins to feel apprehension broaching on fear. She glances over to get her friend's reaction to this odd occurrence, but her friend has also succumbed to this unknown horror, first acting as if she were dazed or disoriented. The friend then slowly, hypnotically reaches up to her hair to pull out a long, sharp pin roughly the size of a crochet needle. The camera jumps to a close-up on the woman's neck as she slowly, calmly pushes the hair pin into her jugular, and the viewer witnesses the first death by this unseen force.

The scene then changes to the busy streets of New York, with all of its traffic and police sirens and horn honking and other chaotic city noises. Very tall buildings are also shown here, similar to that very first shot of the skyscrapers through the trees . . . but here they are beginning to look a bit slanted based on the focal point in the center causing them to bend inwardly a bit. In the first shot of skyscrapers, there was no bend, no slant . . . but here, once "the happening" begins to occur, we are beginning to get an idea of that distortion shown in the film poster. The policeman here is chatting with a taxi driver just moments before they both become affected. Once they do feel the effects, however, both men quickly kill themselves: first, the policeman shoots himself with his own gun, and then the taxi driver calmly goes over and uses the same gun. Mere seconds pass before a lady's feet are seen to come over, and she picks up the gun as well.

Figure 10.6. "The Happening" is about to happen.

The camera then cuts to a construction site not too far away from the events that are occurring. On the left is a tree, and on the right is a building obviously under construction with scaffolding and tarp and vacant windows. The text alerts the viewer that this building lies three blocks from Central Park in New York City, and the time is now 8:59 a.m. And here is the first sign of disjuncture as the beginnings of this deadly plague play out.

For a very short time, only as long as they are in the city, the viewer is provided a glimpse into the world that is embellished by the skyscraper-bending poster. The building at this location is not straight and tall as others appeared before the events began to happen. Instead, it now appears skewed, slanted with a higher degree of angle the closer it gets to the outer edge of the screen as the edges of the shot warp conspicuously toward the center. The perspective of the camera may necessitate the sharp angles, but there is no denying that the building suddenly portrays the visual distortion that is so exaggerated within the film poster. This distortion is perhaps indicative of an almost supernatural phenomenon occurring, and the audience feels the effects of that manipulation, even though they might not realize that the straight and tall buildings shown before the happening occurred were not the visually distorted buildings shown after the happening began.

Here we can clearly see the distortion of the architecture taking more effect, suggesting that the very architecture is also affected by this unseen, unknown force as if the architecture itself was a threat to nature. This observation is even more significant since we are at a construction site, and it

Figure 10.7. On-screen texts attempt to orient the viewer to a world gone disoriented.

seems that nature, as represented by the tree standing straight and tall here, is battling the emergence of new buildings that might encroach upon nature.

As if to further interrogate the architectural distortion, the camera then cuts to a makeshift elevator descending the building, and the sharp angling is again prominent, bending toward the middle.

A very brief moment of normalcy then occurs with workers on a break, joking around, and the camera pans around to show each worker as they are laughing. Then suddenly over the shoulder of one of the workers, a large blurred image falls in the background, sending off an explosion of rocks and rubble as it hits the ground. The loud thud it creates disrupts the men's laughter, and one of them slowly walks over to see what happened. His smile turns quickly to curiosity and then to shock, his mouth agape, as he exclaims in disbelief, "Christ, McKenzie fell!"

A hand-held camera moves to look down at McKenzie, his body twisted and distorted from the fall.

The camera then switches to an upshot of the men's faces leaning over him with the buildings looming over them in the background, bending in threateningly, mirroring the disfigurement of the fallen body and echoing the architectural distortion of the buildings in the film poster.

There is a brief dramatic pause, and then another loud thud is heard as another body falls . . . and then another . . . and then another, and the construction workers look up in horror while the music gets louder and more foreboding, increasing quickly to a pulse-quickening crescendo.

Figure 10.8. The makeshift elevator, angled as if to signal uncertainty.

The scene concludes with a view from the workers' perspective, looking up at bodies calmly, slowly walking off the roof of the unfinished building as if they were lemmings following one after another to their deaths. Once again, the building above is shown in distortion, and the audience now fully and truly feels the dire consequences of this unseen, silent force affecting everyone around.

Shortly after this horrific scene, the camera cuts to the large buildings of Philadelphia, shown straight and rigid, as if in sharp contrast to the visual distortions seen in the previous shots in the large buildings of New York. This image of tall, straight, non-distorted buildings is a visual clue that Philadelphia has not yet experienced the cataclysmic event that New York has just witnessed. The distortion only appears to reveal itself once the "happening" begins to occur. The next cut shows Rittenhouse Park in Philadelphia at 11:31 a.m. The tension builds as the wind blows through the trees, indicating what the audience now knows to be an impending doom: the calm right before the storm.

The final shots of the large buildings are at the end of the film, three months after "the happening" occurred. It once again shows the buildings standing straight and tall in the background, indicating to the audience that everything is back in order and normalcy has returned.

I believe that this was done purposefully in order to emphasize the contrast between "pre-happening" and "post-happening"; it is symbolic of the distortion of the world as they knew it. As the chemicals in their brains

Figure 10.9. Unexpected death.

Figure 10.10. Investigating the unknown.

shifted once nature began to fight back against the threat of humanity, every-thing began to be shifted, including the buildings themselves.

While the bending skyscrapers of the film may be justified as a necessity of cinematography in showing focal points as the camera tilts up or across, the perceived visual distortion still emphasizes an architectural disjuncture, especially in comparison of the shots of the buildings pre-happening. The poster just elaborates and embellishes to an abnormal degree what has been shown visually on screen.

Figure 10.11. Dying calmly and inexplicably.

Figure 10.12. "The happening" is about to happen again.

Rather than chronicling some kind of supernatural event, as the poster might "trick" audiences into believing, the architectural disjuncture—that is, the bending skyscrapers—was intended as a metaphor for the mindset of the characters as they experienced an earth-shaking event that would forever change their world as they knew it: a foreboding, ominous terror of the unknown, both from this event and through the fearful expectation that similar events may follow. Perceived this way, it would have probably made more sense if they had experienced a supernatural as opposed to a natural occurrence.

The disjuncture emphasizes the fact that an event has occurred to alter the known world, and a new normal must take its place. Though the ending does not ultimately denote a supernatural event, a scientific ambivalence emerges in which, in the words of Elliott, "There are forces of work beyond our understanding. Science will come up with some reason to put in the books, but in the end it will be just a theory." As noted by Gaia Giuliani, "*The Happening* [belongs] to the speculative science fiction genre. . . . The possibility that monstrous epidemics, invasions, genetic mutations, and extreme indiscriminate violence might hit the safe West and not be confined to the 'out there' is what engenders terror."[6]

It's an act of nature. We'll never fully understand it.

NOTES

1. Stefan Hall, "DVD Reviews: *After Earth* (M. Night Shyamalan)," in *Science Fiction Film and Television* (Liverpool University Press, 2015), 109.

2. Jeffrey Weinstock, "Telling Stories about Telling Stories: The Films of M. Night Shyamalan," in *Critical Approaches to the Films of M. Night Shyamalan* (New York: Palgrave Macmillan: 2010), xxv.

3. Weinstock, "Telling Stories," xxv.

4. Alex Billington, "M. Night Shyamalan's *The Happening* Teaser Trailer," FirstShowing.Net, 4 February 2008, available at https://www.firstshowing.net/2008/m-night-shyamalans-the-happening-teaser-trailer/.

5. Billington, "Teaser Trailer."

6. Gaia Giuliani, The End of the *World as We Know It*. For a Postcolonial Investigation of the Meaning(s) of Environmental Catastrophe in Sci-Fi Films," *e-cadernos CES*, no 32 (Centro de Estudos Sociais da Universidade de Coimbra, 2019): 145, 149.

Chapter 11

ROUND LIKE A CIRCLE IN A SPIRAL

The Poster Art of Film Noir

MARLISA SANTOS

It is ironic that some of the most well-known film noirs produced some of the least visually innovative film posters. Though produced by different studios, the posters for films like *Double Indemnity* (Billy Wilder, 1944), *Out of the Past* (Jacques Tourneur, 1947), *The Postman Always Rings Twice* (Tay Garnett, 1946), and *The Killers* (Robert Siodmak, 1946) follow a familiar visual formula: the highlighting of either full-body or close-up images of the headlining stars, often locked in a passionate, though doomed, embrace. One of the most iconic noir poster images is that of Rita Hayworth's voluptuous Gilda from her namesake 1946 film directed by Charles Vidor, with her strapless gown and devil-may-care cigarette. Often inspired by the lurid pulp covers of its source material, much film noir paper perpetuates the tough guy and femme fatale mythology of the series, selling the images of, if not A-list stars, the glamorous teasers of stars-soon-to-be. These kinds of posters, according to Ian Haydn Smith, "play up [the] elements of desire and danger . . . offering the sheen of glamour to the nefarious activities of cons and sleuths."[1] However, the majority of film noir posters tell a different story. Regardless of the studio that produced them, they vividly represent the pessimism, anxiety, and emotional turmoil that were central to the cycle itself. And just as noir films were groundbreaking in their depiction of psychological distress, so too does the paper of noir depict arresting representations of the internal gaze, expressing traumatic disconnections, memory ruptures, paranoid fantasies, and psychotic violence. Extreme close-up facial illustrations, transparent,

ghostly imagery, and weapon fetishization, combined with claustrophobic composition and circuitous graphics, reflect the fractured psyches of damaged noir protagonists.

The backdrop of psychological instability, as numerous critics have argued, is woven deeply into the fabric of film noir. In the early days of significant noir scholarship, Raymond Durgnat called noir psychopaths "legion," arguing that they fall into three main categories: "the heroes with a tragic flaw, the unassuming monsters, and the obvious monsters."[2] These were no longer one-dimensional, rags-to-riches 1930s-era gangsters and criminals, but profoundly damaged men who destroyed themselves and others with equal abandon. Durgnat's "obvious monsters" would include such memorable characters as Kiss of Death's giggling Tommy Udo (Richard Widmark) from 1947 and White Heat's maniacal Cody Jarrett (James Cagney) from 1949, characters that defy conventional notions of crime and evil because of the sheer depths of their transgressions. As the moviegoing public was becoming more comfortable with these kinds of filmic depictions, poster art, never to shy away from marketing hooks, aimed to tantalize prospective audiences with images that promised entrance into a suspenseful world of increasingly commonplace criminality and subversion of systemic stability. Beneath these often-lurid depictions, however, lie subtle suggestions of the films' complex investigations into human psychosis.

PSYCHO KILLERS, NOIR STYLE

Joseph H. Lewis's The Big Combo (1955), as part of the back end of the classic noir period, offers the audience a twisted love triangle that comes to life in the film's half-sheet. The queasy entanglements of sex and power involving the victimized Susan Lowell (Jean Wallace), the obsessed police lieutenant Leonard Diamond (Cornel Wilde), and the sadistic gangster Mr. Brown (Richard Conte), who is too menacing to have a first name, are clearly visible in the poster's windowlike layout.

Every image on the poster suggests struggle: background insets of violent altercations between male gangsters appear alongside depictions of the sexual tensions between Susan and Brown, and Susan and Diamond. These illustrations are dwarfed in the background by the image of Brown, who is shown from the chest up in his dapper blue suit, holding out to the observer his massive hand in an almost 3-D effect. In the palm of this hand are the smaller figures of Susan and Diamond, he entreating her and she turning away. As the film bears out, Brown controls not only the potential romantic

relationship between Susan and Diamond, but also their individual fates, through sexual control and fearless sadism, seen in the controversial scenes of suggested oral sex and explicit torture, respectively. As Robert Singer argues, the film employs "ingeniously subliminal and overtly expressive shot sequences of unambiguous on- and off-screen taboo erotic spectacles," displaying "historicized, contextual images of psychosexual aberration and obsession."[3] Diamond is squeezed for information by Brown's thugs through beatings, and then by Brown himself, who begins with using a hearing aid and a radio for auditory torture and ends with forcing alcohol-rich hair tonic down Diamond's throat, both actions signifying aggressive male sexual assault: he penetrates Diamond's open ear with blaring music and then compels Diamond to swallow the uniquely male grooming liquid. The depth of Brown's menace is not nearly fully realized in the poster, but the mystery of his power is eerily suggested by the fact that his facial image begins at his nose, no eyes visible; he is thus depicted as a blind force of control, of both Diamond and Susan. Finally, in the upper right corner of the poster, a square inset of Diamond's face appears with the quotation, "Once you get trapped, there's no escape from them. Girls like Susan never learn!" While the poster tries to sell the story as one of typical male criminal victimization of a not-so-innocent female, the film's narrative just as easily can point the meaning of this quotation at Diamond's being trapped by both Susan and Brown: the sexual attraction of Susan and the power attraction of Brown. Brown tells Diamond, "Your only problem is you want to be me," and indeed Diamond's blind refusal to see the similarities between cop and criminal blocks his efforts every step of the way.

The exploration of taboo rejection through psychotic murder is also obvious in another later noir, Fritz Lang's *While the City Sleeps* (1956). The window card for the film particularly capitalizes on the film's sensationalized plot, in which a serial murderer, ironically named Robert Manners (John Drew Barrymore), exhibits female fetishism by his practice of stealing "ladies' things" when he kills. While other versions and sizes of the poster art display the "Sensational Lipstick Murder!" tagline, as well as the disproportionately large hand threatening to envelop the entire head and torso of the screaming victim, the window card is the only version that displays the lipstick writing in bold red across the cool blue tones of the aforementioned images. The phrase "Ask Mother," drawn from the killer's signature lipstick scrawl in the film, is a bold teaser for audiences that were likely no strangers to Oedipal explanations for deviant behavior in the mid-1950s. Postwar popularization of psychoanalysis, due in part to the advancement of psychiatric techniques in the military, would have made such a phrase effective moviegoer bait.

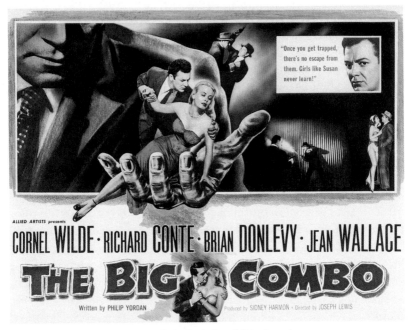

Figure 11.1. *The Big Combo* (Joseph H. Lewis, 1955).

Ironically, the film focuses far more on a cynical view of the unscrupulous practices of modern journalism than on the realities of the killer himself, as the media's incentivized hunt for the killer plays a much greater role than his exploits. Reporter Edward Mobley (Dana Andrews) taunts the killer on television to shame him and draw him out, accusing him of having a "sick ego" and being "exactly like a little girl." The psychosexual impulses at work in Manners's criminal behavior are given cursory explanation by a brief exchange between him and his mother, but the film's poster art drives the association home. The window card also completes the sentence of the film's title, by adding "What sins are committed . . ." above it, to form an implied question that is only partially answered in the film, the absence of a question mark making it more of a statement. The use of the word "sins" rather than "crimes" adds an additional layer of moral gravity to the film's content, again unexpectedly borne out by the film's depiction of society's "sins" going well beyond the acts of the killer. The media's implied ethical culpability illuminates the role of journalism in propagating various notions regarding psychoanalysis and creating a popularized impression of psychological trauma and treatment; as an advertising medium, the poster art for the film perpetuates these ideas as well.

A noir psychopath cut from much more moneyed and respectable cloth is found in John Farrow's *The Big Clock* (1948), in which publishing magnate Earl Janoth (Charles Laughton) murders his mistress, Pauline (Rita Johnson), in a fit of rage. A half-sheet for the film mirrors the way that Janoth's power has the potential to crush any obstacle in the path of his desires. Janoth's cruel and petty tactics, from his torture of his most menial employees to his framing of editor George Stroud (Ray Milland), reinforce the smallness of his character in contrast to both his physical enormity, as well as his vast wealth and influence. The composition of the poster emphasizes this contradiction, as Janoth's face fills the entire background, upon which the figure of the hapless Stroud crouches over Janoth's victim. Janoth's eyes dominate the image, paralleling the film's close-up shots of his sweaty face and crazed eyes prior to the murder, signifying his reaction to Pauline's ridicule that his only attraction for a woman is in the power of his position. The film's shots of Janoth's eyes are meant to emphasize his psychosis, and this poster image represents the most extreme outgrowth of the fanatical scrutiny with which he exercises his dominance over all aspects of his personal and professional life. The positioning of Stroud's figure over the nose and especially the mouth of Janoth's face suggests how Janoth uses Stroud to silence his own guilt; Stroud's entrapment thus is shown to be the voice of the crime, rather than Janoth's own culpability. The relationship between power and psychosis is similarly represented in both *The Big Clock* and *The Big Combo*: a legitimate tycoon, like Janoth, and a criminal boss, like Mr. Brown, suggesting that there is little difference between an illegal "combination" and an exploitive business.

The blurred line between criminality and respectability is also evident in a more psychologically complex film like Steve Sekely's *Hollow Triumph* from 1948. Known also as *The Scar*, and the even more intriguing working title *The Man Who Murdered Himself*, the film portrays the twisted journey of John Muller (Paul Henreid), a would-be psychiatrist turned gambling swindler, who uses the fortuitous resemblance between himself and a real psychiatrist to forge a new identity. Muller murders the doctor and disfigures his own face to match the doctor's scar. . . . except, in true noir fashion, he unwittingly uses a reversed negative photo as a model, effectively marking himself as a faulty double of the real Dr. Bartok. The six-sheet poster for the film, belying Eagle-Lion's low production values with its "first-class art to attract audiences,"[4] effectively captures the trajectory of Muller's sordid path.

Muller's face, painted a lurid yellow-green and cut with deep lines even aside from the gash of the scar, is at the center of the poster; maroon-steel gray accents give depth under the eyes and nose and lips, reinforcing the

cadaverous appearance that reminds one of Boris Karloff's Frankenstein's monster. Muller is indeed a representation of the living dead, as he obliterates his own identity in favor of a dead man's, which he recreates imperfectly. He then becomes an entirely new self, neither Muller nor Bartok, inhabiting a liminal world that eventually entraps him. It turns out in the end that he looks enough like Bartok to satisfy underworld thugs who are looking to settle the real doctor's own gambling debts. The defined circular brushstrokes in the same shade of maroon-steel that mark Muller's face provide the poster's background, suggesting the whirlpool of Muller's life spinning out of control and enveloping other characters, including love interest Evelyn, Bartok's secretary (Joan Bennett). As the poster tagline proclaims, "His scar marked them both!" These words are drawn between their artistic renditions, who are touching their own faces, suggesting both the literal and figurative mark of Cain that denies Muller any promise of fruitful human connection and damns him in wandering otherness until his demise.

ILL-FATED AND ILL-EQUIPPED

Noir's doomed wanderers are often consigned thus to exile through no criminal behavior of their own—as Al Roberts (Tom Neal) in Edgar G. Ulmer's *Detour* (1945) muses, "Fate, or some mysterious force, can put the finger on you or me for no reason at all." But of course, "innocence" in the noir world is a fairly gray concept, and the furrowed brows, haunted eyes, and pursed lips of hunted men in noir posters are evidence of this fatalistic worldview. *Detour's* one-sheet character montage mixes both joy and fear in facial expressions, but the illustrations are on a wash of caution-yellow, the border of the poster a stark black-and-white chevron pattern reminiscent of traffic warning signs. The title of the film appears in capitalized block letters in a left-hand arrow sign, pointing west, their journey being, as Muller says, "the highway to hell," presenting "the doom-drenched definition of noir fatalism."[5] Roberts's ill-fated hitchhiking journey begins with toxic idealism fueling economic distress; his decision not to report the unexplained death of his roadside benefactor and instead assume his identity, leads to misguided, self-satisfied charity that brings him into the orbit of femme fatale Vera (Ann Savage). In the Freudian, no-such-thing-as-an-accident world, his bizarre inadvertent killing of Vera realizes his deadly anger toward her blackmailing. The title of the film, a forced deviation from one's intended path, implies that Roberts may believe that "some mysterious force" has conspired to "stick out a foot to trip" him, but the viewer easily traces his poor judgment, and even

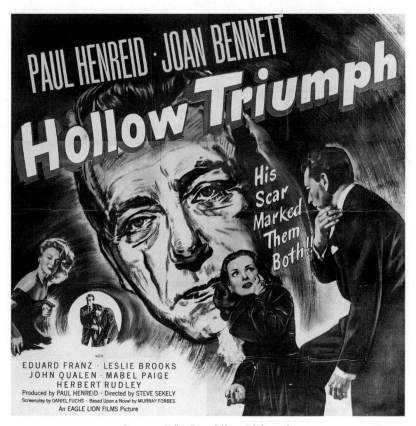

Figure 11.2. *Hollow Triumph* (Steve Sekely, 1948).

dark impulses, as the true root of the trouble, as is so often the case with such noir protagonists. As Foster Hirsch argues, "their entrapment may spring from *guilty thoughts* more than *guilty deeds*,"[6] these thoughts often proving as damning as the deeds themselves.

The parade of noir's "damaged men" is heavily populated by characters who display the uncertain potentiality for crime, rather than its obvious actuality. This character type is perhaps best typified by washed-up screen-writer Dixon Steele (Humphrey Bogart) from Nicholas Ray's *In a Lonely Place* (1950). The fact that we ultimately learn that Steele is not the film's killer in no way sets our minds at ease after witnessing his dangerously unstable motivations and behavior for the majority of the film. Though the film's half-sheet capitalizes on star power— touting the film as "The Bogart suspense picture with the suspense finish!"—these bold, red, block-lettered words appear on yellow, horizontal bars over Bogart's face, visually reinforcing the many messages of entrapment and psychological distress found in the film.

The bars are reminiscent of the ubiquitous venetian blinds found in film noirs, signifying division, guilt, and imprisonment.[7] But the fact that Bogart's eyes are framed between the bars has additional significance, given the way that his eyes are photographed in the film and the weight of the gaze therein. The expression in Bogart's eyes is reminiscent of the famous opening shot of the film: Steele's eyes seen in his car's rearview mirror, as the film's credits begin to run over the continuous shot of him driving. The level of anguish in his eyes varies during the course of the film, from mild at the outset to intense, when he pauses before beating another driver with a rock later in the film, to frenzied, when he is imagining the killer's motivation to friends. Moreover, as Tony Williams points out, the atmosphere of watching and scrutiny amid the HUAC-intrusive backdrop of its time pervades the film, Steele being cornered and hunted by his own anxieties and anger, as well as by police suspicion.[8] The film's poster distills these haunting fears into traffic-shades of yellow and red, as Steele's face floats in a background wash of nausea-green fog, suggesting the film's ever-present implication that the enraged, literate war veteran is irretrievably "a sick man."

Then there are noirs in which Kafka-esque condemnations are terrifyingly depicted, seemingly with the barest of shreds of culpability. The host of "wrong man" noirs includes *Phantom Lady* (Robert Siodmak, 1944), *Deadline at Dawn* (Harold Clurman, 1946), and *Dark Passage* (Delmer Daves, 1947), to name a few. Generally, the "crimes" of the accused arise from character or environmental weaknesses—loneliness, lust, naïveté, or, in the case of Hitchcock's namesake movie of this type, economics. The only crime of Manny Balestrero (Henry Fonda) in *The Wrong Man* (1956) appears to be overreaching his middle-class means; in the repeated position of borrowing insurance money not only for necessity, but also for leisure, he is thus in the position for the company workers to identify him, incorrectly, as a previous robber. The film's various posters sell the "it could happen to you" fear; for instance, the one-sheet's preponderance of text reinforces the docu-noir's true story origin: "For the first time Alfred Hitchcock goes to real life for his thrills! It's all true and all suspense—the all-'round biggest Hitchcock hit ever to hit the screen!" Further reinforcement of this idea is found in the small square inset in the lower-right corner, which states "CHALLENGE! If you don't believe that this weird and unusual story actually happened, see the records of Queens County Court, N.Y., Apr. 21, 1953 Indictment #271/53, 'The Balestrero Case.'" Even the sensationalistic poster art for the true-crime-sourced *The Phenix City Story* (D. Phil Karlson, 1955) didn't send potential audiences to the New York public records department to verify the veracity of the seemingly unbelievable story.

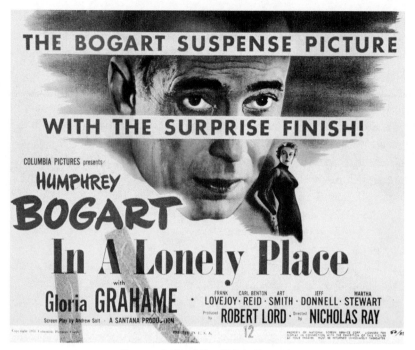

Figure 11.3. *In a Lonely Place* (Nicholas Ray, 1950)

The palpable fear of being wrongly accused in such a profound way is seen in the poster's main image: a man's arm perched on the open, driver's-side window of a maroon car; most of the car is not visible, but the disembodied hand grips the window frame in a settled position, and most strikingly, the car's side-view mirror reflects the image of Balestrero and his wife, Rose (Vera Miles), as they anxiously search for witnesses to corroborate his innocence. The image of the anonymous car suggests the police surveillance that Balestrero finds himself under, or almost, though this literally doesn't play out in the film, that the real criminal is stalking him, emphasized by the additional text to the left of the image: "Somewhere, somewhere . . . there must be the <u>right</u> man!" The car suggests a freedom of mobility that Balastrero lacks, as he relies on public transportation to take him everywhere, from arriving at the Stork Club for his job as a musician to visiting his immigrant parents. The force of this car is always ahead of Balestrero and Rose, the mirror reflecting them in the rearview, the real criminal and true justice being just far ahead. And in almost watermarked, shadowy gray, New York skyscrapers rise above these colorful images of threat: silent, blind, sentinel observers to the injustice that plays out for the majority of the film. The rest of the top text in the poster proclaims that Warner Bros. will present "the

exciting city of New York," almost as another character, in addition to Fonda and Miles, and emphasizes the broader considerations of conformity and bias in the film. In his analysis of the film's "whitening" of Balestrero through Fonda's casting, Jonathan J. Cavallero argues that this occurs "in order to mitigate an audience's ability to distance themselves from a more ethnically marked character. This helps the film to more directly implicate non-ethnic or assimilated audience members and to point out the degree to which the US criminal justice system is able to strip an individual such as Manny of his identifying characteristics."[9] The seductiveness of assimilation in the urban melting pot of NYC takes on a sinister tone here: if you are simply another face in the crowd, how easily might you be mistaken for a criminal? A South African version of the film's one-sheet displays two identical images of Balestrero's perpetually stunned face in a large and small circle, the latter bleeding into the yellow background, with the largest text on the poster asking, "DO <u>YOU</u> HAVE A DOUBLE?" The uncanniness of Balesterero's experience in some ways pales in comparison to that of Rose, whose mental collapse is not depicted in the poster art at all, but which provides perhaps the most chilling coda to the film: even after Balestrero is exonerated, she cannot free herself from her prison of despair. Her deadened response to her husband's overtures is a fitting encapsulation of the noir plight: "It doesn't do any good to care . . . no matter what you do, they've got it fixed so that it goes against you."

NON-REMEMBRANCE OF THINGS PAST

As much as Dixon Steele and Manny Balestrero would like to return to a prewar past and life before suspicion, respectively, many noirs depict a different kind of time manipulation, one related to memory lapse. Noir amnesia films provide an additional complex layer of psychological instability and criminal potential. In these films, the male protagonist is usually missing a piece of his perhaps-dark past and must confront his own criminal motivations and, possibly, acts. The poster art for such films strikingly represents such inner turmoil in various ways. For instance, the insert for Irving Reis's *Crack-Up* from 1946 depicts the hapless George Steele (Pat O'Brien) with subtle, spider web-like white cracks emanating from a large fissure in his forehead. Steele plays an art museum curator caught up in a Nazi art forgery scheme that is using his museum as a pawn, and who has a false memory of being in a train wreck that never actually happened. As Mark Osteen argues, the erasures and repainting in the art forgery process are "repeated in Steele's

lapses of memory, just as forgery comes to represent the blanking out and rewriting of history itself."[10] The cracks depicted in the poster call to mind those of a deteriorating painting in need of restoration, while simultaneously representing lightning-like illuminations. Steele's faulty memory is a forgery of his true existence, as he is manipulated by a nefarious psychiatrist as well as the police; his life and his consciousness are not his own, even appearing at the end of the film to have had no role in his own deliverance. The poster's depiction of his glassy stare, combined with the jagged edges of the ripped paper scrap displaying the title (also represented in cracked block lettering), complete the picture of the film's quest for remembered criminality. The tagline—"Could I kill. . . . and not remember?"—sums up innumerable such amnesia noir dilemmas.

This kind of dilemma is also seen quite prominently in a one-sheet for Jack Hively's *Street of Chance* from 1942, one of the earliest noirs dealing with amnesia. Based on one of Cornell Woolrich's many amnesia/wrong man novels, *The Black Curtain*, the film traces the wanderings of Frank Thompson (Burgess Meredith), who has inexplicably lost entire years of his life, after which a freak accident restores his memory of his original self. His alter ego in this other life, Danny Nearing, is rather shady and is suspected of killing the boss of his girlfriend, Ruth (Claire Trevor). The film's one-sheet depicts a ragged, caution-yellow title and a close-up image of a skewed lamppost, a sign of this upended world. Most strikingly, though, is the transparent image of a massive dagger, the line drawing superimposed upon painted renditions of Thompson and Ruth. A ghostly hand wields the dagger, reinforcing the idea of fluid corruption and criminal potentiality, and the dagger's blade plunges between the two characters, foreshadowing the separation that will occur when Ruth, the real killer, is gunned down, and Thompson leaves the world of Nearing to return to his wife. What Sheri Chinen Biesen characterizes as the film's "dangerous random accidents"[11] are well-represented in the poster, as the off-kilter world and its phantom threats prove unexpectedly dangerous.

Similar art is seen in a poster for a film with a similar predicament: a one-sheet for a lesser-known noir, E. A. Dupont's *The Scarf* from 1951. The phantom threat of its namesake murder weapon is prominent, signifying the plight of amnesiac protagonist John Barrington (John Ireland), who is serving time in a mental hospital for his girlfriend's murder, a crime that he cannot remember committing. His escape from the hospital leads to a harrowing journey in which he is traumatized by associations with the scarf at the same time that he does not remember using it to kill. This disconnection fuels his intense self-doubt and growing fear that he is indeed a murderer,

and moreover, as he says, "I might do it again if it's in me." The poster depicts Barrington's tortured face in its center, with the transparent scarf being pulled taut by equally ghostly hands stretching across the length of the entire rest of the art, including half of Barrington's face and the title itself, another in caution-yellow lettering. The combination of illustration and photomontage was ahead of its time for poster art,[12] and the blue monochromatic photos contrast sharply with the rest of the menacing symbolism. Furthermore, the line drawing of the scarf not only appears to encircle the other images, but also bleeds above and below it, signifying its terrifying reach—for Barrington, the reach beyond his conscious mind into his unremembered criminality. Barrington's psychiatrist friend Dunbar (Emlyn Williams) is the actual murderer and who, through hypnosis, also framed Barrington; he is one of many nefarious psychiatrist characters in film noir, whose presence both perpetuates and undermines the possibilities for therapeutic psychiatry. And though Barrington's innocence comes to light, it is uncertain how much of his memory is actually regained, the film's resolution delivering little assurance that Barrington is free from the demons that haunted him.

Visual representations of amnesia and hypnosis promote another adaptation of a Cornell Woolrich story, Maxwell Shane's *Nightmare* (1956), a remake of Shane's own previous *Fear in the Night* from 1947. Kevin McCarthy plays Stan Grayson, a jazz musician who has a dream in which he murders a man in a mirrored room, only to awaken to find the real scars of the struggle on his body. Grayson must then piece together fragments of his experience and attempt to sort out fact from fiction, with the assistance of his police detective brother-in-law René Bressard (Edward G. Robinson). To look at the film's insert, one might assume that Robinson plays the villain, as the text warns us that he "shocks the screen awake" in this film. In fact, "the eyes of the hypnotist" that the tagline warns us about belong to Dr. Britton (Gage Clarke), who hypnotizes Grayson to induce him to kill Britton's wife and her lover. The eyes have a prominent center placement on the poster, are wide open, and in and of themselves do not appear particularly threatening; they might as well be the eyes of the transfixed victim rather than the villain. But the text parallel to the Robinson teaser lines warns that "these eyes. . . . can transform you into a living robot—they can turn back time—they can make you do anything. . . . anything!" The superstitious allure of hypnosis was strong in the mid-1950s, even as it was becoming a more common medical practice, particularly due to the sodium pentothal drug therapy utilized by the military for post-traumatic stress disorder during and after World War II. In film noir, sodium pentothal is rarely used for genuine therapeutic effect, but more likely employed as a weapon by nefarious quacks and conmen;

thus, the ominous conception of the hypnotist having such boundless power would have been a powerful draw for marketing the film. And *Nightmare* bears out this threat, as it is disturbingly easy for Britton to test Grayson for suggestibility and then drive him to kill. Even though ultimately the murder is shown to have happened in self-defense, Grayson's simple slide into crime and its attendant loss of identity speaks to an alarming vulnerability that the film's poster chillingly projects.

One final compelling noir amnesia poster representation can be found in Joseph L. Mankiewicz's *Somewhere in the Night* from 1946. For amnesiac veteran George Taylor (John Hodiak), his search for identity begins with a letter that he finds in his wallet that states, "I shall pray as long as I live for someone or something to hurt and destroy you, make you want to die, as you have made me." Taylor wonders, "Who writes letters like this? Who do they write them to?" and this is the question he pursues throughout the entirety of the film. The film's one-sheet displays striking composition that reflects the film's psychological complexities and particularly the veteran amnesia victim's fear of criminal potential. Taylor's face is given prominence at the center of a multilayered spiral, which radiates shafts of light directly from his head. The four lights emanating from Taylor's forehead and both sides of his jaw seem to signify the spiral as a wheel, while conversely, the spiral is darkest at its center, suggesting the whirlpool of uncertainty in Taylor's plight. Taylor is thus visually both static, in the paralysis of his unknown identity, and dynamic, as he is being propelled down into the frightening depth of a persona that is an alien, and moreover, a potentially dangerous, force.

Illustrations of the characters who populate Taylor's phantom world punctuate the spiral's rings, including chanteuse love interest Christy (Nancy Guild) and conman Anzelmo (Fritz Kortner) who, like many others, are after two million dollars of Nazi money that is the key to Taylor's real identity. Rounding out the illustrations are the obligatory gun, and more interestingly, Taylor's disembodied hand gripping the bars of an ornate window grate. This action occurs in the film as part of Taylor's dogged search for self-discovery, as he breaks into an insane asylum to find answers from a man who witnessed the murder and hid the missing money. Taylor's unearthing this key piece of information will lead him directly to his identity-puzzle's solution: that he is actually a man named Larry Cravat, a private detective who, seeking a piece of this heist, had to escape into the Marines at the start of the war in order to protect himself from the numerous foes out to destroy him. That this particular piece of the plot found its way into the art of the poster is a telling testament to the quality of the visual representation that so subtly draws attention to Taylor's desperate grasping for any lifeline as he is drawn

inexorably below the surface of his own consciousness. Taylor must literally descend below the surface, as he searches under a dock to find the suitcase of missing money, which also holds the key to his own identity: a coat label that reads, "Made by W. George, Tailor." Taylor discovers that he is nothing but a stitched-together patchwork of circumstances, revealing himself to be almost everything he feared: not necessarily a murderer, but the shadiest of opportunists who got more than he bargained for when he sought an easy escape. This realization connects with Taylor's eyes in the poster image, glancing backward, always needing to look over his shoulder, not only for threats, but also to simply discover who he is—he cannot look forward to find himself. When pondering his predicament earlier in the film, Taylor muses that he is "really alone in the whole world—a billion people, every one of them a stranger—or what's worse, not a stranger, somebody, maybe, who knows you, hates you, wants you to die." This statement encapsulates the predicament of amnesia in noir, and which its poster art visualizes so well—a threat of alienation so profound that one is a stranger even to oneself.

The multitude of psychological images assembled in the poster art of film noir attests to not only the exploration of the deep traumas associated with the noir cycle but also the growing public fascination with these topics. The often-sensationalized depictions of psychosis, anxiety, doom, and amnesia narratives display their own mesmerizing gaze outward, pulling audiences inward toward examination of social instability and the precarious containment of dark and dangerous impulses. Whether Eagle-Lion's brash iconography or 20th Century Fox's sophisticated layouts, such posters provide the fun-house doorways into the noir nightmare.

NOTES

1. Ian Haydn Smith, *Selling the Movie: The Art of the Film Poster* (Austin: University of Texas Press, 2018), 91–93.

2. Raymond Durgnat, "Paint it Black: The Family Tree of Film Noir," in *Film Noir Reader*, eds. Alain Silver and James Ursini (New York: Limelight, 1996), 49.

3. Robert Singer, "The 'How Big Is It?' Combo: Noir's Dirty Spectacles," in *The Films of Joseph H. Lewis*, ed. Gary D. Rhodes (Detroit: Wayne State University Press, 2012), 179.

4. Eddie Muller, *The Art of Noir* (New York: Overlook Press, 2014), 26.

5. Muller, 173.

6. Foster Hirsch, *The Dark Side of the Screen: Film Noir* (New York: Da Capo Press, 1983), 178.

7. See Janey Place and Lowell Peterson, "Some Visual Motifs of Film Noir," in *Film Noir Reader*, eds. Alain Silver and James Ursini (New York: Limelight, 1996).

8. Tony Williams, "The Imagery of Surveillance: *In a Lonely Place*," *CineAction*, no. 87 (Spring 2012): 15.

9. Jonathan J. Cavallero, "Hitchcock and Race: Is the Wrong Man a White Man?" *Journal of Film and Video* 62, no. 3 (2010): 7.

10. Mark Osteen, "Framed: Forging Identities in Film Noir," *Journal of Film and Video* 62, no. 3 (2010): 30.

11. Sheri Chinen Biesen, *Blackout: World War II and the Origins of Film Noir* (Baltimore: Johns Hopkins University Press, 2005), 89.

12. Muller, 120.

MARKETING THE BEASTLY

Lang's *Human Desire*

ROBERT SINGER

Zola did more than anyone else for cinema
—SERGEI EISENSTEIN, 1928

I.

Representations of pathological behavior in film narrative, such as the ubiquitous presence of the serial killer, can be visually compelling. Commenting on the popularity of these violent, macabre, and usually male figures, James Alan Fox and Jack Levin note, "From *Silence of the Lambs* [Jonathan Demme, 1991] to *Natural Born Killers* [Oliver Stone, 1994], Americans have been entertained and fascinated by the enigma of multiple homicide."[1] Perhaps the single most dominant image in contemporary popular culture of humanity's regressive, mysterious descent into violent, near bestial origins involves the emergence of the serial killer in fact and fiction, a virtual naturalist intersection of genetic and environmental causalities. Evidence of this tradition is well-established at the box office; for example, *Hannibal Rising* (Peter Webber, 2007) and *Zodiac* (David Fincher, 2007) were released the same year as major film productions to an audience that consumes the spectacle of animalistic, compulsive brutality as expressed by something human. These two films, among other serial killer film productions such as *Henry: Portrait of a Serial Killer* (John McNaughton, 1986), *Se7en* (David

Fincher, 1995) and *American Psycho* (Mary Harron, 2000), engage numerous industrial standards and genre—melodrama, horror, film noir, adaptation—in stylized narratives of pathology and demonstrate the intertextual and fluid nature of genre structures.

One of the principle works of naturalist fiction that features a prototypical serial killer, Émile Zola's *La Bête humaine* (1890) engages the pathological self and ensuing panic involving violent ruptures of identity for the railroad worker, Jacques Lantier. According to E. Paul Gauthier, "*La Bête humaine* marks Zola's return to extensive use of physiognomic theories and intensified exploitation of man-animal resemblances."[2] As a direct descendent from the Rougon-Macquart-tainted family line, Zola's Jacques contains the genetically based "default" structure that may be activated by various causalities, mostly sexual.[3] In effect, "Jacques is prey to the primitive animal instincts that underlie the entire human race, occasionally surfacing in cases like his,"[4] and Jacques later does kill. The repressed impulse of a pre-civilized, ancestral state returns to vex him. Zola's novel was a progenitive narrative, and Jacques, a complex expression of grim determinism, is a seminal figure in the cult of the serial killer in fiction, one whose presence spawned many descendants and intermedial variations, especially in international art and film culture.

Expressionist artist Ernst Kirchner's painting *Der Mörder* (*The Murderer*) (1914)[5] is a hypertextually incriminating representation of compelling savagery based on Zola's *La Bête humaine*. The act of murder is depicted in a slashing, chaotic movement of expressive sexual agony. In a setting with no escape, the lithograph is rendered in black and darkish-red tonal shadings, with blood flowing down from the neck and across the stomach of the supine, nearly bare, bisected female, a victim of atavistic attraction. Kirchner's painting is a study in the eccentric, visual geometrics of stylized brutality. Other works of art based on Zola's novel by Kirchner include his pencil illustration "Sketch of *La Bête Humaine*" (1914), in which the unformed heads of two women, erratically conceived and seemingly connected in space and time in clashing, frenzied lines are poised behind a head and shoulder of an unemotive Jacques. Kirchner's hand-colored lithograph "The Railway Accident" (1914) depicts in a flurry of black and purple images of chaotic, swirling expressionist urgencies, as a convoluted train wreck is set in front of a house. The illustration suggests released, dark energies, like a bomb's initial effect but frozen in space and time. In these hypertextual citations, Kirchner's art depicts Zola's resurfaced, lurking violent episodes.

Nearly a century later, Belgian mural artist ROA created a fascinating series of acrylic and enamel paintings in 2019 on "found steel" that were

Figure 12.1. ROA's gallery art.

based on Zola's *La Bête Humaine*.[6] According to art critic Lauren Wiggers: "The meticulously detailed paintings and their enormous scale, sometimes up to 50 meters high, aid the artist's ambition: to remind the modern man in his day-to-day life of the nature from which he originated."[7] A mural on the wall of a Belgian art gallery painted by ROA illustrates aesthetic conceptualizations as a biological presence: the enormous image of a buffalo whose upper torso remains intact and whose bottom torso reveals a skeletal structure in a posed, sitting position. The beastly image, a dynamic naturalist referent denoting power and vulnerability—exposure—simultaneously functions like a display poster and beckons the viewer's entrance to the gallery while introducing intertextual relations with *Zolaesque* thematic and visual motifs. ROA's poster-like image establishes anticipatory reactions. The poster-like "buffalo" mural in particular stimulates immediate sensory experience as the audience intuit something familiar and living yet defamiliarized.

ROA's immense and absorbing canvas is a creative juxtaposition between the exterior world of flesh and the interior world of bones; he introduces the public to fleshless and exposed contradictions inherent to one carcass, as one free-range beast on the street may behold a more stationary reflection. According to Emma Arnold, "The figurative nature of street art and new muralism, such as ROA's work, lends itself to aesthetic appreciation. It is easy to understand, admire, and respect."[8] In this exhibit, ROA conceptualizes

animals as corporeal presence, as a subject of speculation and identity, creating an experimental, naturalist canvas.

While the idea of the beast in the man is a familiar trope in naturalist literature and media, the presence of the man in the beast also has historical precedents in various narratives. Intermedial connections with Zola's *La Bête Humaine* are peculiarly inventive and fascinating. In the American "B" film *Gorilla at Large* (Harmon Jones, 1954), trapeze artist and murderer Laverne Miller (Anne Bancroft) performs for the public while covertly plotting homicide and using men to rise in performance ranking and economic stature, with a fake gorilla (containing an actor) assisting in the postwar circus intrigue. Scheming, attractive Laverne subverts the image of the imperiled female in director Jones's eccentrically limp 3D adaptation of Poe's *The Murders in the Rue Morgue* (1841), which itself was the subject of an adaptation directed by Roy Del Ruth. Retitled as *The Phantom of the Rue Morgue* (1954), Del Ruth's film featured another fake gorilla (containing an actor) assisting a requisite mad zoo keeper and an imperiled female, along with multiple victims. According to Barbara Creed, these images of aggressive, lustful simian behavior were not uncommon in the 1950s cinema: "The cinema was so comfortable with the taboo idea of bestiality,"[9] perhaps when considered as marketing strategy for 3D industrial releases. These two films invoke a near preternatural need to suspend disbelief as the actors working inside the gorillas, and the film itself, are flat and not very menacing. Although one shot in *The Phantom of the Rue Morgue* eerily recalls Kirchner's portrait of *La Bête Humaine*'s gory death: there is a featured portrait of a reclining, sexually attractive woman, a frame within the frame that is slashed, literally bisected, with red, signifying blood, as she is another victim of the mysterious murderer.

Harmon Jones's *Gorilla at Large* features the aforementioned absurdly costumed menacing gorilla (not Poe's orangutan), a clever detective (Auguste Dupin-like) in ill-fitting clothes, violent deaths, fumbling assistants, and a 3D Technicolor circus studio backdrop rather than the Parisian streets in the Rue Morgue setting. The fake gorilla desires, as do all the featured male primates, the sexualized spectacle of Laverne, as she dangles above the arena clutching cables in multiple shots of simulated aerial maneuvers. The climactic resolution involves menacing physical contact between the predictably escaped gorilla and semi-conscious Laverne, the object of his craving, as the gorilla perilously climb up the scaffolding and support beams of a nearby rollercoaster while she hangs over its hairy shoulder.

The marketing strategy for the film poster of *Gorilla at Large* involves colorfully constructing an immense image of simian terror as it grips a female

body, suggesting potential frightening carnality, while not excerpting an actual still from the film to illustrate its content. In a predacious pose suggestively recalling the presence of *King Kong* (Merian C. Cooper, Ernest B. Schoedsack, 1933)—in which Kong grips a helpless Ann Darrow (Fay Wray)—Jones's snarling gorilla grasps the curvaceous body of a screaming, shapely woman in a red dress in the immediate foreground of the frame, set directly above the title, printed in bold red and yellow. The great beast and his prey nearly fill the frame and focalize the viewer's gaze on a most primal image; one of the beast's paws is poised on her legs, while she wears alluring stockings and heels, and the other paw is set in close proximity to one of her pointed breasts. The gorilla's gaping mouth hovers over the other upturned gland. Like a rack focus shot, the background images in this poster appear as blurry moments of flight; people run, and clouds overhead disperse. The poster elucidates the idea of the beast-human sexualized dilemma.

According to Peter Childs, "The poster can . . . re-accentuate interpretations of the many thousands of single images that comprise the film reels."[10] The poster for *Gorilla at Large* is designed to market a highly gendered image of inviting menace to the audience the theater: her body, juxtaposed with the gorilla's rage and desire, serves to attract. For the audience exiting the theater, the poster is a recalled highlight of dynamic, perhaps comical, illicit sensuality: one that is never actually fulfilled. "Species interruptus" is not evident in multiple posters designed for Fritz Lang's *Human Desire* (1954); in striking color patterns and multiple print design, these posters highlight the precarious experience of damaged lovers menaced by a corrupt, brooding middle-aged man. Violence is never distant, but there are no apes.

Zola's *La Bête humaine* and its film adaptation, *Human Desire* depicts violent ruptures of identity related to historicized gender and class issues while dispensing with Zola's biological-determinist frame of narrative reference. In a series of intertextual practices recalling Zola's experimental novel, Lang's film represents the beast within the individual, which, as it is affected by catalytic agencies in the environment, solicits extreme antisocial, even subhuman tendencies and behavior. This thematic shift from biological, genetic causalities to social-environmental catalysts occurs primarily in the unhappily married couple, Carl and Vicki, and her ensuing affair with Jeff. Zola's railroad worker Jacques Lantier ("Jeff" in *Human Desire*) is not a serial killer; he commits adultery and *might* be swayed into premeditative murder by Vicki, but he is not the product of tainted genetics. Lang's noir narrative, a stylized interpretation of Zola's prose, critically shifts the emphasis from genetic malfunctions to agencies operating within the work environment, the immediate social milieu, and Jeff's wartime experiences. Lang's adaptation

is the artfully transgressive transcription of a naturalist narrative. In *Human Desire*, destiny is socially formulated, localized in a sphere of coincidental opportunities, and bad things happen to flawed people. Catalytic agencies symbolically grind several human beings, specimens, as a product of distressful, ruinous, and predatory experiences.

Although the critical reception of Lang's film has been less than enthusiastic when compared with other adaptations of Zola's *La Bête humaine*, such as Jean Renoir's *La Bête humaine* (1938) or Daniel Tinayre's *La Bestia Humana* (1957), *Human Desire* contains many artistically satisfying qualities.[11] As Andrew Sarris notes: "Where Renoir's *The Human Beast* is the tragedy of a doomed man caught up in the flow of life . . . Lang's remake, *Human Desire* is the nightmare of an innocent man enmeshed in the tangled strands of fate."[12] Lang's adaptation is far more "obsessed with the nature of the trap,"[13] the workings of the material world, not only the object of the trap, Jeff, the postwar displaced American male whose bad decisions involve the stifling world of work and his awakened sexual urgencies. This sense of nightmarish entrapment will be a focalizing, repetitive image in the stylized composition of multiple posters of *Human Desire*: there are encasing rectangles and squares containing the three leads, with little room to breathe or to escape.

Director Lang re-envisions Zola's plot points and naturalist tropes in a film narrative of hypertextual renewal, as the celebrated serial killer trope evolves into a vision of entrapped-released male-female sexuality infused with brutish violence. In *Human Desire*, characters respond to environmentally caustic, not genetic, causalities; Zola's Jacques is a bifurcated figure, reconceived as two men from the literary source. Jeff (Glenn Ford) is an attractive railroad engineer, a man returning from war, full of repressed urgencies; whereas, Carl Buckley (Broderick Crawford), a fellow worker, is an unattractive, cuckolded, obese alcoholic who is unhappily married to Vicki (Gloria Grahame), a noir femme fatale. Jeff can only fantasize about murder in order to possess Vicki, with whom he carries on an affair, but Carl, full of rage and thwarted passion, kills men in the illusion of "keeping" Vicki. Neither man is a serial killer; therefore, Lang supplants the overtly naturalist context with a noirish series of crimes of passion, matters of choice and opportunity, not defective biological compulsion. Although "the concept of destiny haunts Lang's work,"[14] biological imperatives do not inform this postwar production. In *Human Desire*, determinism is essentially materialist, localized in the world of chance and personal frustration and humiliation. These are the environmentally based catalytic agencies that symbolically grind down the naturalist specimen—the imperfect male—as a result of distressful and often ruinous experiences. As depicted in multiple film posters

of *Human Desire*, Carl is the image of perverse rage, a brooding wreck set between two lovers.

If it is true that "Fritz Lang's cinema is the cinema of the nightmare,"[15] then *Human Desire* situates the space and time of the imaginary world of postwar cultural and psychological anxiety as a sexualized déclassé dreamscape in stylized black-and-white photography. This is also a cursory description of the film noir aesthetic: "[with a] central male protagonist . . . who is divided, but often lacks self-knowledge . . . between femme fatales and domesticating women, both types presented as threats . . . [which creates] a mood of pervasive anxiety."[16] *Human Desire* is a perceptible entry into the noir category of postwar American film production. Lang's materialist, naturalist text is "about departures and lapses from the normal world, and the film's deliberate visual styling enhances the kind of transformation from reality to nightmare that the narratives dramatize."[17] Lang's adaptation utilizes the themes and forms of the noir aesthetic to explore a set of environmental causalities, not Zola's atavistic Jacques, but Lang's conflicted Jeff, a "descendent" of Zola's naturalist text. Yet the naturalist dialectic is complementarily contextualized by Lang's formalist eccentric and stylized *chiaroscuro* lighting, camera placement, and angles, and by the use of mirrors, especially when framing Vicki, a noir "dame," in the rundown, seedy atmospheric setting supporting a local stopover train station. According to Foster Hirsch: "reflections in mirrors and windows are a recurrent aspect of noir iconography . . . suggesting . . . masquerade,"[18] and her reflection reveals the agency of Jeff's and Carl's crises. Lang's set design artfully comments on internalized emotions, rendering their release visible.

In one of Lang's particularly stylized noir sequences featuring Vicki, the director frames a naturalist *moment* in the life of a working-class female adulterer. Vicki sits in her bedroom, placed in the foreground of the shot, in front of a makeup table containing multiple mirrors. Although Vicki looks away from the largest one, in an indifferent pose, the shot of her multiple selves in the other mirrors suggests an inwardly pensive gaze. As the observer looks at Vicki, nearly undressed, legs up, in Lang's chiaroscuro lighting, both the larger and smaller mirror frame her in a side-angle shot. She is not looking at herself but still casts dual images. The mirror functions as a revelatory noir agency for the observer. Its traditional function, to reflect its immediate observer, now indicates that there are other sides to Vicki, since the observer possesses *a priori* information that she plots to ensnare Jeff, as she is herself ensnared in a dreadful, abusive marriage to a violent alcoholic. The large mirror also contains a reflection of a door left open, suggesting a way in for Jeff and a way out for her. In the noir narrative, doors more

often close and entrap. In Lang's thematic entanglements, the possibility of escape is the substance of failed dreams. I would editorialize and state that the image of Vicki sitting before multiple sets of mirrors would have served as an excellent poster design, as a still image taken directly from the film narrative. However, *Human Desire* features three entangled figures.

Jeff Warren, a railroad engineer just returned to the United States from the Korean War, represents the noir male in crisis. Lotte Eisner has observed that: "In *Human Desire* Lang transfers [thematic] tragedy to a different plane. . . . He emphasizes tragic existence."[19] Jeff has changed since his wartime experiences when he had to kill to survive. Although this does make him a sanctioned, legal murderer, the taking of life and other experiences has affected him. He is vulnerable and off-balance, especially when encountering a calculating Vicki after she and her husband commit murder. Jeff is dragged into their misery. He appears to other people in the immediate work and living environment as withdrawn and unsettled. Jeff has trouble reintroducing himself to the demands of 1950s normalcy, especially involving marriage and other domesticating strategies. He is susceptible to Vicki's allure. Now living in a rented apartment with the family of a fellow worker, Jeff represents a noir symbol of postwar America: the troubled, decentered working-class male.

Manipulative factors within Jeff's work and living environment, especially the appearance of Vicki, a sensual, damaged/damaging femme fatale, conspire against Jeff's resettlement into work and society. "Sex in noir is usually poisoned, presented characteristically not in a romantic context, but a psychotic one. Characters are enslaved, victimized by it,"[20] and the affair between Jeff and Vicki does ensnare him and lead him away from plans for the domesticity others envision for him. Vicki is also a victim of her own expressive sexuality; it is a voyeuristic, exposed commodity. The enticing aura of sexuality is a visual trope emphasized in the posters for *Human Desire*, especially in the European models. Vicki's sense of entrapment in a failed marriage, channeled by her indicative, sexual allure, makes her desired but also susceptible to men. From the saloon to the boardroom, she is pursued while also pursuing.

Vicki reveals that she was a victim of sexual abuse and is now a battered wife. Jeff represents an escape from her failed life and marriage. She is the principal environmental determinant which might compel him to murder, not for his gain or release, but, in reality, for her gain. Sex is a lure, her controlling weapon. Although her affair with Jeff unleashes his sexually unrestrained disposition, Jeff's identity crisis involves issues associated with postwar codes of heteronormative behavior, labor, ethics, and conformity. Even when he is highly motivated for lustful reasons, Jeff could not murder

the abusive and increasingly drunk Carl, however violent and pathetic he
may be. Although Jeff is a damaged individual, he is not a human beast;
the predatory Vicki, an expression of damaging and damaged eroticism,
and the scheming, murderous Carl are more consistent with Zola's notion
of the atavistic. Vicki and Carl's marriage is perversely *Strindbergian* in
design, made in working-class hell. In *Human Desire*, Lang's triangulated
series of entrapped lovers, liars, and murderers, in penetrating close-up and
medium shots, re-envision Zola's fulminating naturalist schema as a noir
narrative of sexual interludes and passing trains. Attracting an audience for
Lang's *Human Desire*, while not a major release from the Columbia Pictures,
involves developing publicity strategies employing energizing film post-
ers, visual paratextual referents, engaging familiar noir tropes in full color:
marketing the beastly.

II.

According to Gérard Genette and Marie Maclean, the paratextual, in this
case, the film poster, creates a space of reception and consumption, a "thresh-
old" and "these features essentially describe its spatial, temporal, substan-
tial, pragmatic and functional characteristics."[21] In the multiple film posters
created for both international and American audiences who may choose
to attend *Human Desire*, the poster art strategically and inferentially ref-
erences Zola's source narrative. For American audiences, the film poster
suggests a relationship with 1950s commercial, "B" cinema—the "crime,
thriller, (relatively) erotic narrative"—in which expressive female sexuality
might be presented in the film, later to be controlled or punished. For the
European audience, familiar with the era of neorealism's controversial, real-
istic social themes and less proscriptive heteronormative codes associated
with male-female relations, the poster is a dynamic, expressive revelation: a
vivid paratextual presence.

Several international film posters of Lang's noir narrative of triangulated
social decline visualize near-bestial male behavior and varieties of illicit
passion. These are promotionally effective approaches signifying incipient
violence and in full color. In these posters, interpretive marketing strategies
artfully *presentify* the downward spiraling of Lang's working-class characters,
frequently depicted in gaudy, carnal poses, to prepare the audience for conflict
and resolution. Lang's visually encoded messaging is rendered in these posters
as beckoning images of erotic, spatialized entrapment, framed by windows,
doorways, and bedrooms. In an analogous sense, one enters the film showing

as one "enters" its poster, intrigued and possibly aroused. According to Jonathan Gray, "[P]osters can still play a key role in outlining a show's genre, its star intertexts, and the type of world a would-be audience member is entering."[22] The film poster is a commodified display venue, invoking memories of cinema and experiences of the past for the viewer. Each of the posters of *Human Desire* in this study interpret Lang's series of adulterous escapades as it reinterprets Zola's nineteenth-century naturalist narrative.

According to Stephen Parmelee, "Although the creation of a poster for a film is nearly exclusively monetary in its purpose, with the passage of time, film posters can serve another purpose: they trigger the viewer's memory of past films and, with them, past eras and events in our personal and collective history and culture."[23] From evocative, erotically charged, stylized print and media advertisements to Valentine's Day cards, *red* is the color frequently associated with memories of heightened sensuality. In their study profiling the psychological effects of the color red, "Romantic Red: Red Enhances Men's Attraction to Women," Andrew J. Elliot and Daniela Niesta evaluate the stimulating presence of power of this primary color:

> [O]ur primary hypothesis is that red leads men to view women as more attractive and more sexually desirable. Red is hypothesized to serve as an aphrodisiac for men because it carries the meaning of sex and romance in the context of heterosexual interaction. Empirical work has supported the idea that red has amorous meaning, as studies of color associations have indicated that people tend to connect red to carnal passion, lust, and romantic love . . . in popular stage and film, there are many instances in which red clothing, especially a red dress, has been used to represent passion or sexuality. . . . Red has been used for centuries to signal sexual availability. . . . In sum, red is clearly linked to sex in the context of heterosexual interaction, and this link is viewed as emerging from both societal use of red and a biologically engrained predisposition to red.[24]

The posters selected for examination in this study are not frame enlargements from Lang's *Human Desire*; each poster, with a sole exception, illustrates in bold, artful strokes in predominantly primary colors, especially symbolic red, renderings of sexualized-bestial moments, paratextually invoking a naturalist tone. These posters function in logistical conversation not only with Lang's film narrative but also with each other as intertextual referents.

The Belgian poster of *Désirs Humains* is a study in sexualized, anatomical portraiture, with two contrasting images producing one composite effect in

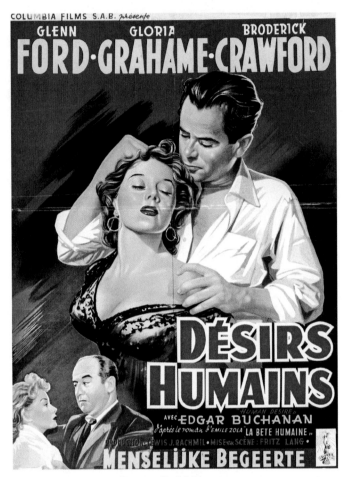

Figure 12.2. The Belgian poster.

the frame: a study of one woman in relationship to two men, as two couples set in binary juxtaposition express states of crisis and arousal to make one visual construct. In the smaller space (at the bottom left), one notes an asexual, detached pose of male-female discontent that could be a moment in any dead marriage. In the expansive, frame-filling background, a blue-tinted portrait of desire manifest, a visually inflammatory confrontation with bosoms lined up next to the text, *DESIR*, indicates oncoming predatory behavior. The male's hand, in caveman style, grabs her hair and pulls her head back, while the other hand is placed on her shoulder, perhaps to slide away her strap or even to take a bite; this is an amorous yet menacing pose. A white shirt is open and exposes Jeff, as much as Vicki's undone dress focalizes for the observer his imminent future and also distinguishes him in the light-dark contrasting

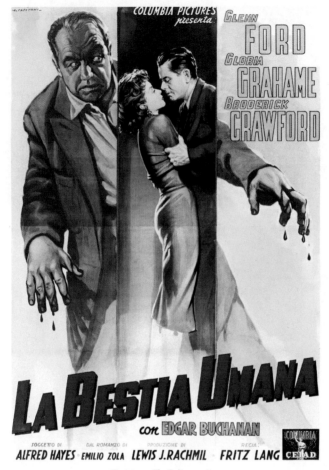

Figure 12.3. The Italian poster.

color scheme. The poster's thematic emphasis is one portraying thwarted relations and pending fulfillment. Vicki is clearly the object of *Human Desire*.

The French poster of *Désirs Humains* is *nearly* identical with the afore-mentioned Belgian poster's design that foregrounds both Grahame's and Ford's sexualized, anatomical portraiture; the skulking figure of Carl, her cuckolded husband, lurks behind the lovers as if he would clutch and engulf them. Toward the left side of the poster, train tracks and a train suggest con-ceptual motion linking the trio, while to the right, at the top of the poster, the performer's names are set in yellow. What distinguishes the French poster from the Belgian poster's blue background design is the pervasive red color-ing framing the background of the composite images. The red is attractive and suggests fiery dispositions.

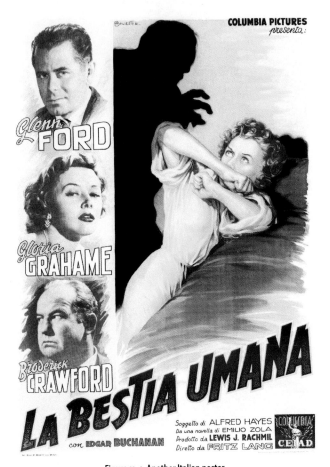

Figure 12.4. Another Italian poster.

This image of life in working-class hell is evident in the first Italian poster *La Bestia Umana*. Carl, an atavistic, genuinely apish depiction of a menacing male, with blood-stained, dripping fingers, is anatomically divided into two sectors within contrasting shades of yellow as he surrounds two attractive figures set in bluish-green, in a clutching-like pose indicating male possession of the female, like King Kong. The poster's tripartite breakdown suggests a naturalist triptych: images of a subhuman, hulking male signals regression and violence to those in the center frame within the frame. Vicki, the only entirely viewed body, is positioned "dead" center, generating the male action, highlighting her face and Jeff's, in side angle. The enlarged film title in bold red print and credits are significantly positioned below synecdochic images of hands dripping with somebody's blood.

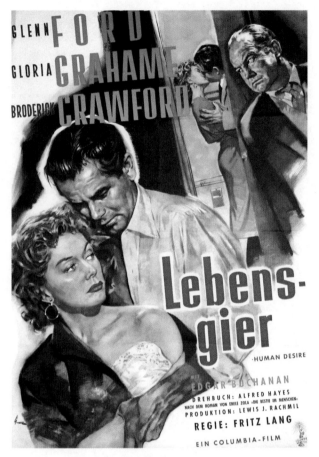

Figure 12.5. The German poster.

In the complementary second Italian poster of *La Bestia Umana*, the poster bifurcates to create two contrasting assemblages. To the left side of the poster, a set of headshots establishes a top-to-bottom series in star/character placement: handsome Glenn Ford, then, sandwiched in-between two men, snarling Gloria Grahame, and below, bulldoggish Broderick Crawford. To the right of the poster, the shadowy outline posed before a greenish-yellow background creates a menacing chiaroscuro and recalls an expressionist presence in the horror aesthetic. This intimidating outline appears to be a man, Carl, who stands before a threatened woman, Vicki, recoiling beside a red-colored bed. The naturalist imagery is one of pending, imposing dread, not to be overshadowed by the reddish-yellow screen title which traverses the frame for *La Bestia Umana* and its credits. The critical concept informing both Italian posters is lurking, lurid male menace and its target of consumption.

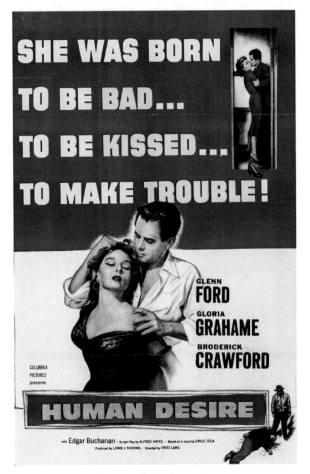

Figure 12.6. The American poster.

In the German poster, *Lebens-gier*, no eye contact is made by its occupants beyond the frame of the setting or even with each other; the poster is a space of violating intrigue. In the foreground, off-center, Vicki is partially and literally exposed, with Jeff's hand gripping her hand and his body hovering over her body; their facial expressions connote a problematic, unromantic moment. Above their accentuated, looming bodies is the credit listing; to their right, the film title, again, appears in bold red print. Situated in the background of the frame, behind the disillusioned duo, in a suggestively *a priori* pose, her husband listens to the lovers in another room, as they kiss behind an open door; the lovers, framed within a frame, pose in a tilted moment of form rendered consistent with content. In its depiction of stages of plot development, the German poster historicizes phases of Lang's naturalist narrative.

The original poster for *Human Desire*, the American version, appears as a series of gendered tag lines, denoting Vicki as the object of desire, without emphasizing incipient brutalities. Within the frame of the poster, two unequal rectangles, from top to bottom contain a set of text and images: the top rectangle focuses on sexually charged text, which highlights phrases in primary yellow: "bad," "kissed," and "trouble." To the right of the text, the pose of the two illicit lovers behind an open door invites observation. Breaking into the top rectangle, Jeff and Vicki's heads are set in the familiar "clutching of the hair and arm pose" that was more creatively interpreted in the Belgian poster. To the right of the duo are the film credits, and below, at the bottom of the rectangle, in unassuming print and stature, the film title appears to the left of two shrunken male figures: one standing, the other, presumably, as dead as the energy emanating from the American poster. Where's the signifying red when it's needed?

Perhaps the single most striking aspect of the European posters and the American poster of Lang's black-and-white noir narrative of naturalist struggle and decline involves the thematic "conversation" among them; these posters interpret and render—before and after *Human Desire* is experienced by its audience—relevant tropes and visual images in a color-based strategy. In the theater, the audience experiences *Human Desire* as a flow of black-and-white projected images; in these posters, Lang's noir atmospherics are rendered as interpretive elucidations. These posters introduce and reclaim moments in Lang's *Human Desire* in signifying, bold colors: marketing memories.

NOTES

1. James Alan Fox and Jack Levin, "Multiple Homicide: Patterns of Serial and Mass Murder," *Crime and Justice*, no. 23 (1998): 407.

2. E. Paul Gauthier, "New Light on Zola and Physiognomy," *PMLA* 75, no. 3 (June 1960): 300.

3. This is the famous family line Zola introduces in his series of twenty novels. *La Bête humaine* is one of the later novels in the series.

4. William J. Berg and Laurey K. Martin, *Emile Zola Revisited* (New York: Twayne Publishers, 1992), 34.

5. A website presenting Kirchner's lithograph may be located at: https://www.moma .org/collection/works/71073?classifications=any&date_begin=Pre-1850&date_end=2018&l ocale=en&q=expressionism%2C+the+crime&sov_referrer=collection&with_images=1.

6. Photo courtesy of ROA. The original show, "La Bête humaine," was held at the Belgian gallery, Keteleer Gallery, Antwerp, 2019. For a detailed collection of ROA's contemporary art, see Ann van Hulle, *ROA CODEX* (Lexington, KY: Lannoo Publishers, 2020). We thank the artist and gallery for permission to reproduce the material.

7. A website detailing the ROA exhibit and Wiggers's catalogue introduction to his work may be located at: https://www.artsy.net/show/keteleer-gallery-roa-la-bete-humaine?sort=partner_show_position.

8. Emma Arnold, "Aesthetic Appreciation of Tagging," in *Urban Planet: Knowledge Towards Sustainable Cities* (Cambridge: Cambridge University Press, 2018), 400.

9. Barbara Creed, "A Darwinian Love Story: *Max Mon Amour* and the Zoocentric Perspective in Film," *Continuum: Journal of Media & Cultural Studies* 20, no. 1 (March 2006): 48.

10. Peter Childs, "Movie Poster: Alien Nature," in *Texts: Contemporary Cultural Texts and Critical Approaches* (Edinburgh: Edinburgh University Press, 2006), 33.

11. Don Willis refers to the film as "dully written" in his article, "Fritz Lang: Only Melodrama," *Film Quarterly* 33, no. 2 (Winter 1979–80): 8.

12. Andrew Sarris, *The American Cinema* (New York: Octagon Books, 1982), 64.

13. Sarris, *The American Cinema*, 64.

14. Louis Giannetti, *Masters of the American Cinema* (New Jersey: Prentice-Hall, 1981), 234.

15. Sarris, 64.

16. Deborah Thomas, "Film Noir: How Hollywood Deals with the Deviant Male," *Cineaction*, nos. 12–13 (1988): 25.

17. Foster Hirsch, *Film Noir—The Dark Side of the Screen* (New York: Da Capo Press, 1981), 90.

18. Hirsch, *Film Noir*, 90.

19. Lotte Eisner, *Fritz Lang* (New York: Da Capo Press, 1986), 338.

20. Hirsch, 86.

21. Gérard Genette and Marie Maclean, "Introduction to the Paratext," *New Literary History* 22, no. 2 (Spring 1991), 261–63.

22. Jonathan Gray, *Show Sold Separately: Promos, Spoilers, and Other Media Paratexts* (New York: NYU Press, 2010), 52.

23. Stephen Parmelee, "Remembrance of Film Past: Film Posters On Film," *Historical Journal of Film, Radio and Television* 29, no. 2 (June 2009): 181.

24. Andrew J. Elliot and Daniela Niesta, "Romantic Red: Red Enhances Men's Attraction to Women," *Journal of Personality and Social Psychology* 95, no. 5 (2008): 1150–151.

ABOUT THE CONTRIBUTORS

VLAD DIMA, PHD, is professor and chair of the Department of African American Studies at Syracuse University. He has published numerous articles, mainly on French and Francophone cinemas, but also on Francophone literature, comics, American cinema, and television. He is author of the following books: *Sonic Space in Djibril Diop Mambety's Films* (Indiana University Press, 2017), *The Beautiful Skin: Football, Fantasy, and Cinematic Bodies in Africa* (Michigan State University Press, 2020), and *Meaninglessness: Time, Rhythm, and the Undead in in Postcolonial Cinema* (Michigan State University Press, 2022).

LAURA HATRY, PHD, earned her doctorate from Universidad Autónoma de Madrid in Hispanic Studies. Her research focuses on cinematic adaptations of Latin American literary works, as well as other convergences (and divergences) among the arts. In addition, she holds an MA in Contemporary Art History and Visual Culture from the Reina Sofía Museum in Madrid and a postgraduate certification in Library Science. She is editor of *Refocus: The Films of Pablo Larraín* (Edinburgh University Press, 2020). She also works as a professional translator.

ALICIA KOZMA, PHD, is director of Indiana University Cinema, an arthouse cinema dedicated to using film and cinema studies for intellectual development and cultural enrichment. An educator, writer, and researcher, she specializes in the everyday work of the media, with a particular focus on how media industries run, the composition of industry employees, and the form and function of their labor. She is particularly interested in the conditions surrounding women's labor and in the industrial conditions that cultivate inequality in the production of film and television. Kozma is the author of *The Cinema of Stephanie Rothman: Radical Acts in Filmmaking* (University Press of Mississippi) and coauthor of *Refocus: The Films of Doris Wishman* (Edinburgh University Press) and *Mobilized Identities:*

Mediated Subjectivity and Cultural Crisis in the Neoliberal Era (Common Ground). Her work has been published in a wide variety of anthologies and journals, including *Media Industries, Film Comment, Camera Obscura, Television and New Media,* and others. Kozma holds a PhD in communication and media studies from the Institute of Communication Research at the University of Illinois, Urbana-Champaign.

LYNNETTE KULIYEVA is currently a PhD candidate in English at the University of South Florida, where she has also earned a graduate certificate in Digital Humanities. Following her research into stylometry and genre within the Shakespearean corpus, her dissertation focuses on Shakespeare's experimentation with medieval romance in his final plays and his transformation of medieval characters and conventions to render them with increased tragic potentiality and to provide commentary on contemporary Early Modern anxieties and debates surrounding politics, religion, and gender. Her research interests include literary and cinematic representations of monstrosities and the analysis and interpretation of alcoholism and addiction within film and contemporary song lyrics.

MADHUJA MUKHERJEE, PHD, is professor of Film Studies at Jadavpur University, India. She extends her archival research into art-practice, curatorial-work, and filmmaking. She edited the award-winning anthology *Voices of the Talking Stars* (2017), and (co)edited *Popular Cinema in Bengal* (2020), *Industrial Networks and Cinemas of India* (2021), and *Wondrous Screens in India* (forthcoming). Mukherjee is also a screenwriter and director; her latest feature-film, *Deep6* (2021), premiered at the twenty-sixth Busan International Film Festival. She is vice-chair of Inter-Asia Cultural Studies Society.

FRANK PERCACCIO, PHD, is associate professor of English at Kingsborough College of the City University of New York. His scholarly research and writing interests focus on the intersection of literature and film and the intertextual development of narrative motifs across movements and genres. His most recent article, "Defending *Purgatorio*: Dante, Brooks, and Finding One's Celestial Place," in *ReFocus: The Films of Albert Brooks*, is part of the Film/American Studies series published by the University of Edinburgh Press. In January 2020, he presented "Cemented Images: The Italian Immigrant Experience and the Labor Narrative" at the Modern Language Association's National Conference.

GARY D. RHODES, PHD, currently serves as full professor of Media Production at Oklahoma Baptist University. He is author of numerous books,

including *The Perils of Moviegoing in America* (Bloomsbury, 2012) and *The Birth of the American Horror Film* (Edinburgh University Press, 2018). Rhodes is founding editor of *Horror Studies: An Interdisciplinary Journal*. He is also writer-director of such documentary films as *Lugosi: Hollywood's Dracula* (1997) and *Banned in Oklahoma* (2004). His most recent book is *Consuming Images: Film Art and the American Television Commercial* (Edinburgh University Press, 2020), coauthored with Robert Singer. His most recent book is entitled *Vampires in Silent Cinema* (Edinburgh University Press, 2023).

COURTNEY RUFFNER GRIENEISEN, PHD, is professor of English and department chair of the Language and Literature department at State College of Florida. She also teaches film at Ringling College of Art and Design. She has published on Italian Americana, Ezra Pound, Edgar Allan Poe, John Donne, Ida Lupino, and Martin Scorsese. She earned her doctorate in Literature and Theory from Indiana University of Pennsylvania. She is president of the Italian American Studies Association, president of the State College of Florida Chapter of the American Association of University Professors, and chair of the Education Committee for the Florida Digital Humanities Consortium.

MARLISA SANTOS, PHD, is professor in the Department of Humanities and Politics and director of the Center for Applied Humanities at Nova Southeastern University. Her research focuses on *film noir* and classic film studies. She is the editor of *Verse, Voice, and Vision: Poetry and the Cinema* and the author of *The Dark Mirror: Psychiatry and Film Noir*. She has also published numerous articles on various topics such as Cornell Woolrich, film noir aesthetics, the James Bond franchise, and American mafia cinema, and on directors such as Ida Lupino, Martin Scorsese, Edgar G. Ulmer, and Joseph H. Lewis.

MICHAEL L. SHUMAN, PHD, is professor of instruction in the Department of English at University of South Florida. Shuman's publications in film studies include "Dracula's Deuce: How Horror Films Haunt Garage and Surf Music," an analysis of film tropes and popular music for *Weird Fiction Review*, and "Accidental Outlaw: Agency and Genre Ida Lupino's *The Bigamist*," a chapter in *Ida Lupino, Filmmaker*, edited by Phillip Sipiora. He is deputy editor of *The Mailer Review*, a publication dedicated to the work of author Norman Mailer, and regularly contributes articles and book reviews to that annual journal. Recent work includes an essay on the 1947 serial *Jack Armstrong: All American Boy*, in an edited collection on the films of director Wallace Fox.

ROBERT SINGER, PHD, is retired professor of liberal studies at CUNY Graduate Center. He received a PhD from New York University in Comparative Literature. His areas of expertise include literary and film interrelations, interdisciplinary research in film history and aesthetics, and comparative studies. Among his more recent publications are the coauthored *Consuming Images: Film Art and the American Television Commercial* (Edinburgh University Press, 2021) and *Beyond Realism: Naturalist Film in Theory and Practice* (Edinburgh University Press, 2024). He is the *ReFocus: American and International Film* series coeditor for Edinburgh University Press. He has written and directed several independent short films and coproduced the animated film *Ulalume* (2022).

INDEX

Page numbers in *italics* reference illustrations.

Printed in the United States
by Baker & Taylor Publisher Services